PITTSBURGH FILM HISTORY

ON SET IN THE STEEL CITY

JOHN TIECH

Charleston · London
THE
History
PRESS

Published by The History Press
Charleston, SC 29403
www.historypress.net

First published 2012

Manufactured in the United States

ISBN 978.1.60949.709.5

Library of Congress CIP data applied for.

.

For the talented Pittsburgh film community

CONTENTS

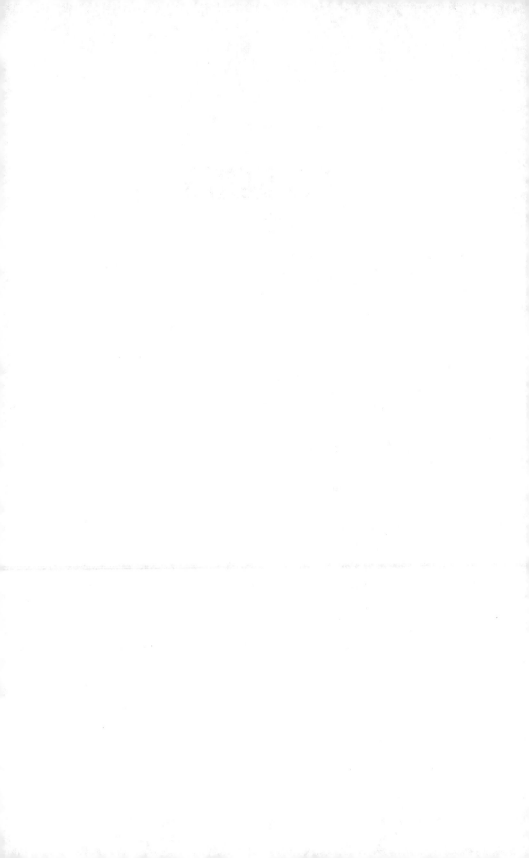

CHAPTER 1
THE GENESIS OF PITTSBURGH FILM

Film is one of the leading industries in America, as new movies appear in theaters every week all across the world. However, the big screen magic isn't just made in Hollywood. Cities all across America contribute to these cinematic spectacles. Some cities even have their own film crews, working sixteen hours a day to assist these productions in creating their art form. This is the present day, and moviemaking has changed over the course of a century. At first, movies had no sound and were known as silent films. Most of the first silent films were documentaries and only a few minutes long. This new technology found its way all over the world.

Known as the Steel City, Pittsburgh was one of the leading industrial cities during the late nineteenth century. The Twenty-seventh Triennial Conclave of the Knights Templar was held in Pittsburgh between October 11 and 14, 1898, and included many Knights Templar Commanderies from various cities. The American Mutoscope and Biograph Company captured the commandery parade, and the American Film Institute (AFI) acknowledges shots taken of the Detroit Commandery winning first prize for the finest drilled commandery at Schenley Park.

On December 2, 1901, film was used to document the cutting of cucumbers and cauliflower at the Heinz Company. Later that same month, another short documentary was shot showing company workers packing pickle jars. These two motion pictures are also recognized by the AFI. In April 1902, two short films provided a panoramic view of two famous city landmarks. The first captures the Sixth Street Bridge and shows Pittsburgh's busy scene. The second captures the Jones and Laughlin Steel Yard and explores the hard, quality work, as well as the machinery used.

Twenty-one registered short and silent films were shot between April 18, 1904, and May 16, 1904. They are known as the *Westinghouse Works Collection* and document the various companies such as the Westinghouse Air Brake Company, the Electric and Manufacturing Company and the Machine Company. Exterior and interior shots of the factories are shown, as well as the workers who made it all possible. The collection was copyrighted in July 1904 but was not registered with the National Film Registry until 1998. Many of Pittsburgh's silent documentaries such as the *Westinghouse Works Collection* can be viewed on the Internet, aiding in the preservation of these delicate and valuable pieces of history.

Pittsburgh was the home of the first nickelodeon in the United States. It was owned by Harry Davis and John P. Harris. Located on Smithfield Street, it opened on June 19, 1905. Eventually, silent films were being made for entertainment purposes. Many recognize *The Perils of Pauline* as the first movie made in Pittsburgh. It is an episodic serial consisting of twenty episodes that were typically shown before a full-length movie. They usually had no fewer than fifteen "chapters" or episodes. Each episode ended on a cliffhanger so the audience had to come back the next week to see what happened to the hero or heroine. In *The Perils of Pauline*, the heroine was Pauline Marvin, played by Pearl White. Over the years, she worked for several movie companies and in 1914 worked for a film company named Pathé, which was one of the largest movie companies. The French-based company specialized in producing movies and providing state-of-the-art film equipment. Pathé was interested in American film and opened a studio in Jersey City, New Jersey, in 1910. *The Perils of Pauline* was the first American-made Pathé film in the attempt to achieve worldwide success. The $25,000 production opened on March 31, 1914, and ran until that December. Pittsburgh only had a small contribution to the serial, with most of it being made in other eastern locations. It was selected for preservation by the National Film Registry in 2008. *Via Wireless* was made in 1915 by Pathé and released on September 17, 1915. It stars Bruce McRae and is directed by George Fitzmaurice. According to the AFI, one of the city's many steel mills was used as a location. *Via Wireless* still exists today and is one of only a few Pathé films that does.

Film exchange buildings were constructed along the Boulevard of the Allies, a section of Pittsburgh known as "film row." They were places where films were rented or traded. Large motion picture studios also owned exchanges where they screened film to potential exhibitors in a local market. The Paramount Film Exchange building still exists today and is the only remaining building, whereas most of film row disappeared in the 1970s. On January 28, 2010, legislation was signed declaring the building a historical landmark.

CHAPTER 2
PITTSBURGH CLASSICS

Pittsburgh's industrial landscape was being demolished to make way for skyscrapers and Point State Park. In Hollywood, this was the golden age of film, an era that utilized Pittsburgh several times. Paramount Pictures' *The Unconquered* was filmed between June 1946 and December 30, 1946. Only Allegheny County was used for the forest scenes and second-unit filming. Before 1950, Pittsburgh was only used for background shots or other minor purposes. *Angels in the Outfield* was set at Forbes Field, the home of the Pittsburgh Pirates. This was unusual because movies were usually shot on set at a studio. It was the first movie to be shot on location in Pittsburgh. Principal photography lasted from March to May 1951, and the movie was released that October.

Television was a new and exciting concept, allowing Hollywood entertainment to be viewed in the comfort of home. Even though KDKA was the first television station in Pittsburgh, an innovative and inspirational children's program became the launching pad for a legacy that continues today. Josie Carey began working at WQED in October 1953, even though the station didn't put out television broadcasts until six months later. She was secretary to the station manager, and a young man named Fred Rogers was to be program developer. Even though Carey and Rogers had around eighty-seven proposed programs, WQED's first station manager, Dorothy Daniel, only wanted *The Children's Corner*.

The Children's Corner aired from 1954 to 1961, geared toward the entertainment and education of children. Carey wrote the lyrics for a total of sixty-eight songs, with Rogers writing the music. Children's drawings were displayed, and their birthdays were celebrated on live television. Based on popularity, it was difficult to name all the birthdays. As a solution, four children were picked to come on the show to get dubbed princes and princesses by puppet

Screenshot of Josie Carey on *The Children's Corner*.

King Friday. The puppets had an important role. David Newell later became a partner and friend to Rogers and said, "She [Dorothy Daniel] gave Fred, the opening night of the first program of *The Children's Corner*, a tiger puppet." The appreciation toward Daniel provided the name for one of the most memorable puppets of all time: Daniel Striped Tiger. Guests such as Johnny Carson, Shirley Jones and cartoonist Charles Schulz came on the show. Carey earned the Sylvania Television Award in 1955 for the best local children's show in the United States. In 1961, Carey went on to other children's programming with stations KDKA and WQEX, as well as a South Carolina TV station. Fred Rogers' legendary career was yet to come.

Pittsburgh shared a few seconds of screen time on *The Rat Race*, starring Tony Curtis, Debbie Reynolds and Don Rickles. Principal photography began on September 23, 1959, and lasted until early December. The few seconds of Pittsburgh appear at the very beginning of the movie as the credits are rolling. The second-unit shot depicts a Greyhound bus crossing the Fort Pitt Bridge, heading east to New York City.

Television was primarily shot on a set, and one of the first shows to incorporate location filming was the CBS show *Route 66*, filming at various locations in the United States. The primary star of the show was Martin Milner. For nearly three seasons, he was joined by George Maharis. During the show's second season, two episodes were filmed in Pittsburgh. The first episode was "Goodnight Sweet Blues" featuring well-known American jazz and blues singer Ethel Waters. The second was "Mon Petit Chou" featuring legendary actor Lee Marvin.

In 1964, *Sylvia* was shot in Pittsburgh and starred Carroll Baker. The daring script wasn't the only interesting aspect of the production. Baker disapproved of the writer in preproduction and requested that a new writer be hired. The studio recommended that she worry about other things like the kind of purses she was going to use. Baker put on a display of defiance and tossed the purses out the door, wearing a purse in only one scene. To prepare for her role, she worked a shift unnoticed at an all-night diner and visited a brothel. This was also the second Pittsburgh production for George Maharis.

CHAPTER 3
CHILLY BILLY

Local news broadcasting provided solid work, but the city was deprived of filmed entertainment. Bill Cardille started his career in Erie, Pennsylvania, at WICV Channel 12 in 1952. He arrived in Pittsburgh in 1957 as he signed on with WIIC Channel 11, which is now known as WPXI Channel 11. "I signed on the station September 1, 1957. They auditioned about five hundred and hired six. As a staff announcer, you audition for all the shows. When it came time to do wrestling, I didn't want to do it. They started it in '59, and the announcer left. I took over and did it for about thirteen years," said Cardille about *Studio Wrestling*. Finally, a form of entertainment for young and older adults was live and direct from Pittsburgh. Wrestling legends such as Bruno Sammartino and George "The Animal" Steele entertained locals every Saturday evening at 6:00 p.m. It was the top wrestling show in the country at one time, and fans lined up outside the doors at noon.

Cardille remembered:

> *They asked me for an idea for a show late at night. I came up with the idea for* Chiller Theater. *I wrote and produced it. After about ten or twelve years of doing it solo, the studio said, "Let's get a family together." The first person I got was Norman "The Castle Keeper." He had a birth defect. People thought it was makeup. I met Stevie in Las Vegas when my wife and I were out there, and he was with his parents. I thought I'd get him to appeal to the young kids. He was only nineteen. I hired and met "Terminal Stare," who wanted to get onto television. We auditioned different girls, and eventually we got a young lady that's a model with my daughter named*

Joyce Sterling, and she was "Sister Suzzie." I had Miss Pennsylvania for the younger guys. Bonnie Barney was Georgette "The Fudgemaker."

Chiller Theater was one of the very few shows that stayed on the air until three or four o'clock in the morning. Fan mail poured in from Texas, Chicago and Canada. Cardille welcomed the fan mail, which typically came in the form of postcards, reading some on the show.

Besides hosting two hit shows, he still had announcing duties to perform at the station. At one point, he was putting in eighteen-hour days. Looking back, Cardille remembered, "I did *Dance Party*, *Luncheon at the Ones*, stock car racing, *Beat the Experts*, which was a panel show, plus my announcing duties. I did the wrestling show that Vince McMahon now does. I did everything except sing the national anthem, and the only reason I didn't do that is because I never asked." He never made it a secret that he loved live television and radio.

Studio Wrestling was cancelled in 1972. Many factors contributed to this cancellation. Bruno Sammartino was no longer champion and was the guy people wanted to see. The show was no longer airing at 6:00 p.m. Channel 11 had new management that believed the show no longer served the purpose or direction of the station. Despite the cancellation, Cardille's work didn't go unappreciated, as he was awarded the Heart Award in 1976 and inducted into the American Federation of Television and Radio Artists' (AFTRA) Hall of Fame in 1979. A few years later, *Chiller Theater* was cancelled on December 31, 1983. Cardille's television career came to an end on June 30, 1996, as he officially retired. In 1997, he was inducted into the Pennsylvania Broadcaster Hall of Fame. He said, "I'm one of three broadcasters in Pittsburgh who is in the broadcasting hall of fame in Pennsylvania."

Although retired, he remained in the public eye. Every year, he hosted the Jerry Lewis Telethon for the Muscular Dystrophy Association. During his retirement, he spent his time on the radio at WJAS 1320 and with his wife, his children and his grandchildren. The cast of *Chiller Theater* still made appearances. As Cardille said, "I just do it with 'Terminal Stare' and Stevie. We do a cruise, and it's the biggest event on the Gateway Clipper. Some years, they tie two boats together. It's very nice." In June 2010, Cardille made an appearance at Westmoreland Mall with some of the legendary wrestlers of *Studio Wrestling*, including Bruno Sammartino and George "The Animal" Steele. Looking back at everything he's done with his life, he said, "I enjoyed every minute."

CHAPTER 4
FRED ROGERS AND HIS LEGACY

For over fifty years, Fred Rogers was an inspiration to children all over the country and was truly one person who made a difference. Through television and public broadcasting, the lives of several generations of children were changed forever. When *The Children's Corner* ended, Rogers got an offer to work in Canada for the Canadian Broadcasting Corporation (CBC). In 1963, he moved to Toronto to begin work on his new show *Misterogers*. This was the first time he was in front of the camera, and he created the trolley and castle that later became part of the "Neighborhood of Make-Believe." The show lasted about three years, and Rogers was able to secure the rights for the show. He moved back to Pittsburgh and became an American institution with his next venture, *Mister Rogers' Neighborhood*.

Production began in the fall of 1967. Developed with the help of the Eastern Educational Network, the show aired on February 19, 1968. Rogers carried over skills as a puppeteer and songwriter to the show and brought his puppets and sets with him. New talent was also required. This is where Rogers met his longtime friend David Newell, who went on to play Mr. McFeely. Newell worked with the Pittsburgh Playhouse children's theater and the Civic Light Opera. He interviewed for about an hour and got the job of playing Mr. McFeely, a character named after Rogers' grandfather. Originally, Newell thought he only had the job for a year, but he stayed for the entire run of the program. Don Brockett was also hired. Newell recalled, "Don was mainly a producer and writer. He started off as a writer locally. Don had an agent, that's how he got the job." Robert Trow was another initial cast member. "Bob Trow started off as a radio performer and worked on KDKA. Sometimes they would tape them and sometimes they would

do them live. Bob was a radio actor. I think he was at the right place at the right time. I don't think Bob had an agent," said Newell. "They both knew the business, and they both knew people who were in the positions of hiring. So it was just word of mouth and knowing who you are in a small city, compared to Los Angeles."

After three years, the show became affiliated with the Public Broadcasting Service (PBS). This move had little impact on the making of the show. To describe a typical production day, Newell said:

> *Well, it depends on what we were doing on that particular day. We would tape it out of order, and what we would do first is to tape the remotes. Then we would film the "Neighborhood of Make Believe." Then, you have twelve to sixteen minutes taped and then you knew how much [time] you had left for the rest of the program, discounting credits. So that's why we did it out of order. We knew how much time it would be to put a program together.*

Over the years, special guests such as Bill Bixby, Lou Ferrigno and LeVar Burton were featured. Newell remembered:

> *When my daughter was very little she was watching* The Incredible Hulk, *and it scared her, and I thought, "Wouldn't it be great if we could show how they make that show and that it is just pretend?" We knew Bill Bixby, and he was directing that particular episode. He invited us to come to Universal, and we met Lou Ferrigno and watched Lou getting into his green makeup to show kids that here is an actor and this is pretend. Then we showed how they do some of the tricks in the studio like overturning cars and things like that. The whole lesson is to help children understand that it is pretend and that when you're angry, you don't overturn cars or beat people up; you try to work things out between each person. So there were a lot of lessons to it.*

Big Bird even appeared on Rogers' show, and in turn Rogers appeared on *Sesame Street*. LeVar Burton came on the show in 1998 to read a book with Fred. Newell recalled, "He [Fred] has known LeVar for a long time, and he [LeVar] is very much interested in children's television and positive television." The show was filled with many memorable moments shared by celebrities and locals alike.

Rogers testified before the United States Senate Subcommittee on Communications and Chairman John Pastore in 1969. Public Broadcasting was proposed a grant for $20 million by Lyndon Johnson during his

presidency, but when Nixon took office, the grant was cut to help pay for the Vietnam War. Rogers stood up to the subcommittee to argue for the full grant. His work was rather new and had not reached everyone's attention, including Pastore. During his testimony, Rogers seemed intimidated by the chairman but didn't sway his courage to do what he believed was right for the children it benefited. Pastore was touched by his testimony and increased the grant to $22 million in 1971. Rogers helped to maintain important children's broadcasting for years to come.

Many have come and gone on *Mister Rogers' Neighborhood*. In 1967, Betty Aberlin knew Joe Negri and Brockett, who were working on *Mister Rogers' Neighborhood*. She joined the show about a year later. In 1974, Rogers met Chuck Aber, who worked on a theater production with Negri and Aberlin. Rogers saw the show and asked Aber if he wanted to be involved with *Mister Rogers' Neighborhood*. "That was the start of a beautiful friendship. It was a lot of fun…I thought it must be like working for Disney and then after a while I thought this has to be better than working for Disney," remembered Aber. Adrienne Wehr was associate producer on *Mister Rogers' Neighborhood* from about 1987 to 1997 and said, "I really needed a break out of the advertising world…I would be there for three months and then I would be off for three months. We weren't producing a lot during those years…they were making anywhere from only ten to fifteen new shows a year…It was nice. It was a nice environment to be a part of. There was kind of a whole 'fairy tale' quality to the whole experience." Nick Tallo started his career on the show and served as floor manager. "That was probably the most rewarding thing I ever did in my life. For as much as I love working on movies, the bottom line is money. Working on *Mister Rogers' Neighborhood*, the bottom line was kids," said Tallo. "What we were doing was very, very important. Fred was the way you saw him on camera." He also had fond memories of working with Michael Douglas, better known as actor Michael Keaton. "Mike was on my crew. It was great! He's a maniac. We used to hang out and be weird together and stuff. We used to have a great time!" Judith Conte remembered being part of a few segments through her work at Carnegie Mellon University (CMU). She said, "Working at WQED with Rogers and the entire production staff was just a treat. Fred was just an extremely knowledgeable man. He was off camera exactly how he was on camera, generous and open, warm, really concerned about humanity. So it was always a pleasure to work for them." Conte helped choreograph a tap dance scene with some CMU students.

In the mid-1990s, tragedy struck. On May 2, 1995, Brockett passed away. Next, piano player Johnny Costa passed away on October 11, 1996. Costa

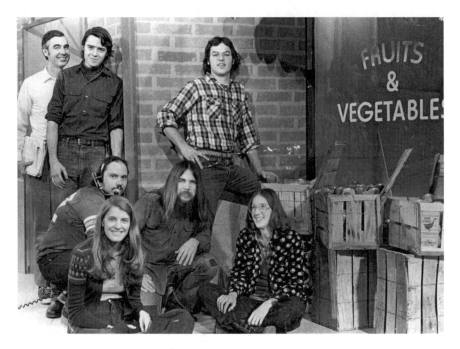

Crew picture from *Mister Rogers' Neighborhood* featuring Fred Rogers, Greg King, Michael Keaton, Nick Tallo, Kate Kearney and others. *Courtesy of Nick Tallo.*

had provided the soundtrack since the show's beginning. His brilliance on the piano enabled him to conduct his soundtrack live on the set. Conte said, "[Costa] was just a magician on the piano." His other coworkers felt the same way about his work. On November 2, 1998, Trow passed away. Given the circumstances, it wasn't too much of a shock that the show was nearing its end as well. In 2001, it stopped taping new episodes and provided public broadcasting with nearly one thousand episodes to use daily.

One of the most emotional moments in television history is the 1999 induction of Rogers into the Television Hall of Fame by his old friend Jeff Erlanger. On July 9, 2002, Rogers was given the Presidential Medal of Freedom by George W. Bush. A statue of Rogers is erected on Pittsburgh's North Shore, and learning centers have been dedicated and named in his honor. One of his sweaters even appears at the Smithsonian. Sadly, in December 2002, he was diagnosed with stomach cancer and died soon after on February 27, 2003. Rogers' legacy lived on thanks to a tool he used so brilliantly to reach millions of children over the span of three decades: the television. He left generations with a sense of inspiration and hope by teaching them about the ability to impact the lives of others and by being their neighbor.

CHAPTER 5
NIGHT OF THE LIVING LEGENDS

George A. Romero attended CMU, which was then known as the Carnegie Institute of Technology, in 1957. He wasn't able to make a decision as to what he wanted to do with his life. He wanted to become an artist like his father, but that didn't pan out. He skipped classes in college and showed little interest in what he was doing. He eventually dropped out around 1962 to pursue one of his lifelong interests: film. Rudy Ricci, a college friend, introduced Romero to his cousin Richard, who introduced Romero to Ray Laine, John Russo and Russ Streiner.

Because Russo signed up for two years' service in the army, Romero, Streiner and Ricci had the task of creating a company. They started off with one 16mm camera and a few lights. Romero even borrowed about $500 from his uncle to help get things started. Ricci found a building on Carson Street in the South Side, and they rented this space out for $65 per month. The building wasn't in good condition. Ricci paid the landlord six months' worth of rent to help get things moving. Romero had to sell oil paintings for money, and they even went without food for days at a time. In 1963, Vince Survinski brought a $10,000 investment opportunity to them that fell through, but Survinski remained as an investor to the new company called the Latent Image. Finally, the company had an investor and an official name. With Survinski, the Latent Image found its first real job. This helped the company get a small business loan of $30,000 in 1965. They decided to move to a better location in downtown Pittsburgh. Russo returned and joined them, as promised. It finally became a fully operating company.

As the snow fell in January 1967, one of America's classic movies was born. Romero, Ricci and Russo had lunch and a discussion of creating

a feature film. They had the equipment to create it, but investment was difficult to obtain. As the conversation continued, it was Russo's idea to do a horror movie and Romero's idea to make it contemporary. They only had about $6,000 to spend. Ricci wasn't a fan of the idea but was on board. It didn't matter how quick the cast, crew and script came together because it was too cold to do anything outside. They collectively decided to wait until the spring, giving them ample time for preproduction. A few ideas were discussed, with none of the full ideas making it to the final script. Romero and Russo didn't get much writing done because of their commitment of sustaining the company. Romero eventually found some time and wrote forty pages of a story that they all loved. The second half of the script consisted of meetings with all the creative minds involved. They had three different endings in mind. One ending had Barbara being dragged into the cellar by Ben, with him accidentally getting shot when the posse members arrived. Barbara rose up out of the cellar as the sole survivor. The second ending was the ending used, having Ben rise up out of the cellar and accidentally get shot by the posse members. The third ending was suggested by Karl Hardman, consisting of everyone dying and the posse members driving away with Cooper's ghoul daughter standing at the top of the cellar stairs. Hardman and Marilyn Eastman were partners at Hardman Associates Inc. and had a prior working relationship with the filmmakers. The forty pages eventually turned into a full script for them to use while casting.

The untitled production informally called "Monster Flick" began casting. Ben was the most important character to be cast. Streiner remembered, "A mutual friend of George's and mine was a woman by the name of Betty Ellen Haughey…she knew of Duane Jones. And she said, 'You should meet this friend of mine from New York.' Duane happened to be in Pittsburgh visiting his family, and we auditioned him. Everyone said, 'Hey, this is the guy that should be Ben.'" Given the civil rights movement of the 1960s, this was a bold step for the filmmakers. Romero was willing to make a bold step in the casting of an African American actor during the 1960s, and he wasn't alone. The other major character that needed to be cast was Barbara. Judith O'Dea remembered, "In 1967, I moved to Los Angeles hoping to break into the movie industry. Shortly after that move, I received a phone call from my friend Karl Hardman, planning to make a film with George Romero and company. Karl wanted to know if I'd like to come back home to audition for one of the lead roles. Without a second thought I said, 'Sure, I'd love to!'" Romero had Betty Aberlin in mind to play the role of Barbara, and it's suspected that Fred Rogers talked her out of the role.

The rest of the cast fell into place. Hardman, his daughter Kyra Schon and partner Marilyn Eastman played Harry and Helen Cooper with their daughter Karen. Originally, the Coopers were to have a son named Timmy. Therefore, a minor change was needed in the script. Schon said, "I was stunned that I was chosen for the part…I had been a huge fan of horror movies since I was old enough to turn on the TV by myself, and I was thrilled that I'd get to be in one. I was a little nervous about it because I'd never done any acting, and I didn't quite know what would be expected of me." For the role of Tom, nightclub singer and actor Keith Wayne was chosen. Romero looked favorably on Wayne, who was suggested to him by Russo and Ricci. Judith Ridley was cast as Tom's girlfriend Judy. She was considered to play the lead female role of Barbara, but the experience fell on O'Dea. Some changes to the script had to be made in order to accommodate the actors and actresses playing the parts. Tom was originally supposed to be a middle-aged caretaker of the cemetery. Ben was almost completely opposite of how he was portrayed by Jones and was originally supposed to be a crude and uneducated truck driver with resourcefulness. A television reporter was needed, and Bill Cardille was cast. "I got a call from Karl Hardman and he asked me, a couple of times, to do it. I was working seven days a week as it was. Anything I did had to be approved by the station. After the second or third time, I said I'd do it," remembered Cardille. Streiner had experience acting at the Pittsburgh Playhouse, and in order to save money, he played Johnny. Bill Hinzman was employed by Latent Image as a snapper and credited his zombie performance to Boris Karloff. Eastman also did makeup. George Kosana, the production manager, played Sheriff McClelland. Over two hundred extras showed up as zombies, and they were paid twenty-five dollars. Casting was completed by June 1967.

They needed a farmhouse that could be destroyed, and the filmmakers knew they couldn't just go into someone's home and do this. They all scouted Pittsburgh for the perfect farmhouse, and toward the end of casting, a farmhouse was found. Jack Ligo, a Latent Image apprentice from an art school, mentioned a large farmhouse in Evans City to the filmmakers. It was going to be bulldozed and the land used as a sod farm. Even though the farmhouse was about forty miles away from Pittsburgh, it was perfect. They negotiated with the owner and agreed to rent it for $300 a month. Conveniently, Evans City also had a cemetery that met the needs of the production. The farmhouse cellar wasn't adequate, and they decided to shoot those scenes on a constructed set in the basement of the Latent Image building. The television newsroom was shot at the converted Hardman

Associates offices. The sets were constructed by Vince Survinski, who also spent two months decorating the farmhouse with furnishings purchased from the Goodwill for fifty dollars. Romero was chosen to direct, and they were set to begin principal photography in June 1967.

The shoot lasted about six months, ending in November 1967. The first scene shot was Barbara running from the cemetery. O'Dea ran into the gas pump that was not bolted down and nearly caused the first catastrophe. Reflecting on her experience, she said, "I can't think of any negative memories regarding the filming. For me, the whole experience was exciting, rewarding and educational…filmmaking, in general, is not all the glamour and glitz we'd like to think it is. In reality, it's an arduous process requiring long hours both in front of and behind the cameras. My production schedule required almost two weeks of twelve- to eighteen-hour days. We had to pick up shots several months later."

One of the most memorable nights of filming was that of the nude ghoul scene, performed by an artist's model. One of the more action-packed scenes was that of the exploding truck. The filmmakers purchased a truck from a junkyard for only fifty dollars. It was in terrible condition and ended up dying. A man who lived down the road from the farmhouse owned the exact same truck and lent it to the production. The dead body at the top of the stairs in the farmhouse was nothing more than a plastic skull with fake hair and ping-pong ball eyes. Many of the body parts devoured were nothing more than mannequin parts. The filmmakers had to be as creative as possible given the time and budget restraints. Principal photography took place in increments so they could maintain their primary job of producing commercials and sustain the company. Most cast and crew commuted over thirty miles, while some stayed in the farmhouse. It was necessary for some to stay because they couldn't hire security. Vandals still came into the farmhouse. Some of the filmmakers stayed in the farmhouse, and there were no showers. They had to take cat baths in the morning. The interior scenes were typically shot during the day, and the exterior scenes were done at night. The final two days of the shoot were at the cemetery. The car was owned by Steiner's mother, who gave them permission to destroy it.

Scenes had to be filmed in Washington, D.C. Streiner said, "We all piled into some cars, drove to Washington, D.C., on a Sunday, had no permits, had no anything. We put military flags on the front of Hardman's Continental to make it look like an official car." The crew knew their prop was believable when a guard approached them, thinking it was a real general's car. Many cast and crew members revealed that they had kept certain props. Streiner

kept the tie he wore as Johnny. Schon said, "I still have the bandage that I wore on my arm and some makeup. I also have the music box that my dad recorded for the movie."

The final hurdle was to find a distributor. Columbia Pictures came very close to offering a deal, but it never happened. American International Pictures (AIP) liked the film but wanted them to change the ending so that Ben survives. Romero defended his work, and the deal fell through. The third attempt at gaining a distributor proved to be most interesting. Streiner said, "The night George and I were driving on the Pennsylvania Turnpike to New York with the answer print to try to arrange a distributor is the night that Martin Luther King was assassinated. That's when we heard the news." Despite the grim news, the trip itself turned out to be very beneficial. They

Night of the Living Dead movie poster.

found a distributor with Continental Releasing, a subdivision of the Walter Reade Organization. The film had several titles before it was released. The finished print bore the title *Night of the Flesheaters*, a title that changed because it had already existed. Romero came up with the title *Night of Anubis*, named after the Egyptian god of death. The Walter Reade Organization was about to release the film when the title changed to *Night of the Living Dead*.

On *Chiller Theater*, Cardille promoted the movie as much as he could. The filmmakers were hoping to at least make a huge impact among hometown moviegoers and acquired the Fulton Theater in downtown Pittsburgh, premiering the movie on October 1, 1968. It was like a Hollywood premiere with the limousines, tuxes, press and klieg lights. The word of mouth spread like wildfire. Fresh new crowds came weekend after weekend nationwide to see the movie everyone was talking about. Critics gave an overall mixed review, with some being completely devastating. Roger Ebert's review in 1969 was one of those negative reviews. But the film also received very favorable reviews. *Night of the Living Dead* became a cult favorite and an American classic, and it only cost $114,000 to make.

CHAPTER 6
THE STRUGGLING SEVENTIES

The first half of the 1970s experienced troubling times. Following the huge success of *Night of the Living Dead*, the founders of Latent Image wanted to get to work on another movie. At first, they wanted to do a "Horror Anthology." Romero wasn't as thrilled with the idea and didn't want to be stereotyped with a single genre. They made a short half-hour film for Ray Laine entitled *At Play with the Angels*. It starred Laine and Judith Ridley, who married Russ Streiner, and was directed by Rudy Ricci. It also won an award from the Visual Communications Society. Everyone decided to do an extended colorized version called *There's Always Vanilla* with the same actors and a budget around $150,000. The community was willing to invest, following the success of *Night of the Living Dead*.

The project was doomed from the beginning. Arguments occurred behind the scenes over the writing, casting and schedule. The group was falling apart. They had to maintain their commercial business and filmed when they could. Principal photography lasted a few years, and those involved with the production remember it being a terrible experience with a lot of tension. It wasn't officially released until February 1972. The length of the release time was attributed to the same problems it had faced throughout production. It was a box office flop and didn't even retain a definitive title, being rereleased as *The Affair*. The production, as well as problems with the commercial end of the business, caused the Latent Image to close. Romero wanted to take control of his own filmmaking career, and this gave him the opportunity to do so. Streiner left the company first, followed by Russo.

Going Home was directed by Herbert B. Leonard and starred Robert Mitchum. Principal photography began on June 16, 1971, and ended in

late August. The bachelor party scene was shot in the warden's house of the Allegheny County Workhouse. The Boys' Industrial Home of Western Pennsylvania was located in Oakdale and could have contributed a school bus. Several sources acknowledge McKeesport to be a filming location as well. Pittsburgh was only used for certain scenes for this movie.

In 1971, George Romero got married and made *Jack's Wife*. Jan White was recommended to Romero and a chosen favorite to play the lead role of Joan Mitchell, the unhappy housewife. She was originally from New Castle, Pennsylvania, and was working in Philadelphia when her sister called, informing her that they wanted her to play Joan. White wasn't too thrilled with the script, as it called for nudity. She still learned a few scenes, went to the audition and was convinced after Romero promised a stand-in for the nude scenes. The production used the home of Mr. and Mrs. Clifford Forrest located in Forrest Hills. Their daughter Christine even helped the production. This house was scouted by Gary Streiner, who knew the Forrest family. The budget was supposed to be $250,000, provided by a Pittsburgh brokerage. However, things didn't go according to plan, as the final budget ended up being under $120,000. Interesting occurrences happened on set. The crew was shooting by an airport and had to wait until the planes were gone to shoot a scene. This annoyed White, and when she shouted, the ceiling cracked. While shooting a scene, White was getting slapped by actor Bill Thunhurst and a light fell on him during one of the takes. When White was writing the Lord's Prayer backward for a scene, the film never showed up on camera. A deal was struck with distributor Jack Harris, and the title was changed to *Hungry Wives* in the attempt to make the film more erotic. It was released in April 1973 and had a very short stay in theaters due to the lack of an audience. Harris attempted to cash in on the film years later. He even changed the title to *Season of the Witch* after the song in the movie. It didn't make as much as he had hoped and was pulled from theaters. It later resurfaced on VHS in 1985 and on DVD in 2005.

A rare success story was the establishment of the Pittsburgh Filmmakers organization in the basement of the Selma Burke Art Center in East Liberty. Its mission was to facilitate the learning of filmmaking to noncommercial filmmakers. In 1972, it partnered with the University of Pittsburgh to offer select courses. This trend continued for years to come as the Pittsburgh Filmmakers partnered with Point Part College in 1974, Carlow College in 1980, Carnegie Mellon University in 1985, Duquesne University in 1991, LaRoche College in 1996, Robert Morris College in 1997 and Seton Hill College in 1999. Over the years, the organization kept up with the ever-

changing technology of filmmaking to provide the most state-of-the-art equipment for its students. The location of the organization changed several times over the years, and it is currently located on Melwood Avenue. Pittsburgh Filmmakers merged with the Pittsburgh Center for the Arts in 2006 and still provides quality filmmaking education.

George Romero made *The Crazies* in 1972. The original treatment called *The Mad People* was written by longtime friend Paul McCollough. Romero was given a chance through a solid budget estimated at $250,000. It was even his first Screen Actors Guild (SAG) production, and he found many of the major actors in New York. The script already provided the necessary filming locations: the old stomping grounds of Evans City and Zelienople. Romero also had an idea for an alternative ending with two reunited lovers running toward each other, and a bomb destroys them before they touch. Just like Romero's last two films, *The Crazies* was given the alternative title *Code Name: Trixie*, the name of the chemical released in the film. It flopped and was the third straight theatrical failure for the director, leaving him in great debt. Romero suffered from stomach problems, and his condition worsened. He spent the next three years building his health and bank account back up. While in New York, he eventually met Richard P. Rubinstein, the man who helped Romero get back on his feet.

One film entity that remained solid in Pittsburgh was WQED studios. This opened the door for Pat Buba and Dusty Nelson. They each had a role to play when it came to filmmaking. Buba was originally into sound and music, whereas Nelson was interested in the cinematography and camerawork. They worked on several documentaries for WQED. Buba explained, "Dusty would be shooting the handheld camera and I would be doing the audio… we would shoot a lot of the documentaries, and we learned our craft by being around film…gradually they just let us do our own little movies… Literally, when I walked into WQED they were looking for people to help." Nelson said, "I love doing documentaries because they're immediate…it's the absolute best kind of filmmaking just from the strict point of view of being there and doing it, the film was happening right before your eyes and it's not like that when you are doing a narrative." Around 1972, they teamed with their friend John Harrison to make film shorts in the area. Their company was called BuDuDa. An example of their work was the 1973 short film *UBU*. Even though the feature film industry in Pittsburgh was relatively dead, commercials and industrial films kept the industry alive because there were so many companies in Pittsburgh.

Another filmmaker was coming onto the scene in Pittsburgh. Pat Buba's brother Tony began his documentary filmmaking in 1972. This was the

beginning of *The Braddock Chronicles*, a series of black-and-white documentary shorts. The first was filmed in 1972 and was called *To My Family*, a three-minute documentary. He filmed *J. Roy: New and Used Furniture* in 1974, which is only eleven minutes long. In 1975, the twelve-minute *Shutdown* was shot, and in 1976, *Betty's Corner Café* became parts three and four of the series. Buba wanted to paint an accurate picture of the suffering Braddock community because of the decline of the steel industry and the exodus of its population to a more urban setting for jobs. He didn't finish the first part until 1980 and the second part until 1985.

The Devil and Sam Silverstein was made in 1974 by Russ Streiner and stars Robert Trow and Allen Pinsker. *The Liberation of Cherry Janowski* was the next movie made, but the title was changed to *The Booby Hatch*. The filmmakers almost closed a deal to make it in New York, but it fell through and was made in Pittsburgh. The cast and crew consisted of John Russo, Russ Streiner, George Kosana, Rudy Ricci and cinematographer Paul McCollough. The comedy earned an X rating due to its erotic nature and was released in September 1976. It marked the beginning of David Emge's performance as an on-screen actor. He was working at the Pittsburgh Playhouse and met some of the local film people.

CHAPTER 7
DAWN OF THE PITTSBURGH FILM INDUSTRY

With the exception of a few television programs and independent work, Pittsburgh virtually had no real film entity. Two productions in the summer of 1976 changed that. The first was the Paul Newman classic *Slap Shot*, which began production by July 1976, directed by George Roy Hill. During the casting process, Al Pacino, Nick Nolte and Donny Most all expressed interest, but none was cast. The production shot in Johnstown, Pennsylvania, where an actual apartment of one of the Johnstown Jets, a local hockey team, was used. The Jets also had roles as opposing hockey players. Their bus driver, Cliff Thompson, had a role as the bus driver for the Charleston Chiefs. Many of the players and actors had fond memories of Johnstown. Newman offered his daughter Susan a chance to work for him as his secretary. He also got her a cameo, appearing as a pharmacist. The production rented a house for Newman, who preferred to associate with the other actors and have fun. Unless his wife was on location, Newman spent time at the Johnstown Sheraton and local bars. Acting as her father's secretary, Susan also found out about her father's interesting life being pursued by women. Newman credited *Slap Shot* as being the most physical film he's ever done. The entire filming experience wasn't all tough and was humorous at times. Newman played some practical jokes behind the scenes. He staged a fake car accident with himself behind the wheel of one of the wrecked cars. Hill raced to the scene to find him smiling. He had staged the crash because Hill had refused to buy a round of drinks for the crew. *Slap Shot* was released on February 25, 1977.

Meanwhile, George Romero documented the sports careers of Kareem Abdul-Jabbar, O.J. Simpson, Bruno Sammartino, Mario Andretti, Reggie

Jackson and more. He also worked closely with Pat and Tony Buba, Dusty Nelson and John Harrison. Pat Buba remembered, "We had a couple of little films we'd done on our own, and that really impressed George…he hired us on the spot to work on the sports docs." Nelson explained, "You couldn't have met a better person to work with because he [Romero] was very loose and he'd share everything. There wasn't a bone in his body that had to do with power or ego or any of that stuff. What a great person to meet." Romero's health and financial status improved during this time. He began dating Christine Forrest during those years as his first marriage was coming to an end. He was also trying to get back into the movie business. They sought out investors to make a low-budget movie and found local investors who put up $100,000. The complete budget was estimated around $275,000, a number created by Rubinstein for business purposes. More and more businessmen in Pittsburgh were willing to invest in movies because tax shelters were created. Investors received a tax deduction if their investment went sour.

Romero was drawn to vampire lore and even did some research on actual murders in Los Angeles. He came up with the idea for *Martin* and formed a moviemaking "family." Rubinstein, Pat and Tony Buba, Christine Forrest, John Amplas, Nick Mastandrea, Mike Gornick and Tom Savini were all part of this "family." This was Savini's first movie. He originally wanted to play Martin, but Amplas was already cast by Romero, who was impressed with his performances at the Pittsburgh Playhouse. Romero granted Savini's request to do makeup and gave him a speaking role, along with stunt duties. They ended up using the home of Angeline Buba, the mother of Tony and Pat Buba. It was an easy find being that they were from Braddock and lived in that house. Angeline provided the best accommodations possible. She cooked fresh food and even baked for them. The crew loved the hospitality. Many of the props and religious artifacts they brought into her home remained there for over twenty years. Principal photography began on August 8, 1976, and lasted until October 1976. The atmosphere was different than those of Romero's previous films. The director praised the hardworking cast and crew. Romero only spent a day or two providing the cinematography and asked Gornick if he wanted to take over. He accepted, alleviating some of the burden for the director.

Romero claims the final cut is still close to what he had intended and is possibly his favorite movie. Before the release, he had a run-in with the Motion Picture Association of America's (MPAA) rating system for the first time. They wanted to give it an X rating. A few cuts needed to be made, but

nothing that altered the story. Romero did what was needed to get the rating. *Martin* was released on July 7, 1978, to critical praise.

The next production in Pittsburgh was *The Deer Hunter*. This was the first Academy Award–winning production Pittsburgh hosted, but only a small portion was shot in Duquesne. Various other places were used for principal photography, such as Ohio, Washington, West Virginia and even Thailand. Thailand, Bangkok and the River Kwai served as suitable Vietnam replacements. Casting included Robert De Niro, Christopher Walken and Meryl Streep. With a powerful script and cast, filming began on June 20, 1977, and lasted for six months on a $15 million budget. It had a limited release on December 8, 1978, and a wide release on February 23, 1979. It met outstanding critical praise and went on to win Academy Awards for Best Picture, Best Director, Best Sound, Best Film Editing and Best Actor in a Supporting Role. It also won several other notable awards. Success was also felt at the box office, grossing an estimated $49 million.

The Oxford Development Company introduced one of America's first indoor shopping malls in October 1969. Around 1974, Mark Mason gave George Romero a tour of the new mall, located in Monroeville, Pennsylvania. After *Night of the Living Dead*, Romero had no interest in making a sequel. The tour of the mall gave him the inspiration to make it. He began writing the script for *Dawn of the Dead* and stopped to work on *Martin*. Irvin Shapiro was Laurel Entertainment's foreign distribution agent. He sent the partial script to Italian producer Alfredo Cuomo. Cuomo had it translated into Italian and sent to a young Italian director named Dario Argento. An overly interested

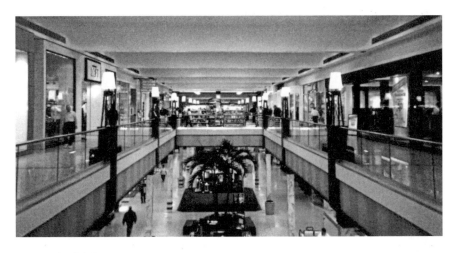

Monroeville Mall.

Argento arranged to meet with Romero and Rubinstein. Rubinstein rented a Lincoln Continental to chauffeur him and wrecked it into a tree, but the smashed car didn't stop Argento from being impressed. He put up half the budget, along with the acquisition of the foreign rights. The filmmakers found small percentages from other investors and also invested $25,000 of their own money.

Scott Reiniger, Ken Foree, Gaylen Ross and David Emge were cast in New York. Foree was involved with a group called the National Black Theater. He heard about the casting and auditioned. Ross was new to acting and was chiefly an acting student. When she was asked to scream during the airfield scene, she refused, unlike the other females who read for the part. Romero liked her idea of a strong woman. Reiniger and Emge were both working at a Manhattan restaurant. They made the auditions and ended up being cast for their respective roles. Once assembled, they all flew to Pittsburgh to begin working. David Crawford was cast as Dr. Foster and said, "I went to a casting call, I remember Christine [Forrest] being there. I was a starving actor living above a pizza shop at that time. Me and some of my buddies went in, and a lot of us got cast." Frank Serrao was a featured zombie and said, "I was a student at the University of Pittsburgh, and the call came out for auditions. I was very happy to be involved with the show and was paid $100 a day for my work. I also worked for the transportation department, traveling by truck to New York City to retrieve costumes and weapons." Tom Savini was also called during the preproduction process. John Rice said, "I was walking around town with a résumé, knocking on doors. And I went into George Romero's production company. They were gearing up to make *Dawn of the Dead*." He attributes being hired onto the production to his friendship with Nick Mastandrea and their need for production assistants. Rice also assisted with casting and script supervision. "When I was a junior at Point Park, John Amplas was doing some casting for George. He came over to Point Park and asked if there was anybody who wanted to get hit by a truck as a zombie. I jumped up! I thought that was my big break into the industry, and I was the only one who stood up. Everyone else looked at him like he was crazy. John went to Point Park, so everyone knew him," said Marty Schiff. He became close friends with Savini, who also did stunt work.

Principal photography began on November 13, 1977, and lasted until February 1978. Roughly nine weeks of production time were scheduled. The voted seven-day workweek was followed through most of the time. The Oxford Development Company was paid $40,000 for the use of the mall. Only thirteen stores denied permission to be filmed, and they worked around

them. The mall closed at 10:00 p.m., with filming lasting from midnight to 7:00 a.m. Because of the Christmas season, principal photography in the mall halted for four weeks, resuming on January 3, 1978. Romero began editing existing footage and filmed miscellaneous scenes. The upstairs hideout in the mall didn't actually exist and was a set constructed in an abandoned warehouse in Pittsburgh. The gun shop in the mall was shot at Firearms Unlimited, a gun shop in the East Liberty district. Argento only visited the set during the television studio filming. Crawford was at the station and said, "We did it pretty quick because we rehearsed it pretty well...I do remember I got paid $50, and I don't think I even got lunch because we didn't take very long to do it. It was just a couple of hours."

The SWAT team scene on the rooftop was shot at Romero's old Latent Image building. Sources claim the interior apartments were filmed in the Hill District. The airport scene was at the Monroeville Municipal Airport. Jim Krut became one of the most popular zombies in history, having his head cut off by the helicopter blades. He said, "I knew Tom Savini pretty well. As Tom was working on *Dawn*, I just happened to be walking down the street from my apartment in Oakland and Tom was there. He said, 'Hey Jim! How would you like to be in a movie?' He gave me a call later and filled in a few details and I said, 'Sure!'" He added, "It actually turned into a couple of weeks of preparation. I got together with Tom at his father's place in Bloomfield where he had his studio set up, and he did a plaster casting of my head. A week or so later, Tom called me and said it dried and cracked, and we had to do it again." Krut spent a few days at the airport. "The first day we just kind of hung around because it was rainy outside. They did indoor stuff at that point. The following day, we did the scene. The helicopter was there. I was very happy to see it. We really didn't do any rehearsals or anything in advance." Krut expressed the joy of being able to meet fans from around the world.

While shooting the airport scene, Romero needed a zombie to walk through the door and encounter Foree's character. He found a musician with a shaved head and asked him to be in the movie, and the extra became the film's logo. The extras consisted of a variety of people. Local police officers and National Guardsmen were cast during their time off. The workers at the mall also helped. "We gave them access to the roof, and they had the helicopter on the roof. What surprised me was they would fool around two or three hours with a plot, and then there would be a minute of actual shooting. There were no problems at all. Everything went smooth, and they were well organized. Everyone had a good time," said mall employee Bob Gracia. The

zombies, apartment tenants and bikers were composed of pagans as well as friends and family of the production. Tony Buba, Pat Buba and Marty Schiff were also part of the biker gang. "George Romero asked if I could come in that Saturday to do more zombie stunts. I did, and that particular night was with the bikers coming in. They weren't delivering their lines because they were real bikers. So George needed someone that could be a biker and act at the same time," said Schiff. Forrest's parents were also in the film as zombies. Clayton Hill had crew responsibilities and appeared as a zombie with his wife. Actor Joe Pilato, who later starred in *Day of the Dead*, also had a minor role as the head officer at the police dock. Amplas supervised casting and played the Hispanic gunman on the apartment rooftop. He put over one thousand zombie extras through a makeup assembly line. The locals had bizarre ideas for their unique zombies, and it scared some of the crew members. Pittsburgh Steeler Franco Harris even showed up. The production resembled a tailgating party in its own way, and many of the zombies were the result of spontaneous casting decisions.

The special effects were impressive, and Savini usually credits his experience in Vietnam because of the violence and gore. It was his job to find creative and violent ways of killing. Taso Stavrikis assisted Savini with the special effects. They also doubled their duties as actors. Savini was shocked when extras wanted to be shot or bitten. Actual pig intestines were used for the devouring scenes, and people wanted the privilege of eating them. Savini acknowledged this wasn't his best work, as the blood looked like melted crayon and zombies had very basic blue makeup. A few minor disasters also occurred. The production was blowing out a large windowpane, and the explosion was a lot stronger than they had hoped. Glass shards landed all around Rubinstein's wife, who thanked her safety to a Jewish pendant around her neck. While playing the role of Blades, Savini got shot and fell over the railing. Cardboard boxes were set up with mattresses for him to fall onto. On the first take they separated, and he fell straight through. He worked from a wheelchair and golf cart for two weeks. One of the last days of shooting occurred at the abandoned warehouse set, serving as the mall's upstairs hide-out. An electrical fire broke out, and the crew immediately went to extinguish it.

Romero quickly finished a rough cut by March and sent it to Argento. The final cut was completed by that August and released as an unrated film that had a warning for children under the age of seventeen. Critics such as Roger Ebert received *Dawn of the Dead* well, even though some newspapers refused to print the ads. The movie was a box office hit and grossed an estimated

$55 million worldwide. For years, fans flocked to the mall to reminisce at the real-life set. It became their Mecca. Pictures from the production remained in the mall, but it can't be compared to the days when drunken zombies stole golf carts and went driving around the mall.

Effects was the first production put together by Dusty Nelson, Pat Buba and John Harrison in 1978. The story originated from William Mooney, a friend of the filmmakers, who wrote a novel about a snuff film. They believed they had enough experience to finally make their own feature and decided on Dusty Nelson to direct. They went around to anyone they knew to take a chance and invest money in the production. Actress Debra Gordon, who was primarily doing theater, tried out for the part and got cast as Rita. Gordon and her husband believed in the project and invested money after she was cast. The budget didn't come in all at once and not in the order it should have.

Harrison said, "Originally, all I was going to do was be the producer...we needed somebody to read against [during casting], and I sat down to read the part [of Lacey]. We cast everybody in the movie, and Dusty and Pat came in the office one day and said, 'You know, maybe you should play Lacey Bickle.' I figured, we'll save some money...and that was that." Much of the cast fell into place from local theater talent, talented friends and Romero connections such as Tom Savini. Gordon met Savini for the first time at his house in Bloomfield. She had to get her leg cast for an effect in the movie. "I laid down while he cast my leg. It was a long process. I remember saying, 'Tom, why do we have to do this? Why can't you just make a fake leg?' He said, 'Because then it would be a dummy leg,'" she unpleasantly remembered. The filmmakers needed a location. "It was through the good graces of a friend of ours that we found a house. His family had this house in Ligonier, and they very graciously allowed us to go up there and shoot," said Nelson.

Effects went into a thirty-day production the week of October 10, 1978, in Ligonier, Pennsylvania. Gordon said, "I always remember not getting too much sleep up there, but everyone got along and was treated professionally." The production also provided more experience to newcomers like Marty Schiff, who did stunts. Nelson had nothing but fond memories of the experience. He attributes this to being with good friends and doing something they enjoyed. Except for a few film festivals, *Effects* never made it to the big screen. It was ready to be released in 1979, but the distribution deal went bad. It didn't receive any kind of release for another twenty-five years, until it was finally released on DVD in 2005. *Effects* even found success over the years as it gained a cult following.

The Death Penalty was shot from November to December 1978. This was the first television movie ever filmed in Pittsburgh. The production brought Joe Morton, Dan Hedaya, Colleen Dewhurst and Dana Elcar to town and utilized locations such as a Hill District church and playground, the local jails, the county courthouse and Point Breeze. Pittsburgher Clayton Hill worked in the casting department. "I get a phone call from Clayton. He asked me if I would come in and audition. I had to wait a few hours. They read the union people first, but they cast me on the spot," said Marty Schiff. "To work with a group of people who've been doing this for decades was pretty awesome. I got a really good taste of what it was going to be like, working in Hollywood. It was very, very cool." He also worked as a production assistant once his acting duties were fulfilled. It was released on January 22, 1980, on CBS.

In 1979, *The Fish That Saved Pittsburgh* was shot. Preproduction took place in the early half of the year during hockey season. Cher and Chevy Chase were once tied to the project but backed out right before filming. The production scouted the Civic Arena, as well as the Moon Area High School gymnasium, and both locations were used. Principal photography lasted during the summer of 1979. The movie was released in November 1979 and only grossed $8 million.

From 1976 to 1980, a show called *Once Upon a Classic* aired on all PBS-affiliated stations. It was hosted by actor Bill Bixby and consisted of live-action performances of literature. WQED in Pittsburgh was one of the leading production studios for the show. In 1979, a live television production of *The Leatherstocking Tales* was filmed at WQED with local crew members such as Nick Tallo. Tony Buba also continued his documentary film work with *Sweet Sal*, a short featured in *The Braddock Chronicles* part two.

CHAPTER 8
DIVERSE FILMMAKING

In 1980, Tony Buba finished the first part of *The Braddock Chronicles* documentary with the shorts *Washing Walls with Mrs. G, Home Movies* and *Homage to a Mill Town*. Television movie productions began to make their way to Pittsburgh. No longer did the film workers have to wait for feature films or rely on commercials and industrial films to survive. The first was *Fighting Back: The Story of Rocky Bleier*. The Pittsburgh Steelers went on to win the Super Bowl in January 1980, and the production filmed between February and April 1980. Robert Urich was cast as Rocky Bleier, and many of the Steelers appeared in the movie. Actor Richard Herd was told about the project from a friend and decided to audition to play Chuck Noll. He credits his previous performance on *The China Syndrome* as the reason he got the part. He said, "We went to Pittsburgh and did the stadium bit, which was fabulous, and we went out to Latrobe and had all the training shots out there. We had lunch at the school, and I think I got some bread from the nuns. They're pretty good bakers! Then we went back over to Three Rivers Stadium." He was very excited to spend three weeks working with the Steelers. An attempt was made for Herd to meet and work with Noll. Due to the importance of the NFL draft, Noll had team obligations and was unable to do so. Although he couldn't work with Noll, Herd had a great time working with the Steelers and Urich. A screening was held in Pittsburgh, and Craig Wolfley said, "After the film was over, Joe Greene walked outside the theater, and traffic all four ways in downtown Pittsburgh stopped, and people were hanging out of their cars and screaming for Joe."

The United Film Distribution Company (UFD) was very interested in working more with Romero because of the huge success of *Dawn of the*

Dead. Romero was set up for the next few years as he signed a three-picture deal, with *Knightriders* being the first movie. The idea came around 1976, when Romero finished working on the sports documentaries. Out of humor, Romero came up with an idea of knights riding motorcycles and eventually came to know of the traveling Renaissance fairs, which hold medieval jousting tournaments. United Artists/Transamerica bought certain rights to *Dawn of the Dead* after seeing it at the 1979 Cannes Film Festival and was willing to put up half the money needed to produce *Knightriders*. It made Rubinstein's job easier to get the other half of the budget from UFD. Preproduction began in early 1980. For the costumes, Romero recruited the services of Cletus Anderson, who had experience with medieval costume design. He met Anderson through Christine Forrest. A different type of casting was needed for such a physical film. They bought about sixty motorcycles and enlisted the help and services of Stunts Unlimited, which had a reputation as being the best stunt people in Hollywood.

Romero and Forrest mostly assembled a cast and crew of people they had worked with in the past. One of the greatest casting acquisitions was Ed Harris. Tom Kibbe, a friend of Forrest, represented and recommended him. He read three lines and impressed the filmmakers. John Rice returned as a crew member. He met Harris and said, "He was a really intense guy, but nice and friendly…a couple of years later, he was in town doing *Creepshow*, and he actually remembered me. I was walking down the street in Shadyside, and he was walking in the other direction and said, 'Hey, John! How are you?'" Additional casting included Ken Foree, Tom Savini, John Amplas, David Early, John Harrison and Scott Reiniger. *Knightriders* was also the acting debut for the well-known actress and stuntwoman Patricia Tallman. This was the beginning of a wonderful friendship between Tallman and the Romero entourage. Pittsburgh actor Bingo O'Malley also worked with Romero for the first time. "I met Ed Harris, and he's very serious and very dedicated. He was a very intense person about his work. He took the work very seriously. He was interested in Pittsburgh," said O'Malley. "George Romero is wonderful. He puts a lot of these real Hollywood types to shame with how nice he can be." Stephen King also appeared in the movie. Romero called him a year earlier and arranged the visit in Maine, wanting to do a theatrical adaptation of *Salem's Lot*. The production fell through because of the string of vampire movies that were released. However, this led to King's cameo in *Knightriders*, along with his wife. Harrison met Stephen King and said, "He was great! He's also funny!"

Principal photography began in May 1980. The production rented forty acres of the Outdoor Life Lodge in Tarentum, Pennsylvania, which

was used for the majority of the shoot. However, the set was destroyed by a tornado the night before filming. "King Billy's throne, which was a humongous wooden structure, was about fifty feet away from where it stood the night before," remembered Pat Buba. Anderson and his crew spent days restoring everything. Weather problems constantly plagued the production. This was one of Romero's most difficult films to make. They also had to worry about injuries with the stunts and the terrain. Injuries occurred from the bike stunts, and Romero tried to be as careful as possible. Harrison was one of those people who suffered injuries. "I threw my shoulder out riding those bikes. They wouldn't let us do any of the stunts…We were hurting the stunt guys almost every day. We had a 24-7 medic on the set and were constantly sending guys off in the ambulance," he remembered. The warm temperatures of the summer fueled the tempers and egos of certain individuals. Anderson continued to have difficulties in his department. Romero called for a giant winged bird in the script, and Anderson spent a lot of time on the prop that was only caught on film for a split second. The difficulty of the design caused a script change.

Despite the problems, cast and crew had fond memories. Nick Tallo said, "It was fun. Ed Harris was young and very intense. But he was cool. He was always good to the crew and got along with us." Marty Schiff also had fun and remembered:

> It was probably the most fun summer I ever had in my life. There was a part of it that was just kind of magical…here we were, camped out at a hotel with unlimited alcohol and room service. We would do things that people would probably get arrested for today. On Sunday nights, we'd climb up and change the marquee. We got Polaroids of all the changes. The stuntmen decided that they were going to try and do it, and the police were waiting for them. So they got busted for what we had been doing.

Due to the rain, interior scenes were shot first at a local warehouse, which also substituted for some exterior night scenes. However, the rain found its way indoors and flooded the warehouse. Anderson was sitting in a rowboat when the crew arrived, attempting to amuse them. The shoot wrapped in August. Pickup shots ran the shoot into early fall.

Romero and Forrest went off to get married. Buba began to edit and said:

> I was supposed to leave about halfway through production to start cutting. Because production was so much harder than we thought, I stayed on as

assistant director. So I was faced with 300,000 feet of film in September, and we needed a cut by December! I started with the first half. George started with the second, and we met in the center. We were working frantically in two different rooms. Although it was physically exhausting, that gave me some of my most pleasant memories—I could hear George's frustration in the back room, and he could hear mine. I'd yell at my machine, he'd yell at his machine and we'd both start laughing!

The rough cut was nearly three hours long, completed by January 1981. Romero brought the rough cut to a screening/dinner hosted by Salah Hassanein in New York. Irvin Shapiro was also in attendance and loved the movie. It opened over the Easter holiday on April 10, 1981, in New York, Florida and Los Angeles. The film had a short stay in theaters and found its way to television in 1983.

Tony Buba continued filming his hometown of Braddock with *The Mill Hunk Herald*. It served as the second short to appear in part two of *The Braddock Chronicles*. Romero also continued his three-picture deal in 1981 with *Creepshow*. At first, he wanted to do King's novel *The Stand* but wasn't able to make it because the budget was around $20 million, and the deal with Warner Bros. was disconnected since the *Salem's Lot* production fell through. Therefore, Warner Bros. provided no guarantee. Romero and King came up with an idea that paid homage to the E.C. horror comic from the 1950s such as *Tales from the Crypt*. King contributed the short stories "Weeds" and "The Crate." He also wrote the screenplay. The first draft was finished by October 1979. He added "Father's Day," "Something to Tide You Over" and "They're Creeping Up On You" to the two he already had. The five short stories, along with a prologue and epilogue, made *Creepshow*. Before preproduction started, Rubinstein got in touch with his longtime neighbor, the veteran E.C. artist Jack Kamen. Kamen was close friends with Rubinstein's parents and was perfect to create the *Creepshow* comic book. UFD agreed to put up money for the project, as well as relinquish complete creative control. The presence of King also played a vital role in the deal. Preproduction began in the spring of 1981.

Tom Savini was brought in as the special effects coordinator. Cletus Anderson had impressed Romero with *Knightriders* and was brought back to work on some scenic effects, as well as the production design. By this time, Marty Schiff had been working with Romero enough that it earned him a role as the garbage man at the end of the movie. David Early, John Amplas, Gaylen Ross, Christine Romero, Tom Atkins, Bingo O'Malley and

Crew members on the set of *Creepshow. Courtesy of Nick Tallo.*

Chuck Aber also had roles. Aber said, "I don't recall auditioning. I think they just called and asked me to do the part." Romero's $7 million budget gave him an opportunity to cast more Hollywood actors. Ed Harris returned for another Romero film. Ted Danson attended CMU and was cast along with legendary actors Leslie Nielsen, Adrienne Barbeau, Hal Holbrook, Fritz Weaver, Viveca Lindfors and E.G. Marshall. Romero was a little intimidated, having never worked with such seasoned actors.

Principal photography began in July 1981 and wrapped on November 20, 1981. The cemetery in "Father's Day" was shot in Fox Chapel, "Something to Tide You Over" was filmed in New Jersey and "The Crate" was mostly shot between CMU at the Margaret Morrison Carnegie Hall and the production's home base at the Penn Hall Academy. The filming at the academy included the laboratory and campus scenes. The Penn Hall Academy was an abandoned grammar school located in rural Monroeville. It provided the isolation needed to work without being disrupted. The interior scenes shot at the academy included "They're Creeping Up On You" and most of "The Lonesome Death of Jordy Verrill." The exterior scenes on the farm were shot on a rural hill near the academy. Aber remembered his party scene in "The Crate" being filmed in Squirrel Hill. He said:

Adrienne Barbeau was wonderful, and Hal Holbrook was terrific. George Romero was wonderful and Stephen King. I found it quite interesting and amusing about Hal Holbrook. When I got to the set, other actors said, "Stay away from Hal Holbrook. Don't talk to him because he's not very friendly, and he doesn't want to talk to anybody." As fate would have it, we were in the makeup chairs together, and he was very friendly and nice, and sometimes those things aren't accurate. Sometimes those reputations are false.

Nick Tallo worked with Romero again as a grip. He said, "Leslie Nielsen was great. Adrienne's a real sweet lady. Hal Holbrook was really cool. There was something about George [Romero]. He always knew who to pick. There's a real work ethic in Pittsburgh, but having lots of respect for the actors. Every actor I know that has come to Pittsburgh, they've got along really well with the crews because the crew's really cool." The crew was impressed with Tallo because he already knew E.G. Marshall from a previous production. John Harrison said:

Leslie [Nielsen] had this little fart machine that he carried around with him. It was this little thing he had in his hand and would squeeze, and it would sound like a fart. He would use it all the time! We would go out to dinner with him, sitting in a restaurant and all of a sudden he'd blow one or two off, and the waitress would be looking at him. He never even acknowledged he had it. It would crack everybody up. It was just insane! He had a wonderful sense of humor.

Postproduction was more tedious than the shoot. It was difficult to incorporate all the optical effects that made *Creepshow* stand out as a comic book–style movie. Four editors were needed. Romero cut the segment "Something to Tide You Over," as well as the prologue and epilogue. Pat Buba cut the segment "The Lonesome Death of Jordy Verrill." Oscar winner Paul Hirsh from *Star Wars* cut "The Crate." Finally, on-set editor Michael Spolan cut the segments "Father's Day" and "They're Creeping Up On You." Harrison was brought in to help with the soundtrack, scoring about three-quarters of the film. He added a certain tone and theme to each segment. The only segment that didn't receive such attention was "The Lonesome Death of Jordy Verrill," in which Buba used library music. Harrison also composed the main theme heard in the prologue and epilogue. Rick Catizone was responsible for the animation, which also added to the comic book style. This was the first production in which Romero

blended live action film with matte paintings and optical effects. The effects were completed in Los Angeles by Dave Stipes and Dave Garber. *Creepshow* debuted at the Cannes Film Festival on May 20, 1982, and was a huge hit. Warner Bros. reappeared for commercial distribution, and Romero had to cut ten minutes in order to make the movie exactly two hours long.

Three small productions were underway in 1982. The first was a docudrama for the BBC network called *Two Weeks in Winter*. It was directed by award-winning director Christopher Olgiati and was about the trade union struggling against the communist government in Poland. The dramatized portions of the film were based on a priest played by Jonathan Pryce. Allegheny and Fayette Counties were chosen as locations for the docudrama. Locals were also recruited as extras. John Russo began shooting his own independent movie called *Midnight*, based on his own bestselling novel. He recruited Romero alumni such as John Amplas, Tom Savini, Paul McCollough and John Rice. "I believe the film ran a little short, so Jack wrote another scene and we went and shot some other stuff in Clairton," said Rice. It received a final rating of R and was released on December 31, 1982. *Hambone and Hillie* was shot in Pittsburgh around the summer of 1982. Director Roy Watts cast Lillian Gish, O.J. Simpson, Alan Hale Jr., Anne Lockhart and a very young Nicole Eggert and Wil Wheaton.

Paramount Pictures was finally looking to make *Flashdance* and hired a rather new British director named Adrian Lyne. He was given a respectful amount of control and got to have final say on the casting and locations. Actresses such as Demi Moore were in the running to play Alex Owens, a female steel worker by day and exotic dancer by night. Lyne cast eighteen-year-old Jennifer Beals, who got the call from her agent. The audition was in New York, and her trip was a nightmare. The airline lost her luggage, and she was low on cash. For two days, she had to live in a local YMCA, eating nothing but pine nuts and blueberries. However, Lyne was blown away by her dancing and audition. He chose to shoot in Pittsburgh because of its compactness, climate and nice people. One of the things that impressed him the most was the city's architecture. Before principal photography, Donna Belajac opened a new casting agency in the city called Holt/Belajac & Associates. It was Pittsburgh's first and oldest casting agency. Belajac didn't have to wait long to acquire work, as the agency was hired to do casting for *Flashdance*. Given a budget of $9 million, the production arrived around September 1982, with principal photography lasting through the fall.

Beals was about to attend her freshman year at Yale and had to skip the fall semester, putting her dream to attend Yale on hold. The filming was difficult

for her even though Lyne used stunt dancers for most shots. It was filmed at places such as the South Side, the Grand Concourse Restaurant in Station Square, the Hall of Sculpture at 4400 Forbes Avenue and the Duquesne Incline overlooking the city. Pittsburgh was greatly exploited. One of the most symbolic props in *Flashdance* is the cut-up shirt that she wears. Two possible stories explain how the iconic shirt came about. Costume designer Michael Kaplan claimed it was his fashionable decision. On the other hand, Beals claimed she cut open the accidentally shrunken shirt.

Originally, Pittsburgh actress Debra Gordon couldn't get an audition. "Donna Belajac was still doing casting, and I actually called and said, 'I want to get an audition for this movie.' She actually picked up the phone in those days," said Gordon. Belajac was able to cast her as an extra due to her dancing skills. At the end of her shooting day, Gordon got a surprise:

> *I guess I was supposed to leave, but Adrian Lyne asked me to stay because he liked the way I was dressed and he sent all of the ballet teachers home. So I knew something was up, and they served us steak and lobster and I thought, "Gee, this is a pretty good movie." Then we go inside…I took charge and improvised a classroom. Lyne said, "Oh, that's good! Can you repeat that?" I said, "Yes, of course." Then a girl comes over and signs me up with a SAG contract, and I did that scene several times and created my own dialogue.*

Gordon also got to talk to Jerry Bruckheimer on the set and corresponds with him to this day.

Flashdance was released during Beals' first semester at Yale. It was a hit and went on to gross around $93 million at the box office. Beals continued to live her life and keep her head down while attending Yale, showing more concern for grades and her private life than looking for stardom. *Flashdance* became a beloved American film. Girls all over the country were cutting their shirts with scissors, and Beals received hundreds of fan letters telling her how the movie had changed their lives.

All the Right Moves was filmed in the spring of 1983. Michael Chapman directed and cast Tom Cruise, Craig T. Nelson and Lea Thompson. Johnstown was a dying steel town and served as the perfect location. One of the major locations was Point Stadium in downtown Johnstown, where the football games were shot. The locker room scenes were filmed at the abandoned Johnstown High School, where a set was constructed. Another locker room was at Westmont Middle School. Cruise's house in the movie was located on Oak Street in East Conemaugh. Being that the houses

are so close together, Cruise actually went to the wrong house around the beginning of the shoot, providing a great surprise to the residents of that house. Character Coach Nickerson's house was on Erickson Drive in the Richland section of town. The school scenes were shot at the Johnstown Vo-Tech, and a few additional locations included Eisenhower Boulevard and the *Johnstown Tribune-Democrat* newspaper building.

Many residents actively participated in the production. The abandoned Johnstown High School was used for the pep rally scene, and many locals were in the crowd. Similarly, locals were at the football games in Point Stadium. During one of the games, it was supposed to be raining. The rain was an effect, and local extras didn't get a drop of water on them. However, the field was ruined because of all the fake rain and had to be replaced. The production recruited local high school football players and paid them forty dollars a day. Many of the star players didn't participate due to a concern about their NCAA eligibility. Some of the football players came from Forest Hills High School. The filmmakers divided them up by size and build, placing them on the appropriate team. Many of the larger and more agile players played for the fictional Walnut Heights, and the players with less stature played for Cruise's fictional team, Ampipe. Some of the local schools even got their team logo and colors into the movie. Behind the scenes, Cruise enjoyed time with his girlfriend, Rebecca De Mornay, whom he had met on *Risky Business*.

Tony Buba made the half-hour *Voices from a Steeltown* in 1983. It compared Braddock's past glory to its present poverty. The impact of this film was felt nationwide in towns that relied on a single industry to survive. Braddock, once known for its contribution to Pittsburgh's steel industry, became part of Pittsburgh's cinematic history thanks to Buba.

The Pittsburgh communities of Brownsville and Grindstone were the primary locations for *Maria's Lovers*. A 1983 press conference took place at Brownsville's Nemacolin Castle, overlooking the Monongahela River. John Savage, Robert Mitchum and Nastassja Kinski were in attendance with Brownsville mayor Barry Cook. Tom Savini was hired to do special effects, and Pittsburgh actress Nardi Novak was cast with a supporting role. "I auditioned for Donna Belajac and got the part. I played Rosie's mother. Robert Mitchum was very, very friendly with everybody. He started chatting with these people who were just extras. He even kissed me goodbye," said Novak. Norman Beck had been laid off and heard about the production from a friend. They traveled to the Uniontown Holiday Inn—where the production was based—to get a job. He said:

I got the job as a carpenter, but I had my name in with Donna Belajac and the people from Maria's Lovers *wanted to audition me based on my looks. I said, "Donna, that's really funny because I'm already working in Brownsville on the movie. Do I really need to come back to Pittsburgh to audition?" She made a call, and I ended up meeting the director at my hotel. I am not credited as Norman Beck. I am credited under my stage name as Norman St. Pierre.*

The 1983 production shot from August 15 to October 15.

Mrs. Soffel was not entirely filmed in Pittsburgh. Production began on February 13, 1984, and lasted until December 1984. Pittsburgh was only used for second-unit filming. The movie was primarily shot in Canada, with a few train sequences filmed in Wisconsin. Very few in Pittsburgh were involved with the production.

The Boy Who Loved Trolls was adapted from a play by John Wheatcroft and produced by WQED studios for the PBS series *Wonderworks*. Casting brought in talent such as Tom Savini, Sam Waterston, Susan Anton and William H. Macy. Principal photography began around June 1984, lasting only a month or two. It showcased the skyline of Pittsburgh in several locations, as well as the Monroeville Mall and Phipps Conservatory. "That was fun," remembered Nick Tallo. CMU faculty member Judith Conte was also part of the production. She had known Barbara and Cletus Anderson, who were her CMU colleagues. They helped her get onto the production, as she revealed, "I was a recommendation via the Andersons. I believe they worked on it in a design aspect...not only did I choreograph, but I was the troll's dance double. The troll's costume was a large jacket or a cape on which the back of it was the face of the troll." She met Waterston on the production and said, "He's a very good person to work with and real professional."

CHAPTER 9
DAY OF THE DEAD

In 1978, Romero wrote a forty-page treatment for *Day of the Dead*, the third zombie film. UFD loved the idea and used the treatment as something concrete to copyright, setting up the three-picture deal. The first full draft was over two hundred pages long, and it was apparent it would cost a lot to make. The script opened with refugees arriving on the Florida coast, looking for survivors and encountering an abandoned city filled with zombies. The refugees escape on the boat and encounter a beautiful tropical island. They discover an elevator that leads to an underground military facility ruled by an insane man named Rhodes, who is training zombies to do his bidding. Rhodes routinely has the lower-class inhabitants of his civilization killed so their body parts can be used for the feeding and training of the zombies.

The script's budget posed a problem and was estimated to cost around $6.5 million to make. United Film Distribution wasn't about to invest that kind of money to fund the production, despite the three-picture deal with Romero. The only solution to the early budgetary problems was a deal that gave Romero his $6.5 million, but an R rating had to be given to the movie. Romero and Rubinstein didn't budge under the argument that the movie wouldn't do as well without the gore. Internal discussion included doing the film in 3D after the success of *Jaws 3D*. The idea never came to fruition, even though Romero was willing to do it for the $6.5 million budget. Romero was forced to rewrite the script for UFD's offer of $3.5 million. During the spring and summer of 1984, he spent his time rewriting *Day of the Dead* at his second home in Florida. By the end of the summer, he had reduced the epic script to 104 pages and an estimated budget of $4.7 million. UFD didn't budge on its proposed $3.5 million offer. Time was running out for Romero,

as he needed to write and shoot the movie quickly for a 1985 release. The deal was under a contract that stated the third film needed to be released in 1985. His original idea had to be changed to meet the proposed budget.

Romero called upon his filmmaking "family" to help. The Pennsylvania Film Commission also helped Romero, finding the perfect location for the underground facility. It was a 125-acre limestone mine in Wampum, Pennsylvania, about thirty miles northwest of Pittsburgh. Romero's wife, Christine, handled the casting once again. She was aided by Bill McNulty and Gaylen Ross. Casting was held in New York, and Lori Cardille was one of the first to be cast. She had ties with Romero through her father, Bill Cardille, who had appeared in *Night of the Living Dead*. She studied theater at Carnegie Mellon University from 1972 to 1976 and was living in New York at the time. She happened to be available for the audition. Cardille was no fan of Romero's films and was in the eighth grade when she first met him, the same time her father was in the original *Night of the Living Dead*. Romero had promised her a role in an upcoming project years earlier, and *Day of the Dead* happened to be the movie he had in mind for her, even though his original concept for Sarah was a lot different. Cardille admitted to liking the filmed version of *Day of the Dead* better than the original. Terry Alexander was cast as the helicopter pilot. He had various roles in television shows such as *Hill Street Blues* and was recommended to Romero by a friend at CMU. Richard Liberty had worked with Romero on *The Crazies* in 1973 and was cast as Dr. Logan. He recalled receiving a phone call from Christine Romero because he didn't audition for the role; Romero wrote the role for Liberty. Joe Pilato had worked with Romero in *Dawn of the Dead* and was cast as Captain Rhodes. John Amplas appeared in yet another one of Romero's films as Dr. Ted Fisher. Taso Stravrakis had previously appeared in *Dawn of the Dead* and returned to play Private Torrez. One of the more unique casting experiences was for the zombie Bub. Romero cast Howard Sherman, who had a theater background and was also a talented mime. Sherman auditioned for Ross and McNulty in New York. When he found out he was to be playing a zombie, he brought a turkey leg with him in the attempt to simulate human flesh. The idea persuaded Romero to cast him. Greg Nicotero, a Pittsburgh native, pulled double duty with a minor role as Private Johnson and serving in the special effects department with Savini. This was the first major film for Greg Nicotero, who is known for this work on blockbuster movies such as *Boogie Nights*, *Scream*, *Spider-Man 3* and *Transformers*. The Andersons also supported Romero during preproduction.

Principal photography began in October 1985 at the limestone mine in Wampum. One miscellaneous location was the Nike missile base outside

Pittsburgh. This was where the elevator scenes were shot. The production ran more smoothly and formalized than any of Romero's previous outings because they had perfected their craft and worked together on several films. They remained in the mine for the majority of the shoot, with the exception of the few weeks they spent in Florida during the early half of December. "We rode around in the dark on golf carts. It was a little spooky in certain places, but we had a good time doing that film. Lori Cardille was great and a lot of fun to work with," said Nick Tallo. Norman Beck said, "George Romero ran a very happy crew. He encouraged people to have fun, and we took advantage of it. He wanted his crew to enjoy what they were doing." Debra Gordon was cast as the lead female zombie. She said, "For the first time, people would avoid talking to me. During the day, I'd get made up early and be there twelve hours, and no one would ever speak to me because I forgot what I looked like."

Conditions in the mine were less than favorable, as they worked from early morning to late evening and, given the short days during the winter months, didn't see much sunlight for weeks. The production was on a six-day

Debra Gordon and Mark Tierno as zombies on the set of *Day of the Dead. Courtesy of Debra Gordon.*

schedule. Most cast and crew woke up around 5:00 a.m. at a local hotel and drove about ten minutes to the mine. "You'd go in when it was dark in the morning, you'd come out when it was dark at night. We never saw the light of day for about six weeks," said Harrison. Life was very rigorous for the production. The shoot went slowly due to the lighting problems in the mine. Also, many of the cast and crew got sick.

The crew worked around the conditions and used what they had at their disposal. An existing office complex inside the mine was used as the crew's base of operations where the cafeteria, Savini's special effects workshop, prop rooms and office spaces were located. Many decisions were made on the set. It was Pilato's idea to yell "Choke on 'em!" to the zombies. It was Howard's idea to use the ear phones in his scene with Liberty. Romero continued his tradition of listening and working well with his actors.

The Florida shoot was a nice break for the cast and crew. They split into two teams. Romero primarily dealt with the cast, as their scenes were filmed near Romero's second home on Sanibel Island. Harrison was directing the zombie-filled city with a second unit crew in Fort Myers. Even though Florida was a nice break, it proved disappointing as well. The filmmakers needed to cast eight hundred zombies to fill the ghost town, and very few auditioned. This problem had never existed in Pittsburgh. The people in Florida also had difficulty acting like zombies. However, Fort Myers was cooperative in letting the crew film there. Romero chose Fort Myers for its visual texture. Cletus Anderson and his production-design teams worked hard to transform the streets into an abandoned city of the dead. Litter, old relics, oil and dust were used for the apocalyptic scene. Dave Garber had worked on *Creepshow* and was hired to do a matte painting for Fort Myers.

The crew returned to continue shooting in the mine in December. Pittsburgh always had a great turnout of locals wanting to be zombies. Don Brockett was a featured zombie, as were many actors and actresses from the Pittsburgh area. Akram Midani, the former dean of fine arts at CMU, and his wife, Watfa, were fisherman zombies. According to Liberty, an audiotape that lends some back story to his character was made on the last day of the shoot. Principal photography ended in mid-January 1985.

Postproduction operated differently than Romero's other films. Pat Buba was the sole editor and spent his time in Pittsburgh, while Romero was at his second home in Florida. The director made frequent visits to Pittsburgh in order to see the progress. Until this time, Romero had been avidly involved with the editing of his own work, contributing to his style of filmmaking, which was somewhat absent from *Day of the Dead*. Many of his editorial

decisions were made on set. This benefited the postproduction crew because it limited the raw footage and enabled things to run smoothly. While Buba was editing, Harrison was in the downstairs room at Laurel's Pittsburgh office working on the soundtrack, inspired by the movie's tropical setting. A premiere was held on May 23, 1985, and the movie was publicly released on July 19, 1985. It was up against tough competition that summer with *Back to the Future* and *Cocoon*. The release of John Russo's *Return of the Living Dead* also hurt, as *Day of the Dead* only grossed an estimated $34 million worldwide.

CHAPTER 10
HOLLYWOOD OF THE EAST

The film industry was growing, bringing success to Pittsburgh's film community and economy. The region received recognition from filmmakers outside the state, and Pittsburgh was being called the "Hollywood of the East." The estimated $2 million production *Rappin'* began principal photography on February 20, 1985. Joel Silberg directed the film and cast Mario Van Peebles in the role of John Hood. Ice-T and Eriq LaSalle also made appearances. Associate producer Jeffrey Silver said, "I loved Pittsburgh...the city was chosen because it had a great inner-city look, and the crews, unlike New York City, were nonunion." Because of his experience in *Maria's Lovers*, Norman Beck was hired onto this Cannon Films production as well. "I was hired as head carpenter, and it was rotten, horrible and cold. We had no heat and were trying to build stuff," said Beck. Mount Washington was the first location used, followed by a two-day shoot at the Bigelow Apartment Hotel and a Twenty-third Street loading dock in the Strip District. The production then headed to the Manchester section of the North Side, where most of the shoot was completed, using Columbus Avenue for a majority of the exterior scenes. Silver revealed:

> *My favorite story from* Rappin' *was from years later. When I was getting to know Antoine Fuqua during the making of* Training Day, *I asked him how he first got interested in becoming a film director. He said that his sister had won a contest to become a dancing extra on the set of* Rappin'. *He told me he came to the set to watch her perform, standing by the barricades all day, just absorbing the activity on the set. He said it was then that he decided to direct. I told him that I [associate] produced that movie. I didn't have the heart to tell him that everyone won the dance contest.*

Principal photography wrapped in the middle of March 1985.

Allegheny and Indiana Counties were chosen as second-unit locations for a television series called *He's the Mayor*, starring *Police Academy* alumnus David Graf. Shots of the Indiana County Courthouse were also used for the short-lived television series, which debuted on January 10, 1986, on the ABC network. The $1.1 million production of *Flight of the Spruce Goose* began filming in Pittsburgh on March 11, 1985. This small production brought actresses Karen Black and Betsy Blair to town. George Romero had a minor role as a teacher named Gromero. Principal photography lasted until the week of April 8, 1985, at local places such as the William Penn, Frick Building, Union Trust Building and Point State Park. The production then headed to California, where the scenes with Howard Hughes' plane were filmed.

Valerie Bertinelli came to Pittsburgh with the production of the television movie *Silent Witness*. Elements of Pittsburgh's skyline—such as the Smithfield Street Bridge, the federal courthouse, the Tin Angel restaurant, the North Side Number 9 police station, a neighborhood in Bellevue, a Washington Vocational School, the Polish Army War Veterans' home in Lawrenceville, the Panther Hollow Bridge, the Carnegie Library in Oakland and finally an A.M.-P.M. Gulf Station on Fortieth and Butler Streets—appeared frequently in the movie. The production employed about six hundred extras to be spectators, prostitutes, bar patrons and other nonspeaking roles. The extras were paid twenty-five dollars a day. Principal photography began on May 28, 1985, and lasted until the week of June 17, 1985.

Location scouts came to Pittsburgh for Ron Howard's new movie *Gung Ho*, starring Michael Keaton. Pittsburgh had what the production needed, and certain scenes were shot between August and September 1985. Pittsburgh was its third location, as the producers had been in Japan and Buenos Aires for two months beforehand. The production shot at Bridgewater and Beaver. Parts of the Assan Motors plant were filmed in West Homestead, and Pittsburgh was frequently referenced throughout the movie. However, the production moved to Argentina, where the car assembly scenes were filmed.

Coraopolis primarily hosted John Russo's *The Majorettes*. Cornell High School in Coraopolis was one of the primary locations, as well as the Fox Chapel Yacht Club. The production began around October 1985 with an estimated budget of $85,000. The low-budget horror film directed by Bill Hinzman consisted of local Pittsburgh talent, many who knew Hinzman and Russo. The football coach was played by the head football coach of the Cornell Raiders, Wilbert Roncone. Orlando Falcione was the high

school principal and remembered, "No school activities were interrupted." Principal photography ended in November 1985, and it was released in March 1987.

Lady Beware began principal photography on July 21, 1986, in Pittsburgh. It was a project that should have begun a few years earlier but was put on hold due to creative differences. The casting department for the Karen Arthur film consisted of Pittsburgh locals Clayton and Sharon Hill. Diane Lane, Michael Woods and Cotter Smith were cast. Pittsburgh casting included Don Brockett, David Crawford, Zachary Mott and Bingo O'Malley. Pittsburgh's landscape was prominently featured in the movie. A more specific location was Horne's department store, serving as Lane's workplace in the movie. "I had a scene at the Horne's window and over at the Grand Concourse," explained O'Malley. Norman Beck heard that an assistant was needed in the special effects department. He pursued the position and got it. However, he remembered having bad experiences with associate producer and first assistant director Paula Marcus. "She was overly aggressive and mean. None of the crew liked her. She thought that the only way to get the crew to do her bidding was to threaten them. She was just an unhappy person," said Beck. At one point, Marcus and Beck argued over a prop, which led to his dismissal. Because the prop couldn't be completed, he was immediately brought back, with Marcus being reprimanded by the director. The Keller Office Equipment Building was also used. Most of it was shot on the North Side, with the rest being downtown. Principal photography ended around August 23, 1986. "The editors really ruined that movie," said O'Malley. "I met the director a year later, and she was just so upset. I liked it when I read it, and I liked what she was doing. It's a shame."

Principal photography began in the middle of August 1986 on a biography called *The Kid Brother*, a movie also known as *Kenny*. It is the story of thirteen-year-old Kenny Easterday, a boy born with undeveloped legs who strives to live a normal life. Easterday lived a dream, starring in his own movie. The Canadian production was directed by Claude Gagnon and featured Pittsburgh actors Bingo O'Malley, Sharon Ceccatti and Clayton Hill. "We had the Japanese and their interpreters and a director who spoke French. It was interesting," said O'Malley. West Aliquippa, twenty miles northwest of Pittsburgh, was used for the shoot. A local crew was hired and consisted of veteran workers such as Nick Tallo and John Rice. "It was fantastic…a great experience," said Rice. "It was quite an interesting production having to work with a translator." Principal photography ended in late September 1986.

Orion Pictures decided to take its chances on a script called *Robocop*. Everyone believed the title could never be marketed, but it stayed. Paul Verhoeven didn't like the idea at first, but his wife convinced him to take a second look. He became interested and decided to direct. At first, Michael Ironside was considered to play Officer Alex J. Murphy/Robocop. However, they felt he was too big to fit into the suit, and Peter Weller was given the role. He was perfect given his physical stature and skills. Stephanie Zimbalist was originally cast to play Officer Anne Lewis but dropped out at the last minute to work on *Remington Steele*. Nancy Allen picked up the role and was told to change her traditional on-screen look, get a short haircut and portray a tougher, more physical character. Ronny Cox was cast to play Dick Jones and was also told to switch his traditional on-screen character from a loving man to an evil man. The story was set to take place in Detroit, but the city didn't have the futuristic setting needed. Dallas, Texas, was the perfect setting, and principal photography began on August 6, 1986. It was the worst time of the year to shoot in Dallas, being that it was so hot. This was a huge contributor to the tensions and problems behind the scenes. Principal photography wrapped in Dallas around the end of September. The production had its sights set on Pittsburgh. A deal hadn't been reached on the Monessen mill until October 21, 1986. Location manager Craig Pointes and his assistant, Scott Elias, a native of the Pittsburgh area, had scouted the mill back on July 19, 1986. Part of the agreement between the production and Wheeling-Pittsburgh Steel had $10,000 donated to the Monessen Plant Unemployed Committee. Principal photography began the weekend of October 24 and lasted about a week. Mill employees were on hand for safety reasons. The Duquesne Steel Works was another location used and hosted the final battle between Robocop and his killers. The production spent nearly three weeks in Pittsburgh.

In November 1986, a short film was made by Pittsburgh filmmaker Bill Hinzman. It focused on sending a message to all school-age children about the dangers of drug and alcohol use. A fourteen-year-old Alyssa Milano came to Pittsburgh for a few days and shot *Makin' Choices*. She heard about it through her publicist and wanted to be part of the production. After she wrapped her scenes, Alan Thicke came to shoot during the week of November 24, 1986. A house in Moon Township was the primary location. A local high school gymnasium, a store in a local Pittsburgh mall and exterior shots of a local downtown street appear as well. It was produced by the Discovery Group, a local Pittsburgh organization devoted to warning school-age children about drugs and alcohol.

Tim Ferrante began production on *Drive-in Madness!* in the late fall of 1986. It was a documentary first conceived as a book and never truly hit publication. Ferrante explained:

> *I was vice-president of Imagine, Inc., a Pittsburgh-based publishing company of horror entertainment. The partners were me, John Russo, Bob Michelucci, Andy Schifino and Tom Savini. I'd travel to Pittsburgh when necessary but worked out of New Jersey even though I had full-time employment with ABC-TV in New York City. I was also writing for* Fangoria. *I had a full plate…we came up with the idea of an original video program, and I would be the one to make it happen.*

The documentary featured the many faces of the horror community, including George Romero. However, Pittsburgh did not house the entire horror community, and others were featured in the documentary. Ferrante wasn't present for the featured drive-in scene. Instead, John Russo filmed it. Ferrante said:

> *The Wexford Starlight Drive-In was located on Route 19 in Wexford and had an oldies night where vintage car enthusiasts would gather. It was Bob's car in which our two teen moviegoers were seen. All of the drive-in material was shot after I did a first edit. The original version was lacking something, although some would argue the final version is lacking something as well! We discussed what was needed editorially, and the resulting answer is the Wexford Starlight footage.*

Dominick and Eugene began preproduction during the winter of 1987. Casting included Ray Liotta, Tom Hulce, Jamie Lee Curtis, Bill Cobbs and Todd Graff. Robert M. Young directed the drama for Orion Pictures, with Pittsburgh scouted as the location. Victoria Dym, a Pittsburgh local, got a pleasant surprise in February 1987 as two location scouts were checking out her apartment. "I was actually walking around my apartment with no clothes on, and I saw people on my porch. They were scouts looking for locations. I quickly gave them my headshot and my résumé. It was so coincidental because I'm an actress," she said. A month later, Mike Farrell, the film's producer, showed up on her doorstep and suggested she audition. Dym was cast to play a cop, and she relocated to a local Holiday Inn when they used her home. A local pizza shop owner had a similar situation happen when they used his pizza shop, and he appears in the movie. The shoot began

Cast and crew photo from *Dominick and Eugene. Courtesy of Victoria Dym.*

that spring and ran into the summer. Various sources reported that Curtis walked off the set. Extras claimed she was very upset about something. The movie was released domestically in March 1988 and went on to gross an estimated $3 million. It went on to be nominated for prestigious awards such as a Golden Globe for Hulce's performance. It received these awards for its strong story and powerful actors. *Dominick and Eugene* competed against *Rain Man* at the box office, with *Rain Man* becoming far more successful.

Dominick and Eugene was shot around the exact same time as *Tiger Warsaw*. Patrick Swayze signed on to play Chuck "Tiger" Warsaw in the Amin Q. Chaudhri film. Swayze acknowledged that it was the most emotionally demanding movie he had done at that time. Production manager Norman Berns' wife is from Sharon, Pennsylvania, and suggested the town. When Chaudhri visited Sharon, he arrived at the Youngstown Municipal Airport, loved it and chose it as the primary location. The production was also set to shoot in Rochester, New York, but that changed to Paterson, New Jersey, because Chaudhri was familiar with that area. Pittsburgh talent such as Don Brockett was cast. Principal photography began on April 6, 1987,

on Sharon's West Hill, the home of City Councilman Joseph Baldwin. The house was used for the kitchen, front exterior and backyard shots. The Baldwins left their home the weekend before filming and returned to a new house. Another house in Sharon was used to fulfill the remaining requirements of the house in the script. The other house was that of Larry Hofius, located on Columbia Street. Production crews blocked traffic on the street and even set up a cafeteria in a garage. They shot on the street for about nine days. Many showed up to play extras, and the production actually had to turn people away because there were so many. Chaudhri praised the city for its support, and Mayor Robert T. Price expressed his appreciation to Chaudhri. Parts of the Shenango Valley were also used. *Tiger Warsaw* wrapped in early August 1987.

George Romero's next Pittsburgh production was *Monkey Shines*. He brought back most of his "family" and cast Jason Beghe to play Allan Mann. Orion Pictures financed the $7 million budget, and principal photography began on July 11, 1987. "I was hired as a truck driver, but that job didn't last too long. The truck I was driving drifted back after I parked the truck because my pant leg got stuck on the emergency brake handle located next to the driver's seat. The producers saw the truck drift back, and I lost my job," said Frank Serrao. Norman Beck said, "This was a Romero production, and people had fun. We sang and danced while we worked, and I mean that literally. It was just a friendly atmosphere." Tallman was dating crew member Nick Mastandrea and living in New York. She was brought on to do miscellaneous tasks and helped out with such things as casting and stunt work. She acknowledged some problems and said, "He [Romero] was working with some new producers, and I think that it was difficult. It seemed to go well. He had a great time." Nick Tallo agreed: "Things changed with the way we worked, a studio got involved...he had to answer to these guys. He had the studio breathing down our necks. I could see the change and extra pressure on George." Despite the problems, co-workers always acknowledged Romero's ability to make the set fun and enjoyable. The shoot ended in September 1987.

A CBS television movie production came to Pittsburgh in September 1987 called *Command in Hell*, a title that would later be changed to *Alone in the Neon Jungle*. Originally, the filmmakers were considering Minneapolis as their location but found Pittsburgh to be better. Director Georg Stanford Brown brought his wife, Tyne Daly, and daughter with him. Suzanne Pleshette, Danny Aiello, Jon Tenney, Joe Morton and Raymond Serra were cast with local crew members such as John Rice. In regard to working with Pleshette,

Rice said, "She's great, very friendly and a very nice person." Pittsburghers Alex Coleman, Ray Laine, Jeff Paul, Kevin Kindlin, David Early and Marty Schiff were also cast in August 1987. Norman Beck was hired to work on props for the production and said, "I only did a couple of things for them. They only had me working on a couple of props, but I did get paid. I was an independent contractor." At the end of August, the filmmakers needed extras to be bikers and punk rockers, and auditions were held at the Green Tree Marriott. Hundreds showed up and were individually looked over in the Jonas Salk Room. Extras waited for over an hour to be in a movie, and some even shaved their heads for the roles. The production wrapped around October 20, 1987, and the movie made its televised debut on January 17, 1988.

Film crews were setting up for *The Prince of Pennsylvania* around November 1, 1987, with principal photography beginning on November 9, 1987, for a six-week shoot. Casting brought Bonnie Bedelia and Keanu Reeves to Pittsburgh. By October 15, 1987, Don Brockett had landed a role as a coal miner. Around the same time, Paul and Geri Young, the owners of Young's Custard Stand in New Sewickley Township, received a call that their custard stand had been chosen as a location. They had closed the shop a month earlier but reopened when representatives from New Line Cinema called. They were excited to witness the shop being renovated into a movie set. The filmmakers thought it was perfect because of the space available for the equipment. Extra police were needed around the shop, and five-minute traffic delays occurred. At the end of principal photography, the shop was restored. The Zelienople Police Station, Houston and Mars were also used.

Principal photography for Bill Hinzman's *FleshEater* began the weekend of November 13, 1987. The estimated $60,000 production tried to change the cliché horror film and brought back some vintage *Night of the Living Dead* characters, with Vince Survinski and Hinzman reprising their roles. South Beaver Township was chosen as the primary location. One of those locations was a five-hundred-acre farm located on McCloy Road, where the filming began. It took Hinzman and his associates four months of preproduction to put *FleshEater* together and one month to shoot the movie. Principal photography for the twenty-four-day shoot ended before Christmas 1987.

Next, Tony Buba filmed his first feature-length documentary called *Lightning Over Braddock: A Rustbowl Fantasy*, depicting the community's frustration and activism after the steel mills shut down. It was made with an estimated budget of $54,000 and appeared in the Toronto Film Festival in 1988, as well as at the Sundance Film Festival, where it was called "a must-see film." The exploitation of Braddock continued.

Victoria Dym on the set of *Bloodsucking Pharaohs in Pittsburgh. Courtesy of Victoria Dym.*

The $250,000 production of *Bloodsucking Pharaohs in Pittsburgh* began principal photography in July. The horror-comedy was originally called *Picking Up the Pieces* and had the name changed after the production. Dean Tschetter transformed the original story into a screenplay that he and Alan Smithee co-directed. James Baffico, a former department head at CMU, co-produced, along with Laurence Barbera and Beverly Penberthy. The lead roles were cast in New York and Los Angeles, with Donna Belajac casting supporting roles and Maria Melograne casting extras. The Pittsburgh crew included Tom Savini, Nick Mastandrea and Diana Stoughton. Pittsburgh's South Side, Strip District warehouses, Market Square and downtown streets were used. Specific locations included the East Pittsburgh Moose Lodge, East Liberty police station, Grandview Park, Monroeville and Point Breeze. It was the mutual agreement among all the filmmakers to decide on Pittsburgh as the setting, whereas New York and New Jersey were originally chosen. The Strip District was transformed into Egyptown, which is similar to Chinatown with the exception of the Egyptian culture. "That was a fun movie to work on," said Norman Beck. "I got a call to work on some special things, very bizarre weapons for a fantasy scene. So that was an independent contractor job."

Principal photography lasted about six weeks and wrapped toward the end of August 1988. Debra Gordon was cast as a hooker. She said, "I had to get a body cast made. That was very painful because the stuff gets all heated up and it's real hot. I thought I was going to die. I felt like I was suffocating. I said, 'Tom, get me out of this!' He said, 'Just a little bit longer.' I couldn't take it. I was burning and got really scared. Sure enough, I did have some bruises on my body from that." Victoria Dym also auditioned. "I heard it was coming out. I sensed it was a little sleazier and was a little scared of it.

They were looking for SAG actors. This was the first time I've ever been asked to show my body in an audition. They wanted to see what I looked like in a bra and panties. That was kind of odd. The character I auditioned for was an erotic dancer," she said. "I was cast, but I never showed any skin other than a little cleavage."

Street Law followed a trend, changing its title to *Simple Justice* after principal photography began on August 1, 1988. The shoot lasted over a month. Cesar Romero, John Spencer, Cady McClain and Doris Roberts were all cast. T. Jay O'Brien and Michael Sergio wrote the screenplay for the Deborah Del Prete–directed film. Nick Tallo said, "To meet and sit around with Cesar Romero was a dream come true for me. What made me feel bad was he made so many movies and was so famous and a lot of the people on the crew only knew him as 'The Joker.' I felt really bad. He was easy to work with, easy to get along with. He joked around a lot. He was a lot of fun, and I was in awe the whole time. Doris Roberts was real nice, very friendly. She was like everybody's mom." It is set in New York's Little Italy, and Pittsburgh was chosen to serve as part of the setting. Pittsburgh only provided extras for the casting. Donna Belajac was in charge of the extras and was required to find minority races and older Italian-looking women. The production wrapped principal photography in early September 1988 and headed back to New York to complete the shoot. The movie toured the independent film market for the next few years.

John Russo directed and wrote the estimated $750,000 production *Heartstopper*. Moon Zappa was a popular casting addition. Also cast were local Pittsburgh talent such as Kevin Kindlin and Tom Savini, who also helped with special effects. *Heartstopper* went into production during the fall of 1988. Scenes were filmed at Ray Laine's house in Hazelwood, downtown Pittsburgh, an antique store in Shadyside and various other locations. "It was a really big crew, a nice six-week shoot and lots of fun," said John Rice. The film appears on DVD under the title *Dark Craving*.

Amin Q. Chaudhri made *An Unremarkable Life* in Mercer County. Filming began on October 10, 1988, and by that time, Chaudhri had moved to Pennsylvania because he loved it so much. He even established his own studio in Mercer County. Marcia Dineen wrote the screenplay for a cast that included Patricia Neal, Shelley Winters, Charles S. Dutton and Mako. Earlier in the year, Chaudhri mentioned that Pat Morita may be cast, but it never happened. "I met Patricia Neal. I was her driver, and she gave me a warm embrace and kiss," said local Frank Serrao. Principal photography wrapped on November 23, 1988. The production flew to Greece during the

week of December 12, 1988, to finish before Christmas. *An Unremarkable Life* was released during an afternoon premiere on Friday, June 16, 1989, held at the Hermitage Square Plaza in Shenango Valley. It was a sellout at fifty dollars a ticket. The premiere benefited the Mercer County United Way and the Mercer County Humane Society.

The television pilot for a new ABC-TV series called *Equal Justice* began principal photography at the beginning of February 1989. The director was Thomas Carter, who was well known in Hollywood for directing the pilot episodes for some of television's most memorable shows like *Miami Vice*. Carter had a good track record opening up a television series. He had help with a talented cast such as Joe Morton, Cotter Smith, George DiCenzo and Sarah Jessica Parker. Pittsburgh was recommended to Carter by his girlfriend, who attended CMU, as well as the president of Orion Pictures, Gary Randall. Carter set up a rigorous schedule for the principal photography, which shot six days a week for twelve hours a day. At the end of each day, he went to the Vista International Hotel, where he watched the dailies. Carter wished he had seen more of Pittsburgh beforehand because he found many parts of the city to his liking and would have written them into the show somehow. The federal courthouse on Grant Street served as one of the featured locations. Principal photography ended on March 23, 1989. Carter was scheduled to pitch the idea to ABC-TV executives on May 18, 1989, for a fall release. He was successful and executive produced the series, as well as contributed to the writing of each episode. He even directed a few of them. Unfortunately, the series only lasted twenty-six episodes. Critics called it an *L.A. Law* rip-off. Those who were involved with the show defended and praised it. Carter was proud of his series but foreshadowed the possibility of failure.

Stuck with Each Other was an NBC television movie that starred Tyne Daly and was directed by her husband, Georg Stanford Brown. Richard Crenna and Bubba Smith were cast to costar with Daly. Brown was in Pittsburgh when he directed *Alone in the Neon Jungle* and said the city was a part of his family, mentioning the friendly people and beautiful city. Brown used the same Pittsburgh crew members and called them "family." Principal photography began on February 22, 1989. The production was on time and under budget for the entire shoot. Pittsburgh had a reputation for being a cheap place to make movies. *Stuck with Each Other* had a similar shooting schedule to that of *Equal Justice*. The production went six days a week for twelve-hour days beginning at 7:00 a.m. Brown also used the Vista International Hotel for filming purposes rather than a retreat like Carter did. The Orchard Café in Pittsburgh was open, but some patrons had to wait a few minutes because

of the filming. Every time they began a shot, a crowd of people flocked past, which created noise. Incidents like this made shooting on locations a challenge but were overcome. Brown sent someone to hold the crowds and let them go when the shot was completed. Crenna relished shooting on location and attended a local toy, train and craft show the first Sunday he was in town. Principal photography wrapped around March 31, 1989.

Homeless was a television movie directed by actress Lee Grant and starred Christine Lahti, Jeff Daniels and Kathy Bates. "I was in my cab at the William Penn Hotel, and the producer happened to get into my taxicab and was going to Shadyside. He was moving from New York City. I began a conversation, and by the time we got to Shadyside, Joe Feury hired me as a production office assistant and driver for the actors," said Frank Serrao. "I received the experience and understanding of the mechanics of filmmaking from the production. Most of my time was spent driving with Christine Lahti and Jeff Daniels to the different locations, learning how they would speak their dialogue lines together. I would be one of the first workers to see the daily call sheets, as I delivered them to each department head." Shooting began around May 1, 1989, and it rained for most of the production. It was exactly what Grant wanted—fitting weather for a story about homeless people. Eventually, the rain stopped and the days became sunny and clear. Mindy Rodman, the script supervisor, reported that the crew worked hard to re-create the dreary weather. The crews blocked out the sun and wet down the street to give an appearance of a gray and rainy day. Grant originally chose New York as her filming location but loved the look of Pittsburgh more, a suggestion made by Orion Pictures, which had an outstanding relationship with Pittsburgh. Norman Beck was recommended and hired to help create a few props. "I was an independent contractor and just made a couple of special effects for them," he said. The estimated $2 million production finished shooting around May 31, 1989, with most of the budget being dumped into the local economy. The title changed to *No Place Like Home* and was released on December 3, 1989, on CBS.

George Romero and Dario Argento split the director's chair for *Two Evil Eyes*. They shot in Pittsburgh, a logical move given the cost-effectiveness of the city and Romero's own filmmaking "family." Romero directed "The Facts in the Case of M. Valdemar," and Argento directed "The Black Cat." Both segments were based on Edgar Allan Poe stories. Romero grew up reading Poe and had an affinity for the genre. Adrienne Barbeau, Bingo O'Malley, E.G. Marshall, Christine Romero, Tom Atkins and Chuck Aber were cast for his segment. Argento cast actors such as Harvey Keitel, Kim Hunter,

Sally Kirkland and Ben Tatar. The Hunter and Kirkland negotiations were completed mere days before Argento began filming. Principal photography began on July 10, 1989, and lasted to September 12. Romero shot his half of the movie first and ended his shoot the week of August 7. Norman Beck said, "I was working props and special effects that they needed for various things. I worked in Lou Taylor's shop between Oakland and downtown. The prop department was centered there. They also used it as a storage place. I set up my own room to work on these special props and worked my own hours." Chuck Aber was happy to be reunited with his *Creepshow* cohort Adrienne Barbeau. "I remember her joking that we were becoming the new Hepburn and Tracy," said Aber. "They had to make body casts of me. It is the most frightening thing in the world," recalled Bingo O'Malley. "I had one straw up one nostril to breathe, and the stuff sits so instantly. You're under there for like twenty minutes. It's not a pleasant experience." He shot his scene in Fox Chapel. "We filmed at night all the time from about 10:00 p.m. until 6:00 a.m., and the people were living in the house the whole time!" The crew was then turned over to Argento. Pittsburgh grip Nick Tallo had never met him before and said, "When we were still doing the first story with George, at one point, there was an ambulance parked on the side of the set and this skinny little guy with greasy, filthy hair standing beside the ambulance. I thought it was a homeless guy or something. I thought this guy was ready to reach into the ambulance and steal something. So I'm watching this guy, and he comes over. Somebody says, 'I want to introduce you to Dario Argento.'"

DEMME GOD

Thomas Harris had become well known for his series of Hannibal Lecter novels with *Red Dragon* in 1981 and *The Silence of the Lambs* in 1988. *Red Dragon* was eventually made into a movie called *Manhunter* in 1986, and *The Silence of the Lambs* was soon to follow. Orion Pictures, the one company that had been pro-Pittsburgh throughout the 1980s, bought the rights to *The Silence of the Lambs* for Gene Hackman to direct and possibility star in. Because the novel had such a connection with readers, it became a bestseller, and it was clear a movie adaptation would be successful. Ted Tally was hired to write the screenplay. He was mainly a playwright, but Hackman read his script for *White Palace* and liked it. The rights to *The Silence of the Lambs* cost around $500,000, and Hackman agreed to split the cost with Orion Pictures. Unfortunately, he read the initial script and left the production, being reimbursed his half of the money. He found it to be too violent. Orion Pictures' next choice was a director by the name of Jonathan Demme. He initially rejected the idea once he glanced at the script. Demme was told to read Harris' novel, and after doing so, he then found a real inspiration to direct the film. One of the things that appealed to him was the character of Clarice Starling. Much of the allure for the cast and crew to be part of such a film was because it was different. It was a feminist piece of filmmaking.

Jodie Foster initially wanted to play Clarice Starling. Demme wanted Michelle Pfeiffer, having just directed her in *Married to the Mob*. Foster didn't give up and remained an advocate through the entire casting process. When a deal with Pfeiffer wasn't reached, Demme met with Foster a second time and decided to cast her. He changed his mind when he witnessed Foster walking down the hall with a determined look on her face. Her counterpart was Dr.

Hannibal Lecter. Anthony Hopkins was doing theater work in London and got a call from his agent about the script. After he read the script, he knew this was a once-in-a-lifetime role and decided to do it. Demme saw Hopkins in *The Elephant Man* and was impressed by his performance. Robert Duval was briefly considered to play Lecter, but Demme felt he wasn't right for the role. The filmmakers were given a tour of Quantico and the FBI training facility. It was the mission of the filmmakers to be as accurate as possible in their depiction of the FBI. The cooperation between the filmmakers and the FBI led to an on-site filming location and opportunity to promote the academy. Scott Glenn was cast as Jack Crawford. The character was modeled after a real-life man at the FBI named John Douglas. Glenn got to know Douglas and became friends with him. Glenn also spent time with the people in Behavioral Sciences researching for his role. Ted Levine was cast as serial killer Jame Gumb and also had to study the role. He researched serial killers and met female impersonators to get some background. He claimed that the character was not a transsexual or a homosexual and instead was a troubled man who had a bad upbringing. He acknowledged that the role was very challenging and very interesting.

Much like Romero, Demme had a filmmaking "family." Crew members such as Ted Tally and producer Kenny Utt were given small cameos. Pittsburgh actors such as Alex Coleman, David Early and Chuck Aber were also cast. "It was a wonderful experience from beginning to end," remembers Coleman. "Originally, a different actor was playing the Sergeant Pembry role, which I ended up with. It was some mix-up in that he ended up getting a hair cut when he wasn't supposed to and got fired or something like that. I was just lucky and one of the first ones that walked through the door."

The script called for several locations such as Tennessee, Ohio, West Virginia, Virginia, Baltimore and Washington, D.C. The crew was looking for one location that suited them all, and Pittsburgh was perfect. Kristi Zea said, "The one place that kept us all very intrigued was Pittsburgh. Pittsburgh has a kind of coal and steel background and the fact that it has many hills and rivers and it's just packed with character. There was a wealth of locations there." According to Zea, the Pittsburgh filmmaking crews also had a good reputation and contributed to the decision. For Steve Parys, this presented an opportunity to get into the movie business. Parys recalled:

I had wanted to get into film earlier than that, but I didn't think you could make a living at it. A buddy of mine called me and said there was a job. I

went, and I worked in the office for like a couple of months, helped them get up and running. When they started shooting, I went out onto the soundstage both when they were shooting and when they weren't. It was kind of like the first job where I did everything they wanted me to do and I took any kind of shift.

The production used a variety of Pittsburgh locations. The little backwoods community of Layton, Pennsylvania, is a place many locals never heard of because it is so small and secluded. The filmmakers used a house in Layton as Buffalo Bill's house. Parts of the jail were filmed at a local city jail as well as the cell, which was a set designed by the production crew, housed in the old Westinghouse turbine plant. Gumb's underground lair was also a constructed set.

The production budget was an estimated $20 million, and the crew had to find ways to make certain things work. One obstacle was Lecter's mask. Because the character was notorious for biting and eating his victims, his mouth had to be covered. Screen tests were done with Hopkins wearing multiple variations of a mask. Earlier masks resembled fencing masks. Eventually, the fiberglass model was chosen due to its old leather look. Most of the masks were medieval in nature and seemed to match the dungeon where he was held. The dungeon area was partially inspired by pictures of the prisons in the Nuremburg trials. Lecter also needed a special cell to contain him. "I just remembered one day how a lot of the liquor stores oftentimes were completely enclosed in Plexiglas, so I suggested that we do that instead and everyone was thrilled with that notion. There was only one person who was not thrilled with that notion: Chris Newman, who was our soundman...I said, 'Well, let's just put some holes in like they do,' and Anthony used them," explained Zea. Another task was finding an appropriate color for Lecter to wear in his cell.

Principal photography began on December 4, 1989, and lasted until March 2, 1990. The crew began filming at the Carnegie Museum of Natural History. The crew shot at the museum for the next three days. Dr. John Rawlins was the curator of the Invertebrate Zoology section of the museum where the scenes were shot. He was the only member of the section who remained as his seven colleagues relocated. Rawlins said:

Director Jonathan Demme actually requested that I, as curator in charge of the section, be present during the shoot and especially during setup that required movie specimens, cases. There was only a slight disturbance during

the weeks leading up to the shoot but nothing exceptional or uncomfortable. They had a really polite, effective staff, and they got what they needed quickly and smoothly…to my knowledge, not a single specimen, case or other item was disturbed. This is amazing!

Financially, the sections did not directly benefit from the shoot, but the museum did. "Since it was released, and especially after it swept the Oscars, we have exploited the rooms where the filming was done a bit—telling people that this is where 'it' took place," he said. The shoot provided interesting moments and curiosity. The heater made a hissing sound when the production crew was trying to film. They had to wait an hour for it to be turned off. Shooting also occurred behind the scenes during museum hours. "At those times, set people would go around telling the public in hoarse whispers to 'be quiet'—mixed with the usual jargon of 'rolling, rolling'…the public was just curious, then got excited that a movie was being filmed somewhere close by, and without exception they kept quiet and unobtrusive. The movie people were, for the most part, gentle and understanding," remembered Rawlins.

Jane Hyland and Dr. John Rawlins from the Carnegie Museum of Natural History.

The production spent December 19 and 20 at a vacant house at 1206 Lindberg Avenue in Shaler Township to shoot the FBI raid. The location had been scouted over a month earlier by Neri Tannenbaum, the film's location manager. The house was up for sale by Bert and Mary Wright, who had recently moved to the Johnstown area. Neighbors received letters about the filming on their street and possible disruptions that might occur. Trucks and campers were parked along Lindberg Avenue and nearby streets. The letter informed residents to keep the street clear of any vehicles so they could film and set up equipment. It also informed them of actors playing the role of FBI agents storming the house and explained that some of them may be crouched in bushes and partially hidden behind cars. This scene featured Scott Glenn and screenwriter Ted Tally.

One of the next locations used was the 171st Air Refueling Facility in Pittsburgh. The site had been scouted back in September 1989. "There were several tours and briefings with various executives of the production company before they determined that the facility at Pittsburgh would be appropriate," said Brenda Johns of the 171st Air Refueling Wing. "Once decided, the necessary requests for approvals were initiated with the office of the secretary of defense." The production spent three to four days at the facility. "January 16, 1990, brought hundreds of movie company personnel with tons of equipment and vehicles to our facility. A detailed parking plan had been developed for all vehicles and equipment. A feeding plan aided in the use of our dining facility to expeditiously feed the entire company every day on base," said Johns.

They taped from 4:00 p.m. until 6:00 a.m. There was not a tremendous impact to our daily operation. Obviously, there was some inconvenience but nothing that hindered the mission of either unit. The February 7, 1990 shoot went as smooth as the January shoot. There were less people on the facility but the same amount of equipment. The company arrived on February 6, 1990, made necessary preparations, shot on February 7 from 6:00 a.m. until 5:00 p.m. and by February 8 were completely off the base. All fees and expenses were computed and a check forwarded to the U.S. Treasury. The company utilized thirty-five to forty of the base personnel as extras. Every individual used as an extra was in leave status.

The film crew made their way to the home of Harold Lloyd, a physics teacher at Bentworth High School. His house in Layton was transformed into the home of Buffalo Bill. Lloyd recalled, "Not that anyone should refrain

from allowing their house to be used, but they must first realize that these people see the house you love as a 'prop.'" He had mixed emotions during the process because of rude crew members and items being stolen from his home. He said, "The security guard had to be fired for running tours through the house during nighttime hours." Lloyd continued, "Many were friendly. What little contact I had with Jodie Foster was polite and professional. She seemed a shy person. Director Demme was a friendly man who seemed driven by his job but seemed to remain down to earth." Lloyd's home was used for filming between February 10, 1990, and February 15, 1990. "The method of compensation is a per-day rate for the days of the shoot only. In my case this was ten days. I, however, had workmen in my house at all hours of the day for eight weeks prior and one week after [the shoot]," he said. During the shoot, arrangements were made for him to stay elsewhere.

David Puskar, another physics teacher at Charleroi Area High School, appeared at Lloyd's house as a police officer and even made it on camera. He was convinced to take part in the production by his wife and daughter. Puskar said:

> *I was instructed to go to Pittsburgh for wardrobe fitting at the hotel near the [then] Civic Arena and was paid fifteen dollars. The actual filming took one day. I really struck it rich, getting paid forty dollars. When the cameras were rolling, all traffic had to be stopped. Filming had to stop when a train would go by. At midday, a lunch break was called. The food was pretty good. Jodie Foster mainly kept to herself. Everyone seemed to respect her privacy and did not bother her too much. For lunch, she ate carrot sticks on the swing at the playground. Jonathan Demme was a bit more outgoing and entered into a conversation with my wife. The star that really seemed to have it best was the dog, Precious. The dog had a handler/caretaker that took care of its every need. Between takes she would feed, brush, exercise, water, proof and fuss over Precious. I had nothing to do all day. Late in the afternoon, one of the set managers told me to enter from the right, walk up the steps and stand on the porch.*

The Soldiers & Sailors Museum featured Lecter's escape. According to Joe Dugan, who worked at the museum, the production rented the building for about $25,000 and spent a lot of time constructing the set. Kristi Zea remembered, "I had put the carcass of a sheep hanging from the inside of the cage and hung a pair of pants off of it, and the head was kind of plopped onto it and you can see all of these ribs and everything. Jonathan came in with

his producer, Ed Saxon, and Kenny Utt, and they took one look at this thing and they spun around and quickly left the room…Saxon said, 'You've gone too far, Kristi. The audience will leave the theater in droves. I nearly threw up when I saw it.'" Production trucks surrounded the area, and the scene was primarily shot at night. "Usually they would start coming in around 3:00 p.m. with their trucks and the filming would start between 5:00 and 8:00 p.m.," explained Dugan. Even though he didn't get to witness any filming or meet any of the cast or crew, Dugan did walk on the set where Lecter made his escape. Alex Coleman remembers the experience with Hopkins, Foster, Heald and Napier as fantastic. "You're talking the crème of the crop. I was particularly delighted to be working with Hopkins because I had admired his work as a film actor for years. When I discovered he was playing Hannibal Lecter, I couldn't have been happier. I had a very good experience with him. I was the head of the master of fine arts acting program at the University of

Side one of *The Silence of the Lambs* shrine at the Soldiers & Sailors Memorial Hall & Museum.

Side two of *The Silence of the Lambs* shrine at the Soldiers & Sailors Memorial Hall & Museum.

Pittsburgh, and he graciously came and visited the students. He had lunch with the grad students. He chatted with them and gave them information," said Coleman. The museum retained memorabilia from the production such as pictures from the set and autographs from the cast and crew.

Lecter's tunnel escape was shot in a tunnel on the east side of Pittsburgh. Originally, the Liberty Tubes were selected, but too many objections were raised about their use. The funeral scene was filmed on Main Street in Rural Valley. Chuck Aber remembered, "It was just a wonderful experience. I would get there in the morning and Jonathan Demme, who had a lot of other things on his mind I'm sure, would come over and say, 'Chuck, have you had a donut and coffee? Is everything okay? Is the trailer okay?' He was so nice; in fact, that whole production team was just terrific." Aber did get to socialize a bit with Jodie Foster and said, "She was wonderful! She was

so friendly and so cordial to everybody." Aber also had a scene with Jodie Foster and Scott Glenn in a car. This scene was shot between Perryopolis and Layton, Pennsylvania. He said, "We were sitting in the car between takes, and all of a sudden Scott Glenn says, 'So how is that John Hinckley thing?' And I thought this is why it is a closed set! But she was very open about it."

The Western Center in Canonsburg was chosen for the look of the administration building, which also housed some interior shots, such as Dr. Chilton's office. John Pokora worked at the Western Center and said, "I had to turn condensate pumps on and off so as not to interfere with the sound equipment. I was given 'cues' when the pumps were to be turned off." Steve Parys said, "They were really nice. Anthony was like really nice and professional and really easy to talk to, and Jodie was just really cool. She was like really more fun on set than you would think because she comes across as very uptight and very intellectual. They had golf carts to get to places, and she used to race around on those…it was great. I came to realize that the shoot itself was actually a very nice, pleasant atmosphere."

The production left an impression on Pittsburgh. Producer Utt praised the city's cooperation and even called Pittsburgh one of the most beautiful cities in the world. Many treasures remain from the production. Dr. Rawlins and his colleagues at the Carnegie Museum of Natural History still have the moth prop that was dissected, as well as an original script. He was visited by Foster and a New York photographer for some promotional photos. "At the end, the photographer took a cheek-to-cheek shot of Jodie and I, presumably to repay me for the help…I was surprised to receive in the mail a single crisp eight-by-ten print of Jodie and I," said Rawlins. "Before the movie was first released, I received a substantial donation from Demme and from the New York photographer. They both had learned that we were interested in studying endangered organisms in Haiti, and that country was of special interest to them and to Foster."

The Silence of the Lambs was released on February 14, 1991. The estimated $20 million film went on to gross about $272 million worldwide. It won several awards, including Oscars for Best Actor in a Leading Role, Best Actress in a Leading Role, Best Director, Best Picture and Best Writing. It also received an Oscar nomination for Best Sound and Best Film Editing. Foster won a Golden Globe award for her role. Demme, Hopkins and Tally were also nominated for Golden Globes. Despite its large scale, the production remained elusive. Demme ordered a closed set to reporters, photographers and onlookers. Regardless, it paved the way for the dozens of productions that came to Pittsburgh over the next few years.

THE REMAKE

John Russo started thinking about doing a remake of *Night of the Living Dead* around 1986. One of the main reasons for doing a remake was because Continental Pictures had failed to copyright the original movie. For thirty years, people duplicated their work. Russ Streiner said, "We felt that if we got many of the same group of people back together and remade the picture, that would help the copyright on the original picture." The remake reunited some of the original filmmakers such as George Romero, who brought his film "family" with him. Romero had a different job in mind for Tom Savini. Streiner said, "George felt he had enough confidence in Tom to let that be his directorial debut." Romero finally began writing the script with word buzzing around Pittsburgh as early as November 1989, when preproduction was about to begin. The film operated on an estimated budget of $4.2 million.

Locations were being scouted across the Pittsburgh area. It was unique for a film and its remake to be shot in the same area with the same filmmakers. They found a farmhouse near Washington, Pennsylvania, with a cemetery only a mile or two away. The production had its locations locked. The farmhouse property was owned by Elizabeth Hamilton and was on the market for $125,000. "I really wanted to buy it, but I didn't have the dough then," said Savini. With no one currently living in the home, it was ideal. On the top of the hill from the farmhouse was the Upper Buffalo Presbyterian Church. The church had some financial problems, and because of its adjacent location to the farmhouse, the production set up shop there, helping to solve the church's financial woes at the same time. "The church was just used for lunch and for big makeup days," said Savini. "It was easy for us, it was logistically logical." According to Reverend Dambach, the church received $125 a day for about thirty days. He also received an overloaded

answering machine, as people were calling for directions to the church, and had to take the phone off the hook during one of his church meetings. He received so many calls because a casting call of two hundred extras was to take place at the church on March 24, 1990. Dambach remembered people were even talking about it at a funeral because of the excitement. "I worked as an independent contractor because I was working at CMU. If it wasn't for my full-time job, I would've worked full time on that movie. So I just made a few things for them," said Norman Beck. "I made some breaking windows."

They postponed the casting call for extras to March 31 and held it at a new location, the North Franklin Township Fire Hall. Extra Casting Director Staci Blagovich scrambled to post signs in bars, theaters and restaurants. She also heavily relied on word of mouth. Prospective zombies made their way to the fire hall as early as 6:00 a.m. Within five hours, she had processed about seventy-five zombies. "If you were born in Pittsburgh, one of the things you want to be when you grow up is a zombie in one of George Romero's movies," said Savini. To Streiner's knowledge, extras came from as far away as Kentucky to be in the remake. Local actors were given an opportunity to be in the remake as well. David Butler, Zachary Mott, Savini's friends Pat Reese and Pat Logan, William Cameron and many other local actors were cast. Bill Cardille also returned to play the same exact role as he had in the original. Donna Belajac ran the local casting in Pittsburgh, with the exception of the extras.

Casting also took place in New York, where Meredith Jacobson was in charge. Much of the major cast came in their own interesting ways. Tony Todd was working on a film in Pittsburgh called *Criminal Justice*. "I had heard about it [the remake] through the grapevine and didn't have an appointment, and I went over to the production office and ran into Savini…I showed them that I could do it, and the next thing I know, I was talking to my agent. It almost didn't work out because of scheduling," remembered Todd. Patricia Tallman had worked with Savini and Romero in the past and was cast to play Barbara. Bill Moseley said, "Savini called me at home in Los Angeles to ask where he could send a script. He told me to pick any character…He said, 'Pick any part, as long as it's Johnny.'…I loved Patty Tallman from the get-go. We met on the plane from LA, went to dinner our first night in Washington, Pennsylvania. We both had relationships, so we bonded as brother and sister. She's sexy, smart and a great actress!" Tom Towles, McKee Anderson, William Butler, Heather Mazur and Kate Finneran completed the cast. Butler said:

I heard about the production through John Vulich, who I grew up with. I asked my agent to get the script, and he got me the script. I asked if I could

read for the role of Tom, and George Romero saw my picture and said of course you can read. So Viggo [Mortensen] *put me on tape while we were in New Mexico. By the time I was done filming* Young Guns II, *I found out I booked the job and was really excited. I went straight to Pittsburgh, which was an amazingly cool place. It was awesome.*

With the casting filled and the extras eager, cameras were ready to roll.

Principal photography began on April 23, 1990, and ended on June 8, 1990. "I would just think to myself, 'Look where you are. You didn't get to do the original film and you're here directing the remake,'" remembered Savini. "When we started shooting, we started with the beginning of the script, which was the graveyard scene. This was springtime in Pittsburgh. We wanted the gloomy, rainy kind of thing going on…instead, we had these glorious sunshiny blue days with birds chirping and it's not scary at all," remembered Tallman. "I didn't get to talk too much to George Romero, John Russo or Russ Streiner. I was only in Washington for seven days, so there wasn't a lot of interaction with our three 'godheads,'" said Moseley. He only worked with Tallman but remembered the experience as being fun. William Butler was behind the scenes at the cemetery. "It was actually sort of intimidating because I didn't know anybody," said Butler. "I was just kind of hanging out, getting to know everyone. I was, and still am, a huge George Romero fan. He was a very, very personable and supportive person. I didn't want to let anyone see I was nervous, so I just played it cool and kind of kept to myself. Everyone was really, really nice there. I had a really good time."

Once the cemetery filming wrapped, they moved down the road to the farmhouse, where the remainder of the remake was shot. It was there that many of the eager zombie extras made their debut. Hamilton, the owner of the farmhouse, appeared as the old woman zombie wearing the purple sweater. Local legend has it that Don Brockett played a zombie as well. The shirtless zombie who appears in the window was actually a cab driver whom Savini had met.

Tallman appreciated the support everyone gave her during the production. She had worked with most of the crew before and only had minor roles. However, the remake was the first starring role she had with that crew. Local actor William Cameron was cast as a news anchor on television. He filmed at the local WTAE television station on a Friday night around midnight. They shot the scene after the late-night news because it was the only time the station wasn't using its broadcast set. According to Cameron, the scene took nearly two hours to shoot.

Patricia Tallman holds Lia Savini next to a zombie extra on the set of the *Night of the Living Dead* remake. *Courtesy of Patricia Tallman.*

Principal photography wasn't without its fun. Butler remembered:

> *There was a serious amount of drinking. Most of the time we shot at night, but we'd start drinking about 6:00 a.m. There's this one breakfast place we always went to in Washington and then go back to our hotel rooms and get drunk. John Vulich put the Bill Moseley dummy in my bathtub, naked with a towel on its head. We went to work the next day and got a call from the hotel. They were threatening to throw us out because the maid went in there and saw the Moseley dummy with blood all over it. Apparently, she was running down the street screaming, holding her rosary beads. We got into a lot of trouble for that.*

The remake was released on October 19, 1990, and grossed an estimated $5.8 million. Even though it made some money, it wasn't quite as successful as it could have been. Being that this was a remake of the original film, many people opposed it. Savini and Streiner have come out and acknowledged the opposition. The film was special because it was the last time Romero made a zombie film in Pittsburgh.

CHAPTER 13
THE PITTSBURGH FILM OFFICE

Pittsburgh opened the doors to its own film office in February 1990. Since its inception, the film office has had two directors of operations, with the first being Robert Curran from February 1990 to August 1994, followed by Dawn Keezer from September 1994 to the present. The film office operates with a board of trustees. Within the board is an executive board, over which longtime Pittsburgh filmmaker Russ Streiner presided as the chairman. "We're the one-stop shop for the film industry," said Keezer. Its primary mission reads, "To serve as an economic generator for the designated ten-county greater southwestern Pennsylvania region by attracting and supporting film, television and related media industry projects, and coordinating government and business offices in support of a production." It provides photographs, local vendor and crew listings and any other information a production might need. The Pittsburgh Film Office also has an educational outreach program, which includes school visits and brochures. Internships are also available. The internships deal with the job processes of the film office and do not involve making a movie. The film office is established in the Century Building in Pittsburgh.

When it comes to work, workers of the film office meet the filmmakers at the airport and show them around. They sit down with them and discuss suitable locations for what the script needs. However, they don't get involved with contract negotiations. The acquisition of a specific location is between the production and the location owner. The staff is constantly on the phone to track down leads, talking filmmakers into considering Pittsburgh for their productions. The film office has extended hours due to most of its business being based out of California. Most of

the staff works the day job, while Keezer closes shop, working until at least 7:00 p.m.

For over twenty years, the film office was responsible for bringing over one hundred productions of all kinds to the Pittsburgh community. "People here are still excited about the film industry. They want it on their streets. They want it used in a movie," said Keezer. Besides the excitement a movie brings to the community, it also impacts the local economy. According to the film office, more than $525 million has been dumped into the Pittsburgh economy because of its efforts and the cooperative efforts of local businesses. The film office has done its job in generating revenue for the city and has assisted some big productions in recent years. With Pittsburgh's reputation, as well as the tax incentive, the film office is expected to continue its mission with great success.

FIVE YEARS OF FULL TIME

S uccess came in the early 1990s, and work wasn't hard to find for the city's film community. *Criminal Justice* featured mainstream Hollywood actors mixed with actors of the Pittsburgh community. Local actors such as William Cameron, Alex Coleman and Don Brockett joined Forest Whitaker, Jennifer Grey and Tony Todd. The same was said of the production crews. It was shot in Pittsburgh between March 8, 1990, and April 3, 1990. Todd said, "It was a great experience, and I loved the downtown area. I got to meet a lot of the crew. They were fantastic and very dedicated. I had worked with Forest Whitaker, and it was a nice bonding thing." He continued, "When I was doing *Criminal Justice*, I heard about the *Night of the Living Dead* production, and I got really excited because that was one of my favorite films." Keith Hammond, a Pittsburgh entertainer, also appeared as an assistant attorney. Hammond was in several Pittsburgh films and only received forty-five dollars a day for the film.

Nancy Mosser was involved with the Pittsburgh film industry for several years. She was given a new job on *Criminal Justice* as part of the casting department. Pittsburgh didn't have a casting agency devoted to extras, and the production was considering bringing someone in to do it. Unfortunately, it was costly to do. "I got an interview and told them that I thought I would be really good at it and had confidence that I would. I told them that I would devote my life to their project for the next fourteen weeks, and they hired me. I did my first open call and got six hundred people and fell in love with it," said Mosser, who continued to cast extras in Pittsburgh for over twenty years. She started her own casting agency, Nancy Mosser Casting, a few years later. As far as locations were concerned, they needed local government buildings. An agreement had to be reached between the production and the city. The

agreement was reached for $1,500 and included the use of the county jail, the courthouse, the Bridge of Sighs and the city-county building.

Jeff Fahey and Bridget Fonda were cast for *Iron Maze*, which began principal photography in May 1990 and lasted until July 1990. Minor roles were being cast by Donna Belajac as early as March. Actor Peter Allas heard about the role, and it was suggested that he try out. "I met with Oliver Stone and Elizabeth Leustig, the casting director. Their partner was Hiroaki Yoshida, and I met with him. They kept stringing me along for about six or seven weeks, but I pretty much knew I had the role. I was pretty much one of the first cast for the project. It was myself, Fahey and Bridget," said Allas. "I thought I was going to hate Pittsburgh, absolutely hate it. I ended up falling in love with Pittsburgh." Yoshida directed the film, and Oliver Stone served as executive producer. It was primarily shot in Braddock, with other parts of Pittsburgh being used as well. "A friend told me they were looking for an assistant makeup artist on the film *Iron Maze*. So I sent my résumé and portfolio to the key makeup artist in LA and was hired on my first film," said Pittsburgher Patty Bell. "As makeup artist, my job consists of designing the look of the character, applying the makeup and maintaining that look throughout the film. Most importantly, I keep the actors comfortable, happy and beautiful on the big screen." Bell was involved with many productions in Pittsburgh, receiving work from either referrals or friends who call her to work.

Many of the mill scenes were shot at an empty mill in Duquesne. Production designer Tony Corbett felt the decaying mill was a safer place to work than the abandoned hotel in Braddock where the crew had set up several sets. The Regional Industrial Development Corporation banned visitors to the set and required the production to have the mill inspected for use. Hazardous materials were removed from the premises. Fitness tests, X-rays and masks were also offered to the members of the crew. By the middle of June, most of the film had already been shot in Braddock. The production made its way to the Greater Pittsburgh International Airport toward the end of June to shoot for a day, costing the production $570. Because the film office was established, it had a hand in helping the production get its permits. Toward the end of the shoot, Braddock police stopped traffic along a two-block section of the city. Detours were set up for commuters, which required the production to pay for police and other necessary components. Usually, traffic detours upset drivers on a hot and humid Saturday in July, but the thought of a film being made took the drivers' minds off the detours. Beaver Falls, Homestead, Harmony and downtown Pittsburgh were also used as locations. Harmony was a unique-looking town that suited the filmmakers. The production dumped about $4 million into the Pittsburgh economy.

The movie made its initial debut at the Sundance Film Festival in January 1991 and had a wide release on November 1, 1991. At Sundance, it was nominated for the Grand Jury Prize and won the Best Screenplay Award at the Tokyo International Film Festival.

The Bride in Black was shot in Pittsburgh that August. The James Goldstone movie starred Susan Lucci and Tony Todd. Todd had just completed *Night of the Living Dead* in June and stayed in the city for the summer. "I hung out at the jazz joints and stuff. What was funny about that production was I got paid five times more than what I got paid for *Night of the Living Dead*, and it was only a four-week shoot. Susan Lucci was a sweetheart," he said. Like most other films, the production hired local crew members. "They started shooting at a time I had to be working at CMU. I had to tell them that I couldn't stay and left after a couple of weeks. I continued to make some props for them after that because I could always do it in my spare time," said Norman Beck. The television movie debuted on October 21, 1990.

The 10 Million Dollar Getaway began principal photography the week of September 17, 1990, and lasted until October 16, 1990. Pittsburgh substituted for New York. Local actors Chuck Aber, William Cameron, Alex Coleman, David Early and Bingo O'Malley joined John Mahoney and Tom Noonan in the television thriller directed by James A. Contner. "I had one scene with John Mahoney. It was a good experience. Mahoney's very nice, a real confidence builder. It was really nice to work with him, he's a very gracious man," said Coleman. Locations included Pines Plaza Lanes along Route 19 in Ross Township, as well as the bar and pool area at the Shannopin Country Club in Ben Avon Heights. The Pines Plaza Lanes substituted for Queens, New York, and the Shannopin Country Club substituted for a Catskills resort. The production was searching for a bowling alley that looked like it came from the 1970s, and location manager Judy Matthews of Squirrel Hill found the Pines Plaza Lanes to be perfect. She sent the picture to director Contner, and he agreed. Another specific location was the B.F. Jones III house in Edgeworth, Pennsylvania, which served as the home of a Mafia don. Further locations included Bloomfield, Squirrel Hill, Shadyside, Point Breeze, the Greater Pittsburgh International Airport and downtown Pittsburgh. Supposedly, the Kennedy Airport in New York didn't allow the production to film there. The Greater Pittsburgh International Airport, as well as the necessary negotiated channels, opened the USAir hangars to the production crew, showing Pittsburgh's support of filmmaking.

Many members of Pittsburgh's film crew remember how terrible the experience was. "We called it 'The 10 Million Dollar Giveaway.' They

beat the crap out of the crew, fed us lousy food. I don't know where things break down as far as having things go smoothly, but the whole crew was just grumbling all the time. Luckily, we weren't complaining to each other, we were complaining about the situation we were in," said Nick Tallo. Rik Billock was cast as an extra, making thirty-five dollars a day. He remembered, "The crew was even wearing T-shirts that said, 'The 10 Million Dollar Giveaway.' They were working eighteen- to twenty-hour days and barely getting any sleep. The extras were working eighteen-hour days, and somebody called and complained." Despite the tension on set, Aber did have a happy memory of the experience:

> *I remember being down on Libery Avenue at the Brown Bag deli. I was a cop or investigator there, and my partner and I go in to question him* [John Mahoney]. *We were standing between takes, and John Mahoney was sitting at the table. The fellow who played my partner went to him, "Long day, John?" He said, "Yeah. They're pretty long days. But you know what? I'm not going to complain because thirty thousand other actors would like to have this job, and we got it. So why complain?" I thought that was so nice to hear other than grumbling.*

Christopher Reeve came to Pittsburgh to make *Bump in the Night*, directed by Karen Arthur. Reeve took time out of his schedule to talk to sixty local drama students from the Quaker Valley and Sewickley Academy. One of the things he spoke about was his first film role. Students also questioned him about his experience as Superman when he did a Q&A session. The production primarily shot in Edgeworth and Sewickley. Making its second appearance on film was the B.F. Jones III house, which was used for a scene; this was its last appearance, as it was demolished in 1991. The recently purchased and vacant Edgeworth home of Pam Gregg and her husband, Walter, was another location. A Leetsdale warehouse was also used. Pittsburgh saved the production a quarter of its budget.

As early as August 1990, it was announced that George Romero's next film was going to be *The Dark Half*, based on the Stephen King novel. Washington County hosted its third feature film of the year, budgeted around $12 million. Romero relied on his Pittsburgh "family" of filmmakers to help with the project. He also worked with Hollywood actors such as Timothy Hutton, Amy Madigan and Michael Rooker. Julie Harris was a last-minute cast member, and her character was originally a man. John Hurt, Michael Gough and Donald Moffat were all originally considered for the part but

were unable to do it. The stars were accompanied by Pittsburgh actors such as William Cameron, Nardi Novak, Zachary Mott, David Butler and David Early. Pat Buba served as the film's editor and Cletus Anderson as the production designer. The Washington-Jefferson College had several scenes to be shot there. Many other scenes were filmed in Washington. Edgewood was another local community used.

Principal photography began on October 15, 1990, and lasted until March 1991. "I constructed two things for *The Dark Half*," said Norman Beck. "One was a set of skylights, and the other was a header for a bed." Novak was cast to play a receptionist and said, "It was very pleasant working with George Romero. He was just so lovely and friendly. We got in line together at the lunch line, and he just chatted away. He was so friendly, it was so nice." The first location used was Old Main at Washington-Jefferson College. Thirty residents were cast at the beginning of the shoot. Cross Creek Park was another early location. Shooting at the park lasted about a week, and it had to be closed to the public for a few days because the boat sounds interfered with the filming. The boat sounds were even heard from the opposite end of the lake. Despite the park having to be closed, the county was very receptive. Jerry Mundell worked for the park and remembered the November shoot. "They were real easy to get along with. They only built like half of a house that was meant to look like a whole house. They started on it around the end of August or something like that. They donated materials to the county, and we saved it. We took it down to Mingo and built one of the garages out of most of the stuff," he said. The locations in Washington County doubled for Maine, where the story takes place. Romero acknowledged that it was fun compromising with popular actors who have strong opinions. One of the more spectacular aspects was the Hitchcock-like scene involving thousands of birds. About five thousand finches were used, and they resided in a large building that seemed like a labyrinth of cages. Real birds were used because this was an era that came right before the advent of computer-generated images (CGI).

The Dark Half was released on April 23, 1993. It was put on hold for about two years because of the financial difficulties Orion Pictures was experiencing. It was sad news in the Pittsburgh film community that their longtime supporter went under. However, this wasn't the only sad news. *The Dark Half* was the final film George Romero made in Pittsburgh. For twenty-five years, he claimed a large portion of Pittsburgh's cinematic history and is celebrated as a local legend.

Filming of the PBS film *Darrow* took place the week of November 19, 1990. Kevin Spacey came to Pittsburgh, starring as Clarence Darrow, with

John David Coles directing. Calista Flockhart also got cast. Hundreds of extras were needed, and ads were placed in Pittsburgh newspapers calling for extras to work twelve- to fourteen-hour days. Primarily, the shoot took place in Washington, Pennsylvania. The movie aired on June 8, 1991.

Diary of a Hitman was the first of several productions in 1991. It was directed by Roy London and starred Forest Whitaker as a hit man named Dekker. The role of Dekker had originally gone to Charles S. Dutton, but that fell through. Sharon Stone and James Belushi were also cast. Principal photography began in Pittsburgh on January 11, 1991, and ran until March. Pittsburgh filmmaker Amin Q. Chaudhri served as the producer. *Diary of a Hitman* was primarily filmed in Sharon, Pennsylvania, where Chaudhri lived and worked. Parts of the film were even shot in Youngstown, Ohio. The film didn't receive a wide release and only played in certain cities and film festivals. At the Deauville Film Festival in France, it was nominated with the Critics Award.

Walter Matthau came to Pittsburgh, signing on to play Harmon Cobb in the television movie *Against Her Will: An Incident in Baltimore.* He was cast with local actors such as Don Brockett and Bingo O'Malley. Delbert Mann was set to direct the film, which was originally called *Cobb's Law.* It was actually a direct sequel of the 1990 film *The Incident.* Principal photography took place in May 1991. Even though it is set in Baltimore, Pittsburgh was chosen because it was cheaper. Matthau knew the film business well. He explained that the unions in Baltimore made it too expensive, and Pittsburgh was a suitable replacement.

Martin Sheen and Brendan Fraser also arrived to shoot *Guilty Until Proven Innocent,* written by Cynthia Whitcomb and directed by Paul Wendkos. Donna Belajac cast Pittsburgh actors such as William Cameron, Zachary Mott, Bingo O'Malley and Ray Laine. Principal photography began on May 16 and ran until June 13, 1991. "Martin Sheen was very nice, very political and that pleased me," said O'Malley. "It was a fascinating movie." While in Pittsburgh, Sheen joined hundreds of locals in the courtyard of the Allegheny County Courthouse for an International AIDS Candlelight Memorial and Mobilization on the night of May 19, 1991. He spoke to reporters about the importance of the AIDS epidemic and of people's responses to it. He also led a caravan of residents on June 2, 1991, to protest the building of a hazardous waste plant in East Liverpool, Ohio.

A Canadian production called *North of Pittsburgh* came to town. It was directed by Richard Martin and written by Jeff Schultz. Pittsburgh was scouted as a location in May 1991. "I can say they involved roads and

highways, factories and bridges—anywhere that looked period 1970s," said Martin. "The Pittsburgh Film Office sent us lots of pictures of industrial areas and roads. After looking them over, I realized we had to go there and get the real thing. We scouted and prepped for nearly a week. The experience in Pittsburgh was smooth, professional and, as I remember, fun-filled." The city was used primarily for second-unit filming, which lasted for only four days starting on May 26, 1991. Martin also remembered an important night in Pittsburgh sports history when he said, "It sounded like there was rioting in the streets. We ran to the windows and threw them open. It was chaos. Horns were honking and people cheering. It was May 25, 1991, and the Penguins had just won the Stanley Cup."

ABC television was responsible for bringing a production based on the true story of Gus Farace to Pittsburgh. Tony Danza was cast to play Farace. He shaved off most of his hair and trained to get in good physical condition, a role that took months of preparation. Peter Markle was set to direct with Ted Levine, Dan Lauria and Samuel L. Jackson cast for supporting roles. Bingo O'Malley, William Cameron, Ray Laine, Lori Cardille and Alex Coleman were among the Pittsburgh talent. Principal photography began in August and lasted until September 1991. *Dead and Alive: The Race for Gus Farace* aired on November 24, 1991.

Passed Away and *Lorenzo's Oil* both began principal photography on September 9, 1991. Charlie Peters wrote and directed *Passed Away* with Bob Hoskins, Tim Curry, Frances McDormand and Dylan Baker cast. Pittsburgh casting included Don Brockett and David Early. Oakmont served as one of the locations. Principal photography concluded on December 7, 1991. Nick Nolte and Susan Sarandon were cast for *Lorenzo's Oil*. Originally, Michelle Pfeiffer was set to play Mrs. Odone but withdrew to play Catwoman in *Batman Returns*. Sarandon knew all about the Odone family and ran into the film's director on a plane as he told her about the project. Out of respect, Sarandon didn't pursue the role until Pfeiffer withdrew. She felt right for the role, comparing herself to the real-life Mrs. Odone. Pittsburgh casting included William Cameron and eighteen-year-old Peters Township resident Aaron Jackson, who was tutored while on the set. He was attending the Village Academy, an alternative school in Upper St. Clair, and had some training at Point Park College and at the Pittsburgh Playhouse. He earned $1,500 a week for playing Francesco, Lorenzo's stepbrother. The budget was set at an estimated $30 million, with the majority of it spent in Pittsburgh. "I worked as a carpenter on the movie for a couple of weeks and then did some side jobs for them," said Norman Beck. "I made legs for a bed at my shop at

CMU. I helped them design an African wooden weapon. A friend of mine at CMU actually carved it." Heinz Chapel, Oakland, CMU and Ben Avon were filmed locations. Principal photography wrapped in the beginning of February 1992. The film was nominated for two Academy Awards and received a Golden Globe nomination for Sarandon's performance.

Australian filmmaker Kevin James Dobson directed the television movie *What She Doesn't Know*, originally called *For I Have Sinned*. Valerie Bertinelli was cast to star with Pittsburgh actors such as Tom Atkins, Alex Coleman and Bingo O'Malley. Principal photography took place in October 1991, with Pittsburgh substituted as New York City. During one of the first days of the shoot, the crew had parked a van near Mellon Bank Center. It had mannequins in it and alarmed a local driver, who decided to call the police. They all had no idea it was for a movie. The streets of the Strip District and Pittsburgh's North Side were also used as locations. Bertinelli remembered a woman walking up to her in Pittsburgh, inquiring if she were a movie star.

The estimated $4 million *Bob Roberts* was the brainchild of Tim Robbins, who initially wrote it in 1986. The character was originally a businessman rather than a politician, but Robbins was interested in Hollywood's take on politics. He turned to Forrest Murray as the producer. Together, they finalized a deal in the summer of 1991 with Baltimore Pictures and Live Entertainment. A deal was also worked out with the British independent company Working Title Films, which provided the film's budget. For as quick as the preproduction process was proceeding, Robbins was able to cast Alan Rickman, Ray Wise, Gore Vidal, James Spader, Jack Black, Fisher Stevens, John Cusack and Helen Hunt. Susan Sarandon was already filming *Lorenzo's Oil* and received a part. Pittsburgh actors Tom Atkins, Bingo O'Malley, Pat Logan, Don Brockett and Rik Billock joined hundreds of local extras. Pittsburgh was chosen because of its architecture, film community and film office.

Principal photography began on November 4, 1991, and ended on December 12. "That was one of the most pleasant experiences I ever had just because of the atmosphere they created for shooting. I just think the world of Tim Robbins. We were down in Sewickley, and I'm in my trailer the first day. Tim Robbins knocks on the door. This was the most amazing thing that a director would come in to your trailer and say, 'Let's talk about a scene,'" remembered O'Malley. Uniontown, Carnegie and Waynesburg were among the thirty locations used. One specific location was the Andrew Carnegie Free Library, where the beauty pageant scene was shot for only two minutes of screen time. However, crews spent three days at the building, including building the set, filming and breaking down the set for original restoration

of the property. This was the building's movie debut. Many extras were needed to fill the stands of the pageant, and they were paid between forty-five and sixty-five dollars a day. The extras casting still had difficulty finding four hundred people for the banquet scene. They decided to stage an actual benefit for WQED with engraved invitations sent at seventy-five dollars a person to Pittsburgh locals, inviting them to the banquet and to appear as extras. There were six concert scenes needed, and the production crew followed the same formula as the banquet scene. It was a successful strategy, as they obtained more than six hundred extras. As for other miscellaneous locations, a South Side hospital was used for one of Robbins' scenes on a cold and rainy Sunday morning. Mount Lebanon High School's auditorium was also used for one of the speech scenes. The production also traveled down to Uniontown's State Theater to shoot a scene.

Stephen Gyllenhaal arrived to direct *Waterland*. Jeremy Irons, Maggie Gyllenhaal, John Heard, Lena Headey and Ethan Hawke were cast. Pittsburgh shared filming locations with England, where the film was actually set to take place. The screenplay written by Peter Prince was adapted from a novel by Graham Swift. *Waterland* made its debut at the Toronto Film Festival on September 12, 1992, and was released domestically on October 30, 1992.

On November 18, 1991, the Pittsburgh film industry became unionized with the formation of the IATSE (International Alliance of Theatrical Stage Employees) Local 489. Some people foreshadowed problems with a union. One fear was that it might drive producers away from the city, even though that wasn't the intention. Robert Curran preemptively blamed the union if no productions came to Pittsburgh. Many filmmakers in America were trying to economize, and union wages had the potential to drive away possible productions because their budgets couldn't pay the wages of union workers. One of the unforeseen benefits of the Local 489 manifested in recent years as studios usually only hired union workers.

Innocent Blood was directed by John Landis, who cast Don Rickles, Tom Savini, Sam Raimi, Frank Oz, Anne Parillaud and Dario Argento. It was set in Pittsburgh, and the city served the needs of the production during location scouting. Bloomfield substituted as the fictional "Little Italy" of Pittsburgh. Shadyside, the Strip District, Oakmont and the Liberty Bridge were also used. Many Pittsburgh crew members were called to work on the production. Principal photography began January 13, 1992, and lasted until April 7. "It was just a blast. We popped around like mad," said Steve Parys.

A month later, Danny DeVito arrived to begin filming *Hoffa*. He starred alongside Jack Nicholson, who played Jimmy Hoffa. DeVito operated on a

Innocent Blood set on Liberty Avenue. *Courtesy of Steve Parys.*

$35 million budget, which he partly financed, serving as one of the producers. He also said the production was giving a significant amount of money to Pittsburgh's economy. DeVito scouted Pittsburgh on December 20, 1991, as he checked out the State Correctional Institution. Principal photography began on February 18, 1992, in Pittsburgh and lasted until the middle of March. Norman Beck said, "I helped create a street vendor's wagon, and I don't think it's in the film. This is also when the union came around. You couldn't get work unless you were union. There were also certain rules. You couldn't take a twenty-minute coffee break. It was a different atmosphere." Specific locations included the Tenth Street Bypass and a North Side home. The Tenth Street Bypass was used as a New York highway. The production hired eight off-duty police officers to help with traffic and paid a modest fee for the closing of the road. The North Side home was transformed into a dry cleaning shop. The Most Holy Name of Jesus Roman Catholic Church in Troy Hill was used as Hoffa's Teamster's Hall in 1935. Production carpenters were working in the church parking lot to re-create the historical location. Reverend W. David Schorr was pleased with the monetary gain to

his church. Pittsburgh actors included Bill Dalzell and Don Brockett, who had a scene with Jack Nicholson and Danny DeVito.

One of the more controversial issues was a nasty rumor about the production being over budget and behind schedule. According to DeVito, it wasn't true. One realistic problem was the Heinz shoot, which never happened. The company vetoed the idea, which would have brought in $5 million and eliminated the company's parking lot for two months. DeVito also received a gift for filming in Pittsburgh, which was given to him by the director of the Pittsburgh Film Office, Robert Curran. He gave DeVito a Penguins jersey with his name on it. It was given to him in part because of his role as the Penguin in *Batman Returns*.

Frank Pierson's HBO film *Citizen Cohn* depicts a dying Roy Cohn in a hospital as he remembers his life through flashbacks. James Woods, Joe Don Baker, Ed Flanders, Fritz Weaver and Pat Hingle were cast, along with many talented Pittsburgh actors, including Chuck Aber, David Early and Zachary Mott. The filmmakers were still scouting locations in the middle of February 1992, and Pittsburgh was chosen for its architecture. According to producer Doro Bachrach, they also decided to come to Pittsburgh because of the local acting talent. Principal photography began in mid-February and lasted until the end of March. A deal had to be reached with city officials to let Woods smoke in the Pittsburgh City-Council Building, a smoke-free building. The fire department agreed, and the site was used as a Senate hearing room. The Washington County Courthouse was chosen as a location, and the crew spent March 26, 1992, setting up for the scene to be filmed for the next two days.

Harold Ramis, the director of *Groundhog Day*, never came to Pittsburgh but sent a second-unit crew to film some exterior shots. Principal photography started on March 16, 1992, and the Pittsburgh shoot took place around that time. The movie takes place in Pittsburgh and Punxsutawney. Bill Murray's character, Phil Connors, is a Pittsburgh weather man who travels to Punxsutawney to cover the Groundhog Day festivities there but gets trapped in a time warp where he lives the same day over several times.

ABC shot *The Jacksons: An American Dream* television movie during the spring of 1992. Billy Dee Williams and Vanessa Williams were cast. Principal photography began on April 28, 1992, and lasted until the beginning of June, with Pittsburgh crews working on the production. Joyce Ellis, a local dance instructor, was hired to recruit some of her students to possibly appear as extras. Springdale was selected as the primary location. It was Jermaine Jackson who spotted the house that reminded him of his childhood home

while scouting for locations. *The Jacksons* aired on November 15, 1992, and went on to win an Emmy for the film's choreography.

Craig T. Nelson and Bonnie Bedelia returned to Pittsburgh to make *The Fire Next Time*. Pittsburgh wasn't the primary filming location, sharing locations with New Mexico and Louisiana. Although the production in Pittsburgh wasn't large, locals such as Frank Serrao were hired to help. "Heading to McConnell's Mill State Park, Bonnie Bedelia dropped her blue jeans and stuck her bare ass out the car window and shot us a 'pressed ham.' I laughed so hard, I almost drove off the road," said Serrao. The two-part miniseries aired on CBS during the week of April 26, 1993, which happened to be International Earth Week.

Rowdy Herrington directed the production *Three Rivers*. However, upon its release the name was changed to *Striking Distance*. The project was given a budget of an estimated $30 million, all of which was spent in Pittsburgh. Herrington cast Bruce Willis, Sarah Jessica Parker, Tom Sizemore, Dennis Farina and Tom Atkins. Local news anchor Sally Wiggin was also cast. "Donna

Belajac, the casting agent, called me and a number of other local anchors. I had to test for the part. They gave me a script, I memorized it and sat in a chair in Donna's office in front of the director, Donna and someone else and just recited the lines," remembered Wiggin.

Principal photography began on June 8, 1992, and lasted until September 8, 1992. "Everybody had a boat. The actors had the boat they were in on camera, obviously. The grip department had a grip truck, but they would load it onto a barge, and their grip equipment sailed around the set all day on

Steve Parys and Sarah Jessica Parker on the set of *Striking Distance*. *Courtesy of Steve Parys.*

the river on the grip barge. And there was an electrical barge, a locations boat and production assistants had these little boats. It was like *Waterworld*. We lived on the water. It was really neat," remembered Steve Parys. "I had some beefs with Bruce Willis here and there, but he was a fun, good guy for the crew. He was kind of a party guy for the crew. Sarah Jessica Parker was dynamite, a totally nice woman." Nick Tallo also remembered working with Willis. "He was very cool. He was like a normal guy, which was really nice," he said. "There were a lot of nights. We were out on the river a lot, so the work was pretty hard." Frank Serrao also met Willis and said, "I drove a taxi in a scene and was excited to shake hands with Bruce Willis. It was the scene when he enters the City-County Building." The production used locations beyond the rivers such as Point Park, Mount Washington and Monessen. A brief location was the WTAE television studio where Wiggin shot her scene. She said, "When the time came to film it, I did it at our station, with the second-unit director. I never saw the director again, nor did I ever meet Bruce Willis or anyone in the cast. It took about a half hour to do the scene."

Tony Buba's next project was the film *No Pets*, originally titled *Pets*. This was the first fictitious film by Buba, who was well known for his documentaries in Braddock. Casting calls were put in the local papers as early as April 1992. Speaking roles were cast in May, with extras casting taking place in June. Buba cast John Amplas, Lori Cardille and Mark Tierno. Filming began right after July 4, 1992. John Rice was brought on as the director of photography. "It was a nice shoot that lasted about twenty days," he said. "We shot in Braddock. We shot in Swissvale. It was a lot of fun; working with Tony is just great fun. He is a super guy. We laugh a lot." In 1994, the film premiered at the Byham Theater in Pittsburgh and received praise all over the country from various critics.

Actor and director Bill Duke directed *The Cemetery Club* with Ellen Burstyn, Olympia Dukakis, Christina Ricci and Diane Ladd all cast. Pittsburgh acting talent included Bingo O'Malley. "We filmed my scene at the William Penn. It was a very nice movie," said O'Malley. The production scouted for the perfect cemetery, and Duke chose an Allegheny cemetery to be one of the primary locations. Spratt Music in Brentwood was used as Moskowitz Music store in the movie.

Laura Linney, Joanne Woodward and Fritz Weaver were cast to star in the CBS television movie *Blind Spot*. Woodward also served as one of the producers. Principal photography began at the end of September 1992 and lasted until the middle of October. "Once again, I only constructed a single prop. It was a clock that they needed to control remotely," said Norman

Beck. Paul Newman, who was married to Woodward, was in Pittsburgh. A few locals spotted him around town wearing a Pittsburgh Steelers cap. Nick Tallo said:

> We were shooting a scene in this nightclub, and we're all milling around. There were a lot of people, and somebody banged into me and I just didn't pay much attention. They bumped into me again. I just turned around to say something, and it was Paul Newman. He was very cool. They had a little party for the cast and crew. At one point they were like, "Oh Paul. Come in here, and I want you to meet these people." And he was like, "No. I'm going in here and drink beer and watch football with the crew." He was like a normal guy.

Three months later, Ramon Menendez directed *Joey Coyle* and cast John Cusack, Michael Madsen, Phillip Seymour, Benicio Del Toro and Frankie Faison. Cusack began preparing for the role as far back as November 1992, when the real-life Joey Coyle showed Cusack around Philadelphia. Pittsburgh was chosen as the primary location, with a few scenes being shot in Philadelphia. Filmmaking troubles were being discussed publicly in town. Pittsburgh had just lost a $5 million production because of a driver dispute between the production and the union. *Joey Coyle* was made with an estimated budget of $11 million. Locations included Duquesne, the South Side, Stanwix Street, Butler Street and Forbes Avenue, which caused some traffic delays. Principal photography ended the week of March 21. The title was changed to *Money for Nothing*. Coincidentally, the real Joey Coyle committed suicide a month before the film came out. Despite concerns, the death didn't impede the release date.

Chris McIntyre, a Pittsburgh native, directed *Finnegan's Wake* with Linda Kozlowski and Paul Sorvino cast. Local actors included Bingo O'Malley and Nardi Novak, with Rocky Bleier playing himself. The title changed to *Dead Wrong* when principal photography began at the end of April. It was McIntyre's intent to capture the city like never before. The crew shot all over the city at places such as the North Side, Bloomfield, Mount Washington, Gateway Clipper Fleet, Three Rivers Stadium and Roberto Clemente Park. McIntyre praised the hospitality of Pittsburgh's film community and said it was better than LA. Bingo O'Malley remembered, "We filmed on Easter Saturday…it was bitter cold." He had to film on the roof of a building with dangers involving the height of the set. The shoot lasted until the end of May 1993 and debuted on HBO as *Backstreet Justice*.

Joanne Woodward made yet another movie in Pittsburgh. James Garner starred with her in *Breathing Lessons*. Principal photography began around June 6, 1992, and ended in July. John Erman directed the film, with Pittsburgh acting talent such as Ray Laine and a boy named Phillip Turkas, who was in the funeral scene with Garner and Woodward. He was able to take a picture with Garner. Turkas got the acting bug in the first grade and devoted his skills to becoming an actor. One of the featured locations was Walkers Mill in Collier. The St. Vincent DePaul Chapel on Noblestown Road was also chosen as a location with the consent of the Pittsburgh Catholic Diocese. A field near the chapel was converted into a cemetery with the use of foam headstones. Second Avenue in Carnegie, Washington Street and M&B Motors in Heidelberg were used. One of the final scenes shot was at Walkers Mill and filmed at Sedlar's Store in July. *Breathing Lessons* aired on February 6, 1994, on CBS and went on to be nominated for several Emmy awards and Golden Globes. Woodward won a Golden Globe for her performance.

Since 1979, Stephen King had been trying to make *The Stand* into a movie. One of the initial problems was the length of the novel. In order to make the film about two hours long, a lot of elements of the story had to be sacrificed. It was through television that King and Richard Rubinstein realized that they could make it. The television version of *The Stand* had a runtime of over six hours. It was decided that a huge, one-hundred-day shoot was needed. Mark Garris signed on to direct with a budget of $28 million. The cast included Gary Sinise, Molly Ringwald, Ossie Davis and Rob Lowe. Shooting began on February 16, 1993, and lasted until early July 1993. Pittsburgh was one of the last stops, with the Armstrong Tunnel substituting for the Lincoln Tunnel in New York between June 25 and June 30. The crews began prepping the tunnel on Friday, June 25, at 6:00 p.m. to avoid rush hour. The actual shoot began later that night and lasted for the next five days. *The Stand* aired on ABC for several days beginning on May 8, 1994. The miniseries was nominated for several awards and won an Emmy for the makeup.

Peter Yates directed *Roommates*, operating on an estimated budget of $22 million. He cast Peter Falk, D.B. Sweeney and Julianne Moore and chose certain performers based on theater experience. Favorable location scouting brought the production to Pittsburgh. One location was the McGinnis Sisters deli in Brentwood. A month before shooting began, deals were being made with the Brentwood council and locals to use their city and shops. The owners negotiated with the film company and agreed to close their shop on September 15, 1993. The Brentwood council agreed to negotiate with

the production company to pay off-duty police officers twenty-five dollars an hour to assist with traffic on the day of the shooting. A primary location chosen was Polish Hill. Not only did Yates find the scene to be favorable, but he also wanted to populate the film with local Pittsburghers. He was known for doing this on many of his films.

Roommates began filming on August 16, 1993, and lasted until late October. One of the first locations was Knell's Bakery in Mount Washington. The film crew spent a day there, and Falk even took pictures with residents. Leonard Engelman had done special makeup effects for *Ghostbusters*, *Sleepless in Seattle* and *Heat*. He was hired to help age certain characters. In Pittsburgh, his work began around 6:30 a.m. and lasted late into the day. Falk rarely saw a break. His temporary home in Pittsburgh was a suite at the William Penn. While filming, he spent between two and four hours in a makeup chair for about three months. That's not including the forty minutes to take off the makeup at the end of the day. Pittsburgh crew member Steve Parys said, "Falk was a maniac. D.B. was a sweet guy, and Julianne Moore was wonderfully nice lady." Many local actors such as Alex Coleman and Nardi Novak were cast, but their scenes were either cut or they appeared in the background.

Director Norman Jewison filmed *Him* in Pittsburgh. Marisa Tomei, Robert Downey Jr., Fisher Stevens and Billy Zane were all cast. It was only partially filmed in Pittsburgh, while the rest was shot in Italy. While scouting for locations, Jewison got really excited to shoot at the new airport. Concourse C was chosen, as well as WQED studios. Principal photography began on August 30, 1993, and lasted until December 8, 1993. The first three weeks of the shoot occurred in Pittsburgh, and from there the production headed overseas on the weekend of September 18. The first scene shot was at a Catholic school. The crew spent a week at WQED, building the set of Faith's apartment. "I only worked on the production for about a week. I helped build a set for them, a single interior," said Norman Beck. Because they filmed where *Mister Rogers' Neighborhood* was shot, crew members took pictures next to King Friday's castle. Kennywood, Dormont and Grandview Avenue in Mount Washington were used as locations. Before its release, the title was changed to *Only You*.

Since June 1993, it had been known that Ed Harris and Melanie Griffith may come to Pittsburgh for *Milk Money*. During the summer, locations were scouted. Unfortunately, Pittsburgh was chosen as a secondary location, with the bulk of it being made in Ohio. Principal photography began on August 9, 1993, and lasted until October. Pittsburgh was one of the final places to be shot around September 30. City papers posted traffic alerts as the crew filmed on Grandview Avenue at Sycamore Street.

Pittsburgh experienced a decline of productions in 1994. Many contribute the decline to a combination of the unions and cost-effective Canada. Work barely existed to sustain Pittsburgh's full-time capacity. Whoopi Goldberg and Drew Barrymore made part of the $21 million movie *Boys on the Side* in Pittsburgh. They were only in town the week of February 7, 1994. They started the week at the Allegheny County Courthouse. Next, they went to the Conley Inn in Monroeville, followed by William Street atop Mount Washington. Off-duty police were hired to block the roadway and redirect traffic. The final shoot took place on the Veterans Memorial Bridge, where they shut down the outbound lane from 5:30 a.m. to 2:00 p.m. The production also had problems with two local radio stations. WXRB-FM called the Fort Pitt Motel, where the actresses were staying, and they quickly hung up the phone. WBZZ-FM offered listeners $50 if they got Whoopi Goldberg on the air. Robert Curran of the Pittsburgh Film Office called the station every morning to stop. Goldberg was driven around in a plush van with heavy security. Before they left, the production was very respectful to the Fort Pitt Motel and cleaned up once they were done. Goldberg even left an autographed picture of herself at the motel. They left town on February 12, 1994.

Pittsburgh suffered a few more problems with *Houseguest*. Director Randall Miller cast Sinbad as Kevin and Phil Hartman as Gary Young. The area was scouted and chosen to be the sole location for principal photography. The International Airport, South Side, Hill District, Edgeworth and Sewickley were used. A variety of Pittsburgh actors were cast. As local city councils were voting for filming to take place, it was apparent that some residents were not so pleased. The film office accommodated disturbed neighbors and offered to put them up in a hotel if problems occurred. The home of David Aloe on Academy Avenue in Edgeworth was used as the home of Gary Young. Miller chose Pittsburgh because it had a more cinematic look than the other cities scouted. Pittsburgh even beat out California. The production operated on an estimated budget of $10.5 million.

Principal photography began on May 9, 1994. Local actor Alex Coleman was cast and said, "That was a lot of fun! It was a week shoot, and we did it at a private residence in Sewickley. It was supposed to be Phil Hartman's home. Sinbad was good to work with. He was notorious for ad-libbing around the script, and it drove the writer and director crazy, but he was great fun to be involved with. Phil Hartman was friendly." Bingo O'Malley was also cast and said, "Sinbad was the most genuine, down-to-earth person. He was terrific." Steve Parys said, "Sinbad was a blast! Phil was here and everybody loved him. He was the greatest guy on the planet. It seemed so phony at first until you

realized he really was that nice. I worked on the marathon scene with Phil. Everyone on that shoot was really fun." The film office posted traffic alerts for motorists along Forbes Avenue when the filming began. The production used Forbes Avenue from 9:00 a.m. to 6:00 p.m. Drivers were told to find alternate routes or allow for extra drive time. Many business owners were upset that their peaceful neighborhood was turned into a movie set. Some locals even complained about the noise. Business owners posted signs in their windows that read, "Disney Co. and Sewickley Borough Council Unfair to Local Merchants." At a Sewickley council meeting, they openly spoke about the business they lost. The production offered business owners $400 to compensate, but the owners wanted $6,000. Extras were paid $80 a day, and most locals actually enjoyed the filming. The production commandeered a local hardware store, turning it into a McDonald's because there wasn't one in Sewickley. Principal photography wrapped on June 30, 1994.

Jean-Claude Van Damme brought more controversy to Pittsburgh. The problems were more internalized rather than upsetting the local commuters and business owners. *Sudden Death* was an idea conceived by Karen Elise Baldwin, whose husband was the owner of the Pittsburgh Penguins. Her story was adapted into a screenplay by Gene Quintano, and her husband, Howard, co-produced. Director Peter Hyams had previously worked with Van Damme on *Time Cop* and cast him for the lead role. Mayor Murphy, Howard Baldwin and Jean-Claude Van Damme held a press conference outside the Civic Arena on August 25, 1994. It was announced that the arena had been chosen as the primary location. *Sudden Death* was looking for about eighteen thousand extras. It was well documented that Van Damme suffered from a drug addiction around this time, and many working behind the scenes knew the reality before it was made public. He was looking for a house to rent in Pittsburgh, and it was suspected he found it in Squirrel Hill. However, he wasn't looking for a quiet place to avoid press and fans. He was looking for a house to party.

Sudden Death began principal photography on August 29, 1994, and operated on a budget estimated at $35 million. Several locations were used in Pittsburgh. On October 1, 1994, about ten thousand extras were given free admittance, free parking and free food when the Pittsburgh Penguins hosted their farm team at the Civic Arena. The game provided movie footage with the Cleveland Lumberjacks substituting as the Chicago Blackhawks. It was perfect timing, as the National Hockey League had delayed its opening season due to a labor dispute. The arena was filled with hockey and movie fans. Empty seats were filled with cardboard cutouts. Many women came

hoping to see Van Damme, but they didn't. The Penguins only played the one game, as the others were staged by the Johnstown Chiefs and the Wheeling Thunderbirds. Only two thousand extras showed up for the farm teams, with most of the arena filled with the cardboard cutout figures. The players were paid $125. Crew member Steve Parys said, "We had all these farm team players. Even though I would yell at them, they would go get drunk. They would have chicken races on the zambonis, they broke into the owner's box and raided the booze stand. It was really contained insanity. It was insane every day." Norman Beck said:

The art director called and asked me if I could build them a miniature scoreboard. He heard about my work. I basically told them no because my shop at CMU was being used and they needed this thing in less than two weeks. A company in California was going to build this scoreboard, and they wanted me to install it. I knew it was going to be a struggle, but they were paying $30 per hour. I met with the art director, drew up specifications for building the thing and they sent the drawings to California. Over a week later, they shipped it to Pittsburgh overnight and I began to install it.

Controlled fire prop on the set of *Sudden Death. Courtesy of Steve Parys.*

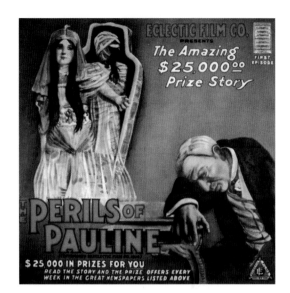

Right: Poster for *The Perils of Pauline*.

Below: Debra Gordon and Brian Dennehy on the set of *10th & Wolf. Courtesy of Debra Gordon.*

The Mellon Institute was used as a location for *The Dark Knight Rises*.

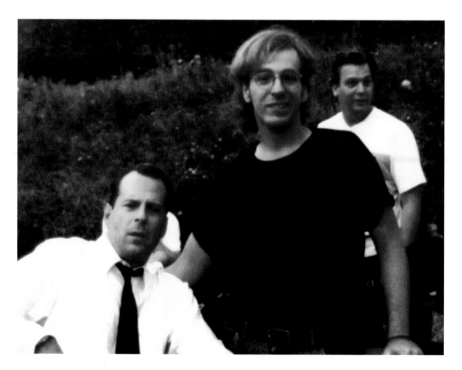

Bruce Willis and Steve Parys on the set of *Striking Distance*. *Courtesy of Steve Parys*.

Blair Underwood celebrates "Pirate Day" on the set of *The Bridge to Nowhere. Courtesy of Steve Parys*.

David "Yoko" Jose, Pam Grier and Steve Parys having fun on the set of *Mafia. Courtesy of Steve Parys*.

Chris Rock, Salma Hayek, Linda Fiorentino, Kevin Smith and Jason Mewes on the set of *Dogma*. *Courtesy of Steve Parys*.

Ben Affleck on the set of *Dogma*. *Courtesy of Steve Parys*.

The Evans City Cemetery chapel. Recently, Gary Streiner has focused his efforts on restoring the cinematic landmark.

Patricia Tallman behind the scenes of the *Night of the Living Dead* remake. *Courtesy of Patricia Tallman*.

The crew of *Riddle* prepares to shoot a scene. *Courtesy of Steve Parys.*

Nick Tallo and Fred Rogers on the set of *Mister Rogers' Neighborhood. Courtesy of Nick Tallo.*

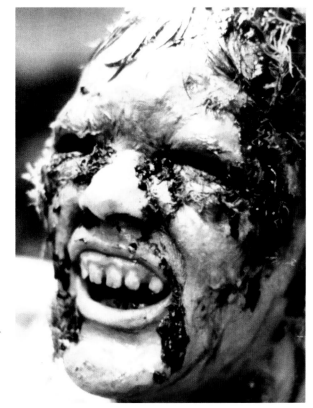

Above: The home of
Harold Lloyd was used for
The Silence of the Lambs.

Right: Jeff Monahan as a
zombie in *Day of the Dead*.
Courtesy of Jeff Monahan.

Jean-Claude Van Damme's stunt man performing on the set of *Sudden Death*. *Courtesy of Steve Parys*.

Left: Director Christopher Nolan on the set of *The Dark Knight Rises* in downtown Pittsburgh. *Courtesy of Sarah Sigler*.

Gary Oldman on the set of *The Dark Knight Rises* in downtown Pittsburgh.
Courtesy of Sarah Sigler.

Batman's aerial vehicle on the set of *The Dark Knight Rises* in downtown Pittsburgh.
Courtesy of Sarah Sigler.

Pittsburgh actress, producer and art director Adrienne Wehr. *Courtesy of Becky Thurner Braddock.*

Pittsburgh actress Debra Gordon. *Courtesy of Debra Gordon.*

Filmmaker Jeff Monahan. *Courtesy of Jeff Monahan.*

Pittsburgh actor William Cameron.

The Soldiers & Sailors Memorial Hall & Museum was used for *The Silence of the Lambs*.

Above: The Western Center Administration Building in Canonsburg was used for *The Silence of the Lambs*.

Director Gus Van Sant on the Avonmore set of *Promised Land*. *Courtesy of Julio Kuok.*

Matt Damon on the Avonmore set of *Promised Land*. *Courtesy of Julio Kuok.*

Val Kilmer and Steve Parys on the set of *Riddle*. *Courtesy of Steve Parys*.

Gary Oldman on the set of *The Dark Knight Rises* in downtown Pittsburgh. *Courtesy of Sarah Sigler*.

Christopher Nolan directs *The Dark Knight Rises* in downtown Pittsburgh. *Courtesy of Sarah Sigler.*

Cast and crew members surround a Batmobile on the set of *The Dark Knight Rises*. *Courtesy of Sarah Sigler.*

A crew member works on a Batmobile on the set of *The Dark Knight Rises. Courtesy of Sarah Sigler*.

The Catwoman stunt double films a chase sequence in downtown Pittsburgh for *The Dark Knight Rises. Courtesy of Julio Kuok*.

Principal photography ended on December 7, 1994. Locally, it was made a spectacle. The film premiered in Pittsburgh on December 11, 1995, at the Showcase North, where one thousand invited guests attended.

On August 30, 1994, the CBS television film *The Piano Lesson* began principal photography with an estimated budget of $4.5 million. It was based on the award-winning play by Pittsburgh native August Wilson. Lloyd Richards directed and cast Charles Dutton for the lead role. Much of the cast from the Broadway production reprised their roles for the film. Wilson arrived in Pittsburgh on August 5, 1994, to begin location scouting, extras casting and rehearsals. Nancy Mosser carefully cast nearly two hundred extras. Norman Beck worked as a carpenter for about a month on an interior set. Locations included Shadyside, the North Side and Harmarville. The production shot on Alder Street in Shadyside first in early September. A block on North Street in the North Side provided two pawn shops, a church and the Harris Studio demanded by the script. The Garden Theater porn house served as a 1936 movie house. Dutton's house was a $200,000 set constructed at a Harmarville factory. The final scene shot was of Lou Meyers gambling in a backroom. Principal photography ended on October 1, 1994, and the movie aired on February 5, 1995, for Black History Month.

The biography of figure skater Oksana Baiul began shooting in September 1994 and was called *A Promise Kept: The Oksana Baiul Story.* One of the locations was the Mount Lebanon Recreation Center. Local actors such as William Cameron and Kathleen Stupp were cast. "I worked briefly as a carpenter and worked at a house on the North Side because it was a location shoot. We were just fixing up a bathroom to make it more camera friendly," said Norman Beck.

Street Corner Justice shot a few scenes during the middle of October 1994. The scenes were shot on Mount Washington during the week of October 16. It was written and directed by Pittsburgh native Chuck Ball and starred Marc Singer. Despite only part of it being shot in Pittsburgh, both Nancy Mosser and Donna Belajac contributed to the casting. Few local actors were cast. Some of those who worked on the film claimed that the producers left without paying most of the crew. The production headed to Los Angeles, where the rest of it was shot. The film had a direct-to-video release on October 2, 1996. With the negative comments of the production and the small amount of time it spent in Pittsburgh, it was a sad way to end five years of full time.

CHAPTER 15
THE CANADIAN EFFECT

Many filmmakers were taking their productions to Canada because it was cheaper. Pittsburgh, along with all the other cities in the United States, lost out on millions of dollars of revenue, as well as job creation and business. This was a battle that Dawn Keezer and all the other film office directors around the country faced. Pittsburgh's reputation was still able to attract some productions. Sharon Stone brought her own problems, according to many crew members on the $30 million *Diabolique*. It was a remake of the 1955 French thriller. Keezer and the film office began making calls in the hope of attracting the production to Pittsburgh. Location scouts came to Pittsburgh three times looking for suitable places to shoot. Luckily, the city had what they wanted. Actors in the tri-state area were trying to get into this production, and a few made it. Local actors such as Bingo O'Malley and Zachary Mott earned roles, and certain Pittsburgh crew members found themselves with long-awaited jobs with three months of work.

Principal photography began around July 30, 1995. Pittsburgh crew member Kevin Roche recalled unpleasant memories. Many remembered Stone to be unpleasant, reporting tantrums and a bad attitude. Norman Beck worked as a carpenter and said:

> *I didn't meet Sharon Stone, and I'm glad I didn't. I heard so many stories from people who worked with her on the film. My friend was delivering something to the set and took her baby with her. Stone saw the baby and was raving about how cute it was. My friend had to go find somebody, and Stone had offered to watch the baby. So my friend left the baby with Stone. Not long after, Stone started screaming because my friend left the baby with*

her. She made a huge scene about this baby when she offered to do this! When my friend came back, everyone was mad at her for leaving the baby with Stone.

Diabolique wrapped around October 21, 1995.

Bill Murray finally made it to Pittsburgh when he was cast in *Kingpin*. Woody Harrelson, Randy Quaid and Vanessa Angel were also cast. Originally, Michael Keaton was rumored to be playing Roy Munson, but negotiations fell apart. Bob Farrelly and Peter Farrelly signed on to direct. Pittsburgh was up against locations in Virginia and Baltimore, Maryland, with Pittsburgh winning the competition. Club Erotica and Monroeville were just two of several locations used. The production also wanted to shoot at the Hunt Armory in Shadyside, but they were told to pay $30,000 a month to use it. The production threatened to leave Pittsburgh and finish shooting in Baltimore. This prompted Pennsylvania state representative Ron Kaiser to introduce legislation prohibiting state agencies from charging such fees to movie companies. It passed unanimously. About $9 million was spent in Pittsburgh. Principal photography began on October 2, 1995, for a one-month shoot. One of the first scenes filmed was at Club Erotica in McKees Rocks. Local actress Linda Carola appeared in a diner scene as a waitress opposite Harrelson and Murray. Carola was a Point Park College student and said nothing but nice things about them. Steve Parys said, "It was a whole different experience, working just second unit. They got behind on some shots, and I got a call as soon as *Diabolique* wrapped. It was only a couple weeks. It was all pickup stuff. It was kind of boring." *Kingpin* wrapped on December 14, 1995.

Tony Buba made another documentary in 1995 titled *Struggles in Steel: The Fight for Equal Opportunity*. The documentary focused on the African American struggle for equality in the steel industry as they faced discrimination from fellow white workers, union leaders and employers. Buba was accompanied in the director's chair by Ray Henderson, a former African American steel worker. The documentary appeared at the Sundance Film Festival between January 18 and January 28, 1996. Much like Buba's earlier works, it received a wealth of critical praise all over the country.

John Russo's *Santa Claws* was the first production of 1996. He cast bombshell Debbie Rochon to play the lead role of Raven Quinn. *Night of the Living Dead* alumni Marilyn Eastman, Karl Hardman and S. William Hinzman were also cast. Principal photography began on January 12, 1996, and lasted until March. The film was released for VHS on October 22,

1996. This was also the release date for Russo's documentary *Scream Queen's Naked Christmas*, a joint production with *Santa Claws*.

John Harrison returned to make his next movie called *Out in the Cold*. Sherilyn Fenn and Tom Verica were cast alongside veteran actor Paul Winfield. Verica received the news of the film right before an Asian vacation he had planned. "Pittsburgh is a great place to make movies…It's got a great talent pool, it's an exceptionally beautiful city. There are lots of possibilities, so let's look," said Harrison. Chicago and Baltimore were also considered for the shoot, but in the end, Pittsburgh was chosen. "For me, it's coming home. It's very exciting to be making a movie here. I know the city very well, I can visualize the story here. It's wonderful to come back and see the energy and enthusiasm for the industry," said Harrison. Local actors such as Marty Schiff, Bill Cardille, Chuck Aber and William Cameron were cast. It was a pleasant homecoming for Harrison, working with his friends for the first time in over ten years. Principal photography began on April 22, 1996. Locations included CMU, Station Square, Shadyside, Ligonier and various Pittsburgh hotels. "The old Gateway Studios up on Ross Street is where we shot my sequences. All of the scenes that I did were in that building. It was great! I really loved the role, and working with John again was great," said Schiff. "It was fun. They did some really neat stunt work," said Steve Parys. Verica's parents flew all the way to Pittsburgh to watch their son act, and they were also cast as extras. The production wrapped at the end of May 1996 and debuted on Starz on October 5, 1996, under the title *The Assassination File*.

Coraopolis native Michael Keaton returned to Pittsburgh for *Desperate Measures*. Location scouts were in Pittsburgh during the summer of 1996. Even though San Francisco and other parts of California supplied the production with the locations it needed, Pittsburgh filled the missing gaps. The production wanted to use Mellon Center, the headquarters of the company. The negotiations for this location weren't easy. In July 1996, the company denied the production permission to shoot there. Negotiations commenced a few days later, and finally the company agreed to the filming on August 14, 1996.

Principal photography commenced in the first three weeks of September before heading to California. Besides using Mellon Center, the production used various spots, including Ross Street, which was closed between Forbes and Fifth Avenues for the two-week period. Nick Tallo worked on the production and was reunited with Keaton:

I went into work and all of the teamsters were telling me, "Keaton's looking for you." After about two hours, the key grip said, "We're caught up on what we got to do. Go find Keaton." So I go to his trailer and see his mom and sister. I'm talking to them, and all of a sudden this person jumps on my back, screaming in my ear and it was Mikey. He's the same. He hasn't changed. He hasn't gotten an attitude and hasn't turned into a Hollywood jerk.

Steve Parys also talked to Keaton and said, "I talked to Michael Keaton a good bit because he was the hometown boy. He was asking me about some of the guys he used to work with on *Mister Rogers' Neighborhood* and stuff like that." During the shoot, September 10 was officially declared "Keaton Day" in Pittsburgh by Councilman Bob O'Connor. Keaton was awarded with a plaque and belated birthday present in honor of his contributions to the local film community. Upon the film's release, many noticed that Pittsburgh and its crews were not given a credit. Many were disheartened. However, the filmmakers weren't contractually obligated to credit Pittsburgh. Mellon Bank received a credit because the filmmakers were contractually obligated.

Sally Field made her way to Pittsburgh to direct the television film *The Christmas Tree*. This marked her directorial debut. She cast Julie Harris and Andrew McCarthy for the lead roles and began shooting her estimated $3 million film the week of September 30, 1996. She chose a mansion at Hartwood Acres as one of the primary locations. Executive producer Wendy Japhet also loved the mansion. McCarthy and Harris loved the environment and considered Field an exceptional director. Pittsburgh crews and actors like Zachary Mott also got a chance to work with her. They spent a month in town and left for New York to film the Christmas tree at Rockefeller Center on December 3, 1996. Between the Pittsburgh and the December 3 filming, *The Christmas Tree* was edited in order to make the December 22, 1996 air date on ABC.

The final production of 1996 was *The Journey*, directed by Harish Saluja. He operated on a budget under $3 million. Despite a small budget, it was enough to get his vision to the screen. The film starred Indian actors Roshan Seth and Saeed Jaffrey. Principal photography began in the middle of November 1996 and ended at the beginning of December. Much of the shoot took place around McMurray. Miscellaneous locations included the Pittsburgh Center for the Arts, Mount Washington and Ligonier. Steve Parys said, "That was my first real independent film, and now that's what I like doing." It was released at various film festivals around the world, winning few awards and much critical praise during its tour.

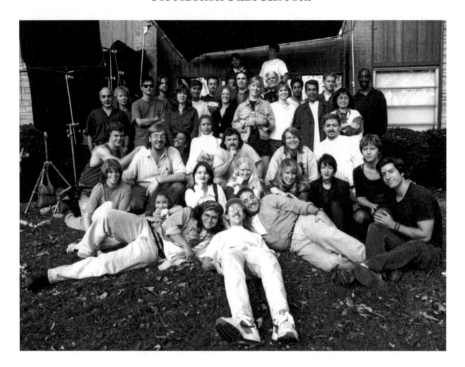

Cast and crew of *The Journey*. *Courtesy of Steve Parys.*

One of the worst years of Pittsburgh's cinematic history was 1997. Only a few scenes were shot for a production called *Daddy Cool*. It was directed by Brady Lewis, who lives and works in Pittsburgh. *Daddy Cool* is an independent film paying tribute to the science fiction and horror genre of the 1950s. Because of budgetary issues, his production took nearly five years and an estimated $150,000 to make. Principal photography was completed in 2002, and the movie was finally seen on the big screen at the Three Rivers Film Festival on November 8, 2002. Lewis' efforts weren't wasted, as it received many positive reviews.

Pittsburgh filmmakers at Happy Cloud Pictures began shooting their first movie called *The Resurrection Game*, written and directed by Mike Watt. The cast included Ray Yeo, Kristen Pfeiffer and Amy Lynn Best, with appearances by Debbie Rochon and Jasi Cotton Lanier. Principal photography began in the summer of 1997. Faced with scheduling and casting problems, principal photography lasted three years. It received an award at the Pittsburgh Filmworkers Film Festival for Best Production after it was released in 2001.

Warner Bros. was looking to bring back the Superman franchise. Kevin Smith wrote an original screenplay that the studio liked. Tim Burton and

Nicholas Cage were attached to the project at one point around 1997, working in conjunction with producer Jon Peters. Burton made his way to Pittsburgh and fell in love with the city, choosing it as Metropolis. Steve Parys helped the studio scout locations. "The Warner Bros. private jet landed, and Tim Burton got off. He was really cool and really loved Pittsburgh! He told us he loved the old buildings next to shiny new buildings. It was me, Tim Burton and these three guys from out of town," said Parys. While in town, Burton stayed at the William Penn Hotel. "Basically, they came in and scouted like maniacs. We were taking helicopter rides over farms. There would've been massive amounts of filming downtown where there was going to be a massive fight scene. It was by far the biggest film that would've ever come here," continued Parys. "I loved it! I made a big chunk of money! The studio lost a lot of money though." Soundstages were reserved for the production, and part of Krypton was even created. Cage even tried on the Superman suit. Filming was set to begin in 1998. Unfortunately, the project fell apart as start dates kept getting pushed back and the script was never officially finalized. Financial issues arose, with the budget estimated at $190 million. Dan Gilroy was hired to write a more economically feasible script for an estimated budget of $100 million. Burton also exited the production to make *Sleepy Hollow* and was unhappy with producer Peters.

Director, writer and actor Kevin Smith made his $10 million film *Dogma* in Pittsburgh. He cast Ben Affleck, Matt Damon, George Carlin, Salma Hayek, Alan Rickman, Chris Rock, Alanis Morissette and Janeane Garofalo to star. Not only did Pittsburgh crew members find work, but local actors such as Betty Aberlin were also cast. Casting agent Nancy Mosser was also given a role as Governor Dalton. Several locations were chosen in the area. The production began shooting in Pittsburgh on March 27. Many of the cast members were in town rehearsing two weeks prior. Smith, Damon and Affleck even attended a late-night screening of *U.S. Marshals* on March 16, 1998, at the Showcase North, a local movie theater. Smith was very accommodating to fans and media, but the set was closed, a decision made by Miramax and the producers. Mosser was in charge of extras casting. Smith, producer Scott Mosier and actor Jason Lee all made an appearance at Point Park College on April 1, 1998, for an independent film showcase. Smith also attended the Pittsburgh Comicon on Sunday, April 26, at the Monroeville Expo Mart. One of the few filming locations that got publicity was the former Burger King on Banksville Road. It was turned into a "Mooby's." Steve Parys said:

The electrical crew for *Dogma*. *Courtesy of Steve Parys.*

I started off in the locations department. It was nice and friendly. Everyone was approachable, from the actors to director Kevin Smith. It was a fun shoot. Every day, there was just something crazy going on. I actually had a cameo that was cut, but they gave me the footage. Matt Damon was a down-to-earth nice guy. He loved Pittsburgh...I got a gun pulled on me when I tried to shut down a basketball game. They were way in the distance, but you could see kids playing basketball. We just covered it with smoke.

Kevin Smith wrapped on June 4, 1998.

The Temptations was directed by Allan Arkush, and he cast Charles Malik Whitfield, D.B. Woodside, Terron Brooks, Christian Payton and Chaz Lamar Shepherd. Otis Williams was brought on to the production, having a behind-the-scenes role. Nearly two months before the shoot, NBC confirmed that Pittsburgh had been chosen as its location. Suzanna De Passe, the executive producer on the Jackson family miniseries, served as executive producer on this movie as well. It was speculated that the positive experience with the Jackson family movie was the deciding factor to bring

this production to Pittsburgh. The estimated $8 million production began principal photography on July 21, 1998. Portions of Penn Avenue in Garfield were used, as well as Friendship Elementary School, houses along Roup and South Fairmount Avenues and South Graham Street in Friendship. Many Penn Avenue buildings, including the Eastern Hairlines barbershop, were given a 1950s makeover. NBC was slapped with a lawsuit by the family of the late singer David Ruffin. They claimed that they never gave NBC clearance to do the project on their deceased relative. Principal photography ended in late September, and *The Temptations* aired on November 1, 1998, on NBC. It was nominated for several awards and also won a few, including an Emmy for the directorial vision of Allan Arkush. NBC also won the lawsuit in federal court and an appeal that was made a few years later.

The filmmakers of *Inspector Gadget* came to Pittsburgh in the spring of 1998 to scout locations. Director David Kellogg cast Matthew Broderick as Inspector Gadget. Kellogg brought his $90 million film to Pittsburgh during the weekend of September 26, 1998, with most of it already completed in Los Angeles. The first week of shooting was nothing more than second-unit shots, causing minor traffic delays. Many PPG Place shots were second unit, and extras were used on September 26. Kellogg and Broderick arrived around October 1 and shot for the next three weeks. Locations included PPG Place, the South Side and the Sixth Street Bridge. They first filmed on the South Side, where Inspector Gadget lived. The scenes were shot on October 6, 8 and 9. The Sixth Street Bridge was closed for the first three weeks in October as the filmmakers shot the end of the movie. Nancy Mosser cast extras, but some were found by chance. The production was looking for a lime-green fire truck, and Fire Chief George Beerhalter of the Ingram Fire Department had one. His daughter answered the phone when the production called their home. After a $500 donation to the Ingram Fire Department, Beerhalter was on set with his truck. He was given more privileges than that of a typical extra and was allowed to roam the set with his family. They had lunch with the cast and crew and met Broderick, Joely Fisher and Rupert Everett. Broderick said the shoot was fun, and he had been in Pittsburgh a few years earlier when his wife, Sarah Jessica Parker, was making *Striking Distance*. Principal photography wrapped on October 18, 1998.

Director Curtis Hanson cast Michael Douglas, Tobey Maguire, Frances McDormand, Robert Downey Jr., Katie Holmes and Rip Torn for *Wonder Boys*. He scouted Pittsburgh in October 1998 and knew he had found his location. Principal photography began on February 2, 1999, and lasted for

about nine weeks on a budget of $55 million. Oakland, Shadyside, Sewickley, Beaver and downtown Pittsburgh were the primary locations. This was the first time Michael Douglas came to Pittsburgh, and he was pleasantly surprised with the city. Most of the cast and crew worked fourteen hours a day, six days a week. Bingo O'Malley was cast and said, "I met them all. They had a reading prior to shooting, and they all came into the city. They had a big set-up at the William Penn. They rented the ballroom and had a big buffet. We had a reading of the entire movie, which is very unusual, but nice. Frances McDormand is from Pittsburgh and was wonderful! Michael Douglas was very friendly, and he came around everybody."

One of the first locations used was Baker Hall at CMU. Nancy Mosser cast a group of Pitt students, and some of them made it onto the CMU set. John Chopin helped Mosser by offering extra credit to his Pitt students who tried out. Shooting occurred overnight in the brisk cold. Several takes were shot, and for the extras carrying heavy book bags over their shoulders, it was a difficult shoot. A more pleasant experience for extras was when the warm dinner tent arrived and they had the opportunity to meet Douglas, McGuire and Downey. Chopin and his wife also worked on the production when the filming took place at the Pittsburgh International Airport. "In one sequence, Robert Downey Jr. ran into her. She was delighted because she got to smash up against him multiple times. So she met him and Michael Douglas. She really loved Robert Downey Jr. He was keeping everybody entertained between takes, really friendly. He told her she had beautiful eyes. So he was really friendly with everyone on set." The production headed south to Rostraver Township, where it filmed at the Main Course Restaurant along Route 51. The Monaca Bridge in Beaver County was also used. "Tobey, Michael and Robert were all great guys. Robert's hilarious! He was a fun guy and really social. Tobey hung out with the crew a good bit," said Steve Parys. Principal photography wrapped on April 28, 1999.

Steve Parys wrote and directed *Reign of the Dead*, which was shot in July 1999. "That was a light work year. I wanted to do an independent film and shoot some footage to raise some money," said Parys. He recruited local talent such as Phil Nardozzi, David "Yoko" Jose, Chris Stavrakis and Robert Oppel to work on the production. Nancy Mosser was used for the casting. "Everyone came out and helped for free. I got the locations for free. The production house lent me a truck and their gear for free. It was insane how people turned out to help. That was really great," said Parys. Once completed, it only ended up being a short film with a runtime of seventeen minutes. It was subject to a limited release in March 2000.

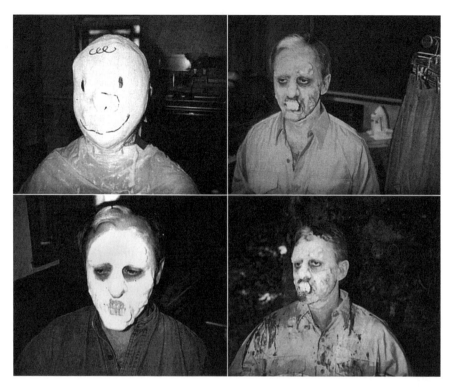

Phil Nardozzi being made into a zombie for *Reign of the Dead*. *Courtesy of Phil Nardozzi.*

Achilles' Love began principal photography in Pittsburgh. It had the working title *Achilles' Heel* but was changed before its release. Meredith Cole directed the independent film and cast Pittsburgh actors such as Alex Coleman. "It was a very fun project. I had a wonderful little role where I played this Greek tycoon. It was a pivotal little role. I had two days shooting on it," said Coleman. The film debuted at the Three Rivers Film Festival in November 1999.

Hughes Dalton directed *Shake 'Em Up*, which was shot in August 1999 with some additional scenes filmed between September 21 and September 24, 1999, according to local newspapers running ads for extras. Pittsburgh actor Tom Stoviak had the featured role, playing an alcoholic lounge singer. Locations included Polish Hill, Greenfield, the South Side, Homestead, Sharpsburg and West Mifflin. One infamous location was the Homestead Carnegie Library, where the bingo game was shot on a hot and muggy day in August. The air conditioner had to be turned off so no background noise interfered with the shoot. The production was operating on a very low budget,

and all shots had to be filmed within a few takes. "I was just sweating through the makeup; it was just ridiculous," said Stoviak. Behind the scenes, he stayed in character and entertained all the bingo players, who actually thought he was a real-life lounge singer. The lighthearted atmosphere off-camera soon changed. "There was trouble with the number-one cameraman, and the director had asked the producer to ask me to stop talking between the takes. I threatened to walk off the set. They were paying me $100 a day to do this, and it was just miserable. I'm sweating and everyone's uncomfortable...here I am, doing them a service by keeping the extras entertained. These people were only getting food; they weren't getting paid," said Stoviak. The movie was shown at the Three Rivers Film Festival in 2001 and went on to be showcased at many other film festivals around the country.

The estimated $300,000 *Reversal* held principal photography from the end of October 1999 to November 19, 1999. *Reversal* is a realistic take of a high school wrestling squad. The majority of the locations used were in Washington County. Oil City, the county airport, Washington Hospital, Washington High School and Washington Cemetery were all used, as well as the home of Ray Dunlevy. The movie was released on September 14, 2001.

LIGHTS! CAMERA! LIFE SUPPORT!

Pittsburgh's film community was struggling to find work. Many survived with odd jobs and traveling or struggled through unemployment. Revenue stopped coming into Pittsburgh. An internal blame game fueled the fire of hard times. Pittsburgh wasn't the only city suffering from the bargain that foreign countries had to offer. Even though America was on life support, the few productions sustained life for the film industry. Pittsburgh had a tradition of independent filmmaking that grew over the next several years.

Regardless of the difficult times, new and exciting additions were being made to the Pittsburgh film community. Along with the Douglas Education Center in Monessen, Tom Savini opened the Special Makeup Effects program. The program was housed in its own building, with rooms dedicated to molding, animation and makeup. For several years, Savini owned and operated a haunted house in Monessen called Terrormania. The haunted house was a place for his students to practice. The program evolved in many ways over the years. Savini served as the dean of the program while others actually taught the students, who came from all over the country.

Stephen Herek directed the first movie made in Pittsburgh during the twenty-first century, called *Rock Star*, and cast Mark Wahlberg, Jennifer Aniston and Timothy Olyphant to star. Even though California hosted much of the production, Pittsburgh was scouted for partial filming. One of the primary locations was Johnstown. With an estimated budget of $57 million, Herek began principal photography on March 6, 2000. Filming wrapped on June 7, 2000.

Pittsburgh returned to its horror roots with a low-budget zombie film called *Children of the Living Dead*. Pittsburgh casting included Tom Savini,

Tom Savini's haunted house in Monessen, circa 2002.

Marty Schiff, Tom Stoviak and John Yost. John Russo and Bill Hinzman also boarded the project. A few years earlier, Russo had updated the original *Night of the Living Dead* with additional scenes and made it colorized. *Children of the Living Dead* was meant to be a direct sequel to Russo's thirtieth anniversary edition. Half of the film was shot in Ohio and the other half in Pittsburgh. Principal photography began around July 7, 2000, and ran into the month of August with a budget of $500,000. The production utilized the help of the South Beaver Fire Department, the South Beaver Police Department, the Beaver Falls Police Department and the Pittsburgh Film Office. The production stayed at the North Fayette Residence Inn and the Green Tree Hampton Inn. The shoot was difficult for many involved. Director Tor Ramsey recalled being pressured by producers Karen Wolf and John Russo to use many of their friends as crew members rather than the people he had in mind. It was released on October 9, 2001, on video.

A group of Pittsburgh filmmakers got together to create an award-winning independent film called *The Bread, My Sweet*. It was directed by native Melissa Martin, and this was her directorial debut. The idea came to her when husband Larry Lagatutta became owner of Enrico's Biscotti bakery in the Strip District. "I saw this beautiful rooftop garden above the bakery. This person grew tomatoes and flowers which cascaded over the building in bright red olive oil containers," she said. The garden was maintained by a family living on the floor above the bakery, providing the

rest of the inspiration she needed. "I had never made a film, and I didn't know which end of the camera to look through," admitted Martin. She needed help in her endeavor, and Adrienne Wehr seemed to be her best bet. "I recognized in her an amazing work ethic—she is an empathetic, giving, control freak, maniac, and she had produced the Emmy Award–winning *Mister Rogers' Neighborhood* for many years. She thankfully agreed to join in as producer," she said. Wehr said, "Melissa and I have formed a partnership for the future—we're stronger together than we are individually—and we have lots more distance to travel with *The Bread*." Another major player in the production was executive producer Bill Hulley. According to Martin and Wehr, it wouldn't have been possible without him.

Martin began looking for the perfect cast, and her script found its way to Scott Baio through his agent, who told him he probably wouldn't want to do it. He was wrong. After Baio called Martin on the phone, he liked her. Martin also cast Kristin Minter, Rosemary Prinz, John Amplas, Bingo O'Malley and Zachary Mott. Martin shot *The Bread, My Sweet* in June 2000. Being from the East Coast, Baio loved Pittsburgh and bonded with a lot of the people. The

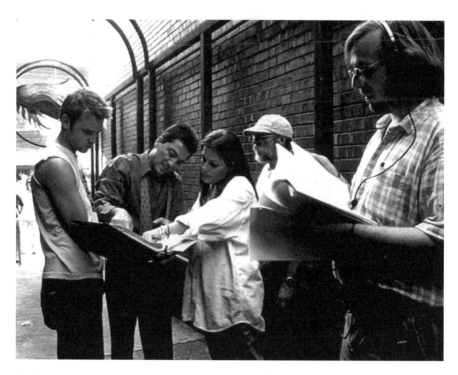

Melissa Martin directs Scott Baio on the set of *The Bread, My Sweet. Courtesy of Adrienne Wehr.*

movie was first shown on November 2, 2001, at the Three Rivers Film Festival. It went on to have several film festival releases and won several awards.

Karl Kozak co-wrote and directed the $1.5 million *Out of the Black*. He assembled an award-winning cast with Tyler Christopher, Sally Kirkland, Dee Wallace, Jack Conley, Jason Widener, Sally Struthers, Tom Atkins and John Capodice. Once the casting was completed, Kozak was off to Pittsburgh. "I contacted the Pittsburgh Film Office, and they were very helpful…I was very impressed," said Kozak. "Pittsburgh had it all—WRS Film Lab, Haddad's production trailers and seasoned crews. Pittsburgh was a fantastic location. I'm glad we were there." The production moved to Pittsburgh to begin the official preproduction process. "I wanted economical, fully furnished suites. We got a great rate and put everyone up [at an Extended Stay America]. The hotel employees felt like family…One thing nice about filming in small towns is that the people are very open to it. It's a fun experience, and the whole town gets behind you," said Kozak. He only brought the director of photography, production designer, line producer and unit production manager to town; the rest of the crew was composed of Pittsburgh talent.

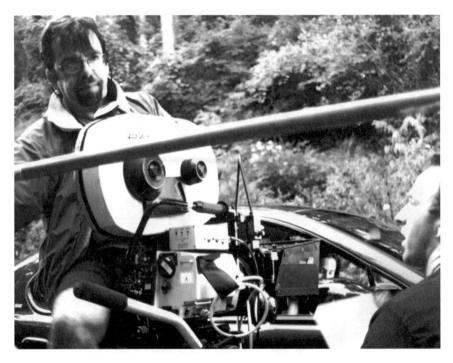

Maximo Munzi, Jacqueline Pinol and Greg Magidow on the set of *Out of the Black. Courtesy of Steve Parys.*

Lights! Camera! Life Support!

Principal photography began the week of August 14, 2000, and ran until the end of September. One of the featured locations was at the Tour-Ed Mine & Museum in Tarentum. "The Pittsburgh locations really added another layer to the movie. Filming in California wouldn't have looked the same at all," said Kozak. During the shoot, the Natrona Heights medical rescue team loaned the production its emergency vehicles. The members of the medical rescue team also helped the production close down the streets for shots that were needed. "It was a great crew. I loved working with our director. It was just a good shoot, and I enjoyed it a lot," said Wallace. During the city's Labor Day parade, many local nurses protested for increased staffing at Allegheny General Hospital, and Wallace protested the advertising industry. She claimed the advertising industry was robbing actors of their livelihood by breaking up an eighty-thousand-member union. She particularly loved Pittsburgh because it reminded her of her own hometown of Kansas City. *Out of the Black* had a very successful run at film festivals and won several awards.

Mark Pellington was flying over Point Pleasant, West Virginia, scouting for his next project. In September 2000, he knew he was going to direct *The Mothman Prophecies* and knew Richard Gere was going to star in it. He also knew it was going to be a battle between art and commerce and was hoping to create his vision rather than what those above him wanted. Preproduction fluctuated between Pittsburgh and Los Angeles over the next few months for location scouting. Producer Tom Rosenberg mentioned Pittsburgh having a wonderful reputation in Hollywood and credited the film office for being very helpful. Their search brought them to Kittanning, Pennsylvania. They got more than they bargained for, as the entire town—not just the bridge, as hoped for—substituted as Point Pleasant. In November 2000, Pellington shot part of the film in the basement of the production office, testing lighting effects. Casting brought Laura Linney, Debra Messing and Will Patton to the production. On December 18, 2000, the Powell family got a knock on their door from a location scout who said their house was perfect. Location scouting continued into January 2001. Gere and Linney also arrived in Pittsburgh that January to begin rehearsals. Just as the production was gearing up to shoot, $2 million was erased from the budget, infuriating the director, who was now working with $32 million.

Principal photography began on January 24, 2001, when the interior hospital scenes were shot at the cafeteria. Gere was late the first day, but Pellington wasn't upset and even greeted him when he arrived. They walked in together and were welcomed by anxious women. Gere didn't

sign autographs but did take some pictures, making up for lost time. The second day of filming occurred at the house Gere and Messing's characters were looking to buy. Most of the shots taken didn't make the final cut. The production then revisited the hospital, where some exterior shots were taken. Only a few shots from that day were used. The production headed to the Powell residence in Fallowfield Township for the next few days. Tents and equipment covered the lawn along Route 917. The family was set up at the Best Western hotel in Bentleyville. They were able to return home during the day, as shooting occurred between 7:00 p.m. and 7:00 a.m. Ringgold High School was down the road from the house, and the district lent its parking lot as the production's base. The high school parking lot was also used as a miniature set as the crew built a forty- by forty-foot temporary bathroom. "Nobody concentrated at all during the time he [Gere] was there. Even the teachers were trying to get outside to meet him," remembered Stephanie Smith, a senior that year at Ringgold High School who got to shake Gere's hand. Todd Balogh was another student at Ringgold and saw Gere once or twice. He also remembered the students couldn't park at the school because of the trailers. Jennifer Cattaneo tried to get an interview with Gere for the school paper but was unable to do so. "We used to drive out to the house though. There were cops everywhere," she said. On February 11, Pellington pushed executive producer Richard Wright while trying to get a shot. Before this incident, Pellington had expressed time and again how he felt pushed around by the producers. This incident didn't affect the shoot or their friendship.

Filming occurred at the Avalon Motel along Interstate 70 between Bentleyville and Washington, Pennsylvania, on Valentine's Day. The production then headed to Pittsburgh to shoot for several days. The *Pittsburgh Post-Gazette* was part of the news, as its office was used to double that of the *Washington Post*. Because of the limited space, no one other than the newsroom staff and filmmakers was allowed to be there. Reporters, editors and page designers relocated for a short time. Some were even used as extras. The Lafayette Park scene was then shot in Oakland. Pittsburgh streets substituted for the streets of Chicago. Pellington shot Alan Bates' scene next. On February 28, the production moved to Kittanning, Pennsylvania, to film the police station, town square and bridge. The Kittanning Citizens Bridge was closed to motorists during the shoot. They headed back to Pittsburgh to complete set filming, as well as the tank work. The last few days of the stage shooting were of Richard Gere in his motel room. The underwater scenes were shot at Settlers Cabin Park outside Pittsburgh, where principal

photography wrapped. The crew drank champagne in celebration of their work. A wrap party was held on April 21, 2001, at the Big House Studios on the South Side. Nick Tallo said, "Richard Gere was nice. If he wanted to talk to you, he'd sit down and just talk to you. But you just didn't walk up to him and strike up a conversation unless he wanted to have a conversation. He had somebody with him all the time that kept everybody away." Kevin Roche said, "Gere's about the coolest you'd ever want to meet."

David Hollander, a native of Mount Lebanon, served as executive producer and writer for a television pilot called *The Guardian*. Simon Baker starred alongside veteran actor Dabney Coleman. The majority of the pilot episode was filmed in Toronto, Canada. However, many second-unit shots were taken in Pittsburgh on April 3, 2001. CBS decided to pick up *The Guardian* for a season, and it ended up lasting three. Over the next two years, *The Guardian* filmed during the week of June 17, 2002, the week of October 7, 2002, and the week of August 18, 2003. The second-unit crew also shot in Shadyside, Allegheny General Hospital, Mercy Hospital and the Strip District, as well as the building at the corner of Seventh Street and Fort Duquesne. That building is used as the exterior of the Legal Services building in the show. On October 7, 2002, some of the cast came to Pittsburgh. Mayor Tom Murphy handed Hollander the key to the city as the production crew and locals watched. Baker was handed a microphone and was asked to say a few words to fans during the event. He talked about how he had brought his daughter Stella to Pittsburgh and that he planned on catching a Penguins game. He also told everyone that his daughter thought it was funny how her dad receives all kinds of attention. Despite the miniscule shoot, fans from around the country flocked to Pittsburgh when the shoot was taking place. Some enjoyed the breathtaking beauty of Pittsburgh, while others enjoyed the filming.

John Russo and Bill Hinzman re-teamed once again to make *Saloonatics* in the summer of 2001. Russo recruited the legendary professional wrestler Bruno Sammartino for a role. Hinzman's daughter Heidi was also cast for *Saloonatics*. It is the story of a group of people in a small town who get mixed up with a gangster. It was released on home video in 2002.

Why We Had to Kill Bitch was directed by John-Paul Nickel for only $15,000. He used the local film community for casting. "We shot at the Penn Avenue Theater, the Oaks Theater in Oakmont and in the streets of Bloomfield. I can remember there was a chase scene and we were running across the street and my partner in crime was running with a plastic snowman underneath his arm. He had stolen it from a bar in the scene," said John Yost. Principal

photography took place in June 2002 for a thirteen-day shoot. It was set to have its premiere at the AMC Loews Theater in Homestead, Pennsylvania, on June 10, 2003. Over one thousand people came to see the film, making it the largest local premiere at the time.

Biophage was another Pittsburgh independent film originally titled *Hemophage*. It was written and directed by Mark Rapp, with Steven F. Clark co-writing. Rapp explained:

> *I was in film school here in Pittsburgh and realized that the best way to learn about making a film was by making a film. I was far beyond the classroom didactic and ready to put it all into practice. I began discussing and writing with a classmate and chose the zombie subgenre because it seemed relatively inexpensive. We would be able to use a lot of local talent from the Tom Savini School of Makeup to be extras and make one another up…I had been saving money from working overtime, banking tax returns and general scrounging. I had even volunteered for a study group where you stay over a weekend, take a medication and give blood every few hours so they can measure the absorption levels. While there, I polished the script. Once I had reached the $10,000 mark, we went into production.*

He networked well in Pittsburgh and knew many local actors, which helped when it came time for auditions. "I used a few non-actors, too—this was not a union shoot—and I felt that some of them came off as well as the trained actors," he said. Among those chosen were local actors Kristin Pfeifer and John Yost. Principal photography began on July 2, 2002, and lasted until July 15, 2002. Pickup shots were taken during the following weeks. Bud Adams remembered, "We were in the middle of editing it when *28 Days Later* came out. It's very, very interesting how it's identical." *Biophage* wasn't released until January 2010.

The West Wing was one of the most popular shows on television in 2002. The fourth season was given the royal treatment, as the season premiere was a two-hour-long episode. Pittsburgh was one of the locations used for the premiere. Martin Sheen was in town from August 20, 2002, to August 27 shooting part of the season premiere episode called "20 Hours in America." Local actor John Yost had an uncredited role as a Secret Service agent. It aired on September 25, 2002, on NBC.

Hunter F. Roberts, a filmmaker with Pittsburgh roots, was in Los Angeles and came up with an idea for a film based on the ghost stories of the Pittsburgh Playhouse. He received help back in Pittsburgh from his friends,

colleagues and the film office in setting up the production. With a budget of $25,000, most of which was paid toward traveling expenses, he began principal photography. Most of the cast comprised people he knew, but some additional casting was necessary. Local actors such as John Yost were cast. The shoot began in September 2002 and lasted until the first few days of October with fourteen straight days of filming. It was rigorous for the cast and crew as they worked twenty hours a day. A few additional shots were filmed in California when Roberts returned. The movie was released in 2004, when it debuted at the AMC Loews Theater in Homestead, Pennsylvania. *Playhouse* sold so many tickets that it was shown on two screens and was received well among the locals. *Playhouse* finally reached a few film festivals a year later, followed by a video distribution deal. "The reviews at first were great. In fact, we really only got one bad review, and that was in Fangoria... It is quite possibly the worst review I've read about anything," remembered Roberts. *Playhouse* earned a cult following and tons of fan mail. Looking back on the film, Roberts said, "I did everything on that film. I did the catering on that film...You can't help but be proud of something like that."

Immediately after, the local filmmakers at Happy Cloud Pictures were back to work on another production called *WereGrrl*. Unlike the last outing, they were hard at work on a short film production about a girl who is cursed by a gypsy and becomes a lesbian during the full moon. This short was released a few years later as a special feature on the *Severe Injuries* DVD.

Fox Searchlight Pictures and director Pieter Jan Brugge put a script called *The Clearing* into production. Robert Redford was cast to play CEO Wayne Hayes, and Willem Dafoe was cast to play kidnapper Arnold Mack. Helen Mirren was also cast to play the wife of Redford's character. Principal photography on *The Clearing* began on September 23, 2002, and lasted until the end of November. Pittsburgh was chosen as one of the film's locations and was the final stop for the production that had already filmed in Georgia and North Carolina. The Pittsburgh shoot occurred the week of November 17, 2002, and Redford didn't come to town. However, Dafoe and Mirren did arrive with the rest of the production that Sunday. Nancy Mosser was hired to take care of casting extras, looking for elegant people to be luxury hotel guests, as well as police or military people to be FBI agents. The guests were the first to film that Monday at the William Penn Hotel. They got ready early in the morning in the basement of the hotel and soon worked with Helen Mirren for a ten-hour day. "Helen Mirren, she was incredible," said Nick Tallo. "We were shooting at this subway station upstairs on the street level, and these two guys in this souped-up car with fancy wheels drove by real slow,

and they sort of stopped because they were checking out what was going on, and Helen Mirren walks over to their car and says, 'That's a really nice car, man!' And they were like, 'Oh, thanks!' They had no idea who she was." John Yost was cast as the head of the FBI agents. Even though he had no scene with Willem Dafoe, Yost got to meet him. "I walk into the elevator and Dafoe's in there. I really like Willem Dafoe and just turn around to him and I said, 'Mr. Dafoe, I respect your work sir, thank you.' Well that big, old craggy face just smiles and he shook my hand and asked how I am and what I'm doing, what I was about. Even after the elevator ride, we got out and we were standing in the hallway talking for a few minutes. It meant the world to me," said Yost. Tallo also had a great encounter with Dafoe as he said, "Willem Dafoe, he's great...He and I are standing around in this supermarket and I said, 'Hey, I just saw a movie of yours,' and he said, 'Oh really, which one?' And I said, '*The Loveless*,' and his face just dropped...It blew his mind."

Concerns grew about funding a film office when no productions were coming to the region. The incentives that Canada and other countries offered seemed to make the competition too great. It also seemed that history repeated itself in that Pittsburgh's film industry had died like the steel industry, but this was not the case. In 2003, the Steeltown Entertainment Project was created by Carl Kurlander, Ellen Weiss Kander and Maxine Lapiduss. They not only made a name for themselves through their own film work but also had many respected ties in the film industry. Their mission was to promote and sustain a film industry in the Pittsburgh region. This was accomplished through establishing working relationships with local resources such as the Pittsburgh Film Office, building relationships with local professionals, nurturing emerging talent and educating the workforce. Since its inception, the organization has been partly responsible for the establishment of the Pennsylvania Film Tax Credit, as well as many other filmmaking incentives.

Besides the miniscule shooting of *The Guardian* in 2003, Happy Cloud Pictures was working on a second feature film called *Severe Injuries*. Mike Watt wrote the screenplay about a terrible serial killer who has his sights on killing sorority sisters. Amy Lynn Best was accustomed to being in front of the camera, but for *Severe Injuries*, she made her directorial debut. She also starred along with Robyn Griggs, Bill Homan and Francis Veltri, with special appearances by Jasi Cotton Lanier and Debbie Rochon. Principal photography took place in the spring of 2003. *Severe Injuries* was screened in select film festivals and received a DVD release. Over the next several years, Happy Cloud Pictures kept making independent films such as *Spatter Movie:*

The Director's Cut, which was shot at the Hundred Acres Manor haunted attraction in South Park; *The Night We Didn't Discuss Myra Breckenridge*, shot at the Scarehouse haunted attraction in Etna; *A Feast of Flesh*; *Demon Divas and the Lanes of Damnation*; and *Razor Days*.

In January 2004, Matt Green was working at Savini's program in Monessen when he started preproduction on a small film called *Loaded Dice*, a movie he wrote and directed. "I'm a big fan of effects, but directing is my first love," said Green. Casting was completed in April 2004 and brought in local talent such as Tom Savini, Sam Nicotero, Mark Tierno and Amy Lynn Best. Auditions were mainly held in Monessen, but advertising was done all over Pittsburgh. Being cast meant the world to Chris Paglia, as this was his acting debut. He received the job by responding to an ad for acting extras in the local paper, but Green saw more potential and gave him a role. Some casting choices brought hidden talents with them. Dean Blair, a Charleroi native, was cast as Benny and also served as the gun expert. Green recruited many students at Savini's school to help and went beyond local recruitment by acquiring a local band, Fynal Tyme, to do some of the music. Location scouting took the production all around southwestern Pennsylvania to places such as Naomi, Brownsville, Arnold City, Belle Vernon and Monessen.

Principal photography began on May 27, 2004, for a ten-week shoot. Green used the Avalon Motel along Interstate 70, a junkyard in Brownsville and Sonny's Restaurant in Arnold City. The various locations in Monessen included Savini's school, Savini's haunted house and the Italian Club. Alleys, streets and the Monessen parking garage served as other small locations. "This town has a great look," said Green. He also praised the city's cooperation as he said, "They bent over backward for us. The chief of police pretty much told me 'whatever you want.'" Many streets were blocked off for the production, something Green greatly appreciated. Theatrically, the movie was seen at the Loews Theater in Homestead, Pennsylvania, on October 19, 2004, and released on video on May 9, 2007.

With a seemingly dead film industry, the summer of 2004 proved to be one of cataclysmic change for Pittsburgh. Those at PBS television decided to make a documentary about a young George Washington who is a military officer in his twenties and accidentally triggers the French and Indian War while trying to earn a reputation. Graham Greene, who was nominated for an Academy Award for *Dances with Wolves*, narrated the documentary. Larry Nehring was cast to play the young George Washington. PBS television began production on the four-episode miniseries in the spring of 2004 and began principal photography in June. The production operated with an

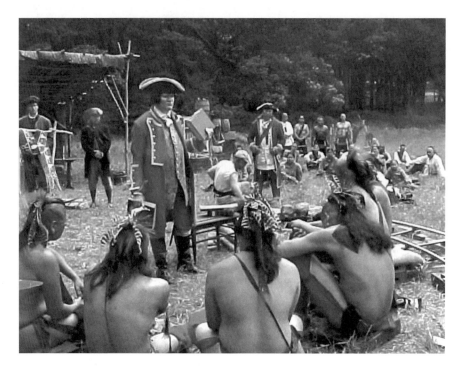

Set photo from *The War That Made America. Courtesy of Jeff Monahan.*

estimated budget of $14 million as it used locations all around southwestern Pennsylvania. During the production, Pennsylvania governor Ed Rendell signed the Pennsylvania Film Production Tax Credit into law in July 2004. Under this new law, a 20 percent tax break would be given to productions that make 60 percent of their movie in Pennsylvania. It was welcome news to the members of Pittsburgh's film community. Principal photography wrapped on *The War That Made America* in August 2004.

10th & Wolf shot in Pittsburgh with an estimated budget of $8 million. James Marsden, Tommy Lee, Dennis Hopper and Brian Dennehy were all cast. Principal photography began around Pittsburgh on September 7, 2004, and lasted until October 22, 2004. Filming occurred in various spots around the city at places such as the Bloom Cigar Company and Tom's Diner in the South Side. The Hartwood Mansion in the Hartwood Acres Park was also used. Pittsburgher Patty Bell was hired to do makeup on the production and said, "I got to work with legendary actor Dennis Hopper and rock star Tommy Lee. Needless to say, the girls all loved Tommy, but he was a real pro to work with and nice to everyone on the crew."

In the fall of 2004, Hugues Dalton and Jeff Garton wrote and directed a short called *Lift*, starring Dominique Pinon. "Dominique was a true gentleman. I have a great picture of him. He's a very, very nice guy with a dry sense of humor and a real trooper," revealed John Yost, who was joined by Pittsburgh actors such as Sam Nicotero, Mark Tierno and Adrienne Wehr. "*Lift* is one of my favorite projects of all time," said Norman Beck. Pittsburgh crew members such as Steve Parys, David "Yoko" Jose, Nick Tallo and David H. "Wino" Weinstein also worked on the production, which lasted a little over two weeks. Eva Kamienska-Carter served as the production designer and art director as she designed the unique elevator the filmmakers needed. "Eva got me involved because they needed these magical things to happen in it, and there I was with my reputation for making strange things happen. The way the elevator operates, it has these little flipping panels where he keeps his toiletries. He has a bed, and one wall folds down where he sleeps and they needed the elevator doors to operate. The whole thing was a set… They built the elevator in a studio at filmmakers," explained Beck. Pittsburgh Filmmakers was one of the primary locations used, as well as the Grant Building and a rubber band factory on Craig Street in Oakland. *Lift* went on to win the Best Narrative Short award at the Fargo Film Festival and the Crystal Heart award at the Heartland Film Festival.

Despite the new film tax credit, no major productions headed to the city in 2005. However, several independent films shot back to back. The first independent film was called *Dumpster*, directed by John Rice. Originally, Tony Buba was set to direct, but he had other commitments. The film had an estimated budget of $10,000 and debuted at the Three Rivers Film Festival in November 2005. *Graduation* was the next low-budget film. In July 2005, extras were being cast by Nancy Mosser. Adam Arkin and Huey Lewis were cast, as well as veteran Pittsburgh actor Tommy Lafitte. Shooting began on August 3, 2005, and lasted until the middle of September at Pittsburgh-area locations such as Mount Lebanon and Beaver Falls. *Pain Within* shot from September 19, 2005, until October 19 with an estimated budget of $200,000. The primary filming location was the Hartwood Mansion. A few days after *Pain Within* began principal photography, *Strange Girls* began to shoot on September 22, 2005, and lasted until April 2, 2006, with an estimated budget of $125,000. It was directed by Rona Mark. This was her first feature-length film after a twenty-year absence. She recruited Pittsburgh talent such as Adrienne Wehr, Steve Parys, David "Wino" Weinstein and David "Yoko" Jose. Out of all the independent films, *Chasing 3,000* had the largest budget, set at an estimated $10 million. However, the production only

came for a few days in October 2005. One of the featured days of filming was on October 8, 2005, at PNC Park. Many extras were needed to show up at PNC Park that Saturday from 8:00 a.m. to 6:00 p.m.

G. Cameron Romero, the son of George Romero, began work on the estimated $100,000 *The Screening*. The primary location was the Loews North Versailles movie theater. Principal photography began on November 21, 2005, and lasted until December 18, 2005. With the exception of the use of local woods and a barn, it was shot at the theater. Romero's relationship with the other filmmakers involved led to the formation of Batpack Studios, which officially opened in January 2007, located in Cranberry. The studio was a subsidiary of Communifax, a viral and direct marketing firm owned by Jeff and Bill Battin, who were investors in G. Cameron Romero's film. Batpack worked with local companies for commercials, as the studio possessed state-of-the-art equipment for productions to use.

Dr. Ravi Godse, a local Pittsburgh doctor, got the filmmaking bug and decided to attend Pittsburgh Filmmakers. In December 2005, he began principal photography on his first film, called *Dr. Ravi and Mr. Hyde*, a comedy about a midlife crisis. The independent film also featured Pittsburgh legend Myron Cope. Part of it was even shot in Africa. One of the most impressive features of the production was that it only took a total of six days to shoot. It was released to much critical praise and set Dr. Ravi up to make two more films.

CHAPTER 17
PERSEVERANCE

Pittsburgh began to persevere against a ten-year drought because of the new film tax legislation. Pittsburgh was poised to be competitive again. The city rose to new heights, and members of Pittsburgh's film community found themselves with jobs. The local economy greatly benefited from the millions of dollars that were spent. It was announced that Simon Baker was going to star in a new television series pilot called *Smith*. He was joined by Ray Liotta and Virginia Madsen, with Christopher Chulack set to direct. Not only was the story for the pilot set in Pittsburgh, but part of the filming also took place there in March 2006. Many downtown streets were used, as well as PNC Park, Mellon Institute, Station Square and David L. Lawrence Convention Center. The Smithfield United Church was used as a base of operations for the production. *Smith* debuted on CBS on September 19, 2006, and received many positive reviews. However, it was cancelled after three episodes.

Rawson Marshall Thurber directed *The Mysteries of Pittsburgh*, a film based on a 1988 bestselling novel by Michael Chabon. There was an earlier attempt at a film adaption around 2000, when filmmaker Jon Sherman wrote a screenplay, but the project fell apart. Thurber cast Jon Foster, Sienna Miller, Peter Sarsgaard, Mena Suvari and Nick Nolte. Once Pittsburgh was decided as the location, the production was in need of local actors. Tommy Lafitte, Tony Amen, Mark Tierno and William Kania were all cast. Principal photography began on September 5, 2006, and ended on October 17. While making the movie, Miller referred to Pittsburgh with a derogatory word in *Rolling Stone* magazine. Local papers were quick to fire back at the actress, who quickly apologized for the remarks, claiming that they were taken out of context and that she was referring to the nighttime shooting

Pittsburgh actor William Kania.

schedule of the production. She also said that what she had seen of the city was beautiful. Once completed, *The Mysteries of Pittsburgh* debuted at the Sundance Film Festival in January 2008. When the film was given a small domestic release, it only grossed an estimated $80,000.

Terrence McClusky wrote and directed the Pittsburgh production *I Remember Chloe*. He was joined in the director's chair by local Steve Parys. Nancy Mosser and Katie Shenot cast the estimated $200,000 production, while many local crew members such as David "Wino" Weinstein and David "Yoko" Jose lent their talents to the project. Principal photography began around October 2006, and the movie was released on June 21, 2007.

R.L. Stine had become popular years earlier with his *Goosebumps* series of children's horror literature. Another previous work of Stine's was an anthology called *The Haunting Hour*, which was converted into a direct-to-video film in 2006. Director Alex Zamm cast Emily Osment, Cody Linley, Brittany Elizabeth Curran and Tobin Bell. Pittsburgh talent such as Marty Schiff and Tony Amen were also cast. Katelyn Pippy, the daughter of Pennsylvania state senator John Pippy, also received a minor role. Pippy, a native of Moon Township, was cast for the role of Erin. The film shot between October and November 2006. Locations included Carnegie and Cranberry Township. The $3 million kids' film was released on September 4, 2007. Papa John's Pizza co-promoted the release with a DVD coupon placement on its pizza boxes. The pizza franchise was featured throughout the film, and many critics wrote many negative reviews due to the overused product placement.

The final production of 2006 was director Noam Murro's *Smart People*. Murro cast Dennis Quaid, Sarah Jessica Parker, Thomas Haden Church

and Ellen Page. Originally, Rachel Weisz was cast. She decided to leave the project and was then replaced by Sarah Jessica Parker. Local William Kania was also given an uncredited role as a man at luggage pickup. CMU was used as one of the primary locations, as well as the Pittsburgh International Airport. *Smart People* began filming on October 6, 2006, and lasted until December for a twenty-nine-day shoot. Additional scenes were shot at the Allegheny General Hospital, South Graham Street and the University of Pittsburgh. It premiered at the Sundance Film Festival on January 20, 2008, and was released domestically on April 11, 2008.

A few months passed until *The Bridge to Nowhere* was directed by Blair Underwood with an estimated budget of $4 million. This was his first time back since graduating from CMU. Before principal photography began, it was estimated that about one hundred jobs were created from this production. Nancy Mosser was used to cast the extras, and Dawn Keezer had a helping hand in making Underwood's production run smoothly. Many involved with the production were Pittsburgh natives. Pittsburgh talent such as Daniel London, Tony Amen and William Kania were cast. *The Bridge to Nowhere* began shooting on March 26, 2007, and lasted until the end of April for a four-week shoot. It shot in places such as West Mifflin. Pittsburgh crew members included Patty Bell, David "Yoko" Jose and Steve Parys. "One of my favorite films to work on was *The Bridge to Nowhere*. We had such a great time with the cast and crew. Having director Blair Underwood as your boss every day was a real bonus. He is such a kind, charming man. Thomas Ian Nicholas had his guitar. He and Ben Crowley used to serenade us in the trailer while wild woman Bijou Phillips danced around! Ving Rhames played a drug lord in the movie, and his performance was incredible and so believable," said Bell.

One of the most ambitious productions to come to Pittsburgh was *The Kill Point*, a miniseries made for the Spike TV network. Two directors served on the production during its short tenure. Steve Shill directed eight episodes, and Josh Trank directed the other five. Donnie Wahlberg, John Leguizamo and Tobin Bell were all cast. Originally, the script called for the bank to be located in Manhattan, but the idea was scrapped. Bingo O'Malley was cast and was part of seven episodes. Nancy Mosser recruited over three thousand extras. Filming began on March 28, 2007, on a constructed set in Lawrenceville. The shoot took place in and around the city. Various streets were closed down for the production that May. PPG Place and Market Square were the focal points of filming. Principal photography wrapped on June 29, 2007, and the show debuted on July 22, 2007.

I Am Schizophrenic and So Am I was Dr. Ravi Godse's second production. He decided to dabble in a new genre of film, the murder/mystery. Filming took place in May 2007 for only seven days. Pittsburgh served as the primary location, with a few scenes shot in Poland. The film's release brought enough critical success to convince Dr. Ravi to continue making films.

Filmmaker Thomas Dixon wrote and directed Pittsburgh's next movie, *The Korean*, starring Josiah D. Lee. Dixon's production consisted of a local crew, and auditions brought in Pittsburgh actors such as David Early and John Yost. One of the more notable casting choices was that of veteran Pittsburgh extra Rik Billock. Dixon saw Billock's work and wrote a part for him in *The Korean*. "I went down to Sewickley and read for the part, and the next thing that I know we filmed this thing in like fifteen days for $15,000," said Billock after receiving a call from Dixon. Principal photography took place in August 2007 at various locations such as Ambridge, Sewickley and Oakmont. *The Korean* became critically acclaimed, as it won and was nominated for several awards at various film festivals. "The next thing I know, we have an offer from Universal and Paramount for $14 or $15 million, and I talked to the director and he said it wasn't enough...I said dude, this is Paramount and Universal for $14 or $15 million, if we can do this for $15,000 then let's do a zombie movie or a quick horror movie and make a ton of money, and I don't know what happened," said Billock. It received a limited release in February 2010.

The estimated $75,000 crime drama *Trapped* was written and directed by Ron Hankison and Gavin Rapp. They cast legendary Pittsburgh actor Tom Atkins to star along with Corbin Bernsen. They began shooting on September 8, 2007, and wrapped principal photography on November 5, 2007. The film's premiere was held on three screens on August 17, 2008, and grossed $50,000. It appeared at the New York International Independent Film and Video Festival on October 25, 2009, and won the genre award there. It was successfully released on DVD on September 7, 2010, where it grossed another $100,000. Next, G. Cameron Romero and Batpack studios produced *Staunton Hill*. With less than a $1 million budget, they shot in Fombell, Harmony, Beaver County and Butler County. The shoot took place in October 2007, and it was released to video on October 6, 2009.

Pittsburgh turned into *Adventureland* during the fall of 2007, and director Greg Mottola made this possible with an estimated budget of about $8 million. He originally wanted to shoot in Farmingdale, New York, at the real Adventureland, where he worked years earlier. The park had been remodeled since he was last there, and he decided not to shoot there.

Kennywood Park seemed to grab his attention. With the park available, he decided to film in Pittsburgh and the surrounding communities. He cast Jesse Eisenberg, Kristen Stewart, Kristen Wiig and Ryan Reynolds. Principal photography began on October 3, 2007, and lasted until November 16, 2007. Nancy Mosser and Katie Shenot were in charge of the extras casting. Many Pittsburgh crew members found themselves at Kennywood after its season ended a month earlier. Additional scenes were shot around places such as Beaver and Coraopolis. Before making a theatrical run, it was shown at the Sundance Film Festival on January 19, 2009, as well as several other film festivals around the world. *Adventureland* was released on April 3, 2009, and earned an estimated $17 million worldwide.

The final production of 2007 was the independent film *Homecoming*. The thriller was directed by Morgan J. Freeman. He cast Mischa Barton, Matt Long and Jessica Stroup. Filming began in late December and wrapped on January 18, 2008. *Homecoming* premiered in New York and Los Angeles on July 17, 2009. It received a wide variety of distribution and wasn't limited to a small theatrical release, with a television premiere on the Lifetime network and DVD release.

More than eight feature films were shot in Pittsburgh in 2008. Kevin Smith returned to make *Zack and Miri Make a Porno* with Seth Rogen and Elizabeth Banks. *Entertainment Weekly* reported that the Weinstein Company greenlit the production based on the title alone. When Smith wrote the roles, he originally had Seth Rogen in mind to play Zack and Rosario Dawson to play Miri. Dawson couldn't do it because she was already contractually obligated to star in *Eagle Eye*. Smith also wanted to film in Minnesota. Budgetary restrictions led him away from Minnesota and into Pittsburgh. He rewrote the script to take place in Monroeville, Pennsylvania, where most of it was shot. Tom Savini and David Early were part of the Pittsburgh cast. Pittsburgh's highly efficient crew members were also hired. Principal photography on the $24 million project began on January 16, 2008. Many location shots took place along Business Route 22 in Monroeville, such as the Monroeville Mall and coffee shop. Shots around Mellon Arena were also used. Smith finished shooting on March 11, 2008. The movie was released domestically on October 31, 2008. Much of the advertising was censored or banned in the United States. Even though it didn't do as well as everyone had originally thought, *Zack and Miri Make a Porno* became Smith's highest-grossing movie as of 2009.

Next, director John Hillcoat brought *The Road* to Pittsburgh. It's a post-apocalyptic drama based on a novel by Cormac McCarthy. Pennsylvania

was chosen because of its tax breaks and various locations. Viggo Mortensen, Robert Duvall, Guy Pearce and Charlize Theron were cast. Principal photography began on February 27, 2008, with an estimated budget of $20 million. The production was in the city for the next eight weeks, using various locations such as the run-down parts of Pittsburgh. Braddock, Hanover Township, McKeesport, Harmony, Nemacolin and the Strip District were all used. Mortensen and Kodi Smit-McPhee attended a Pittsburgh Pirates game together and an exhibition at the Carnegie Science Center. Many involved with the production also visited family-owned restaurants, local attractions and behind-the-scenes tours of the Pittsburgh Zoo and PPG Aquarium. Filming wrapped on April 29, 2008, at the old Berkovitz warehouse in the Strip District. Mortensen and Hillcoat praised Pittsburgh for its crews, residents, tax incentives and film office. *The Road* was released at several film festivals. The domestic release date was pushed back three times until it was finally released on November 25, 2009. It became a critical success.

Jimmy Miller, a native of Castle Shannon, returned to Pittsburgh to produce *She's Out of My League*, a film directed by Jim Field Smith with an estimated budget of $20 million. Smith cast rising stars Jay Baruchel and Alice Eve. Principal photography began on March 27, 2008, at the Mellon Arena during a real Pittsburgh Penguins game, and Baruchel got to meet Sidney Crosby. A scene was also shot at the 2008 Wings Over Pittsburgh event at the U.S. Air Force Reserve Base in Moon Township. A set was constructed on an empty bandstand in Pittsburgh's Market Square for the date scene between Baruchel's character, Kirk, and Eve's character, Molly. Principal photography concluded at the end of May 2008, and the movie was released on March 12, 2010.

Julianne Moore was seeking *Shelter* with Swedish directors Måns Mårlind and Björn Stein. The co-directors operated on an estimated budget of $22 million, and they cast Jonathan Rhys Meyers to star alongside Moore. Mårlind and Stein chose Pittsburgh as their primary location. Principal photography began on March 31 and wrapped on May 13, 2008. It received theatrical releases in several European countries and is set to be released domestically.

Patrick Lussier directed the remake of the 1981 slasher film *My Bloody Valentine*, and Pittsburgh was the perfect location because of the state's tax incentives. The area's geography and architecture also led to the decision. The ambitious project was only made for an estimated $15 million. One of the key marketing gimmicks was that it was shot with Real D technology, making it the first R-rated movie to do so. Lussier cast Jensen Ackles, Jaime King, Kerr Smith and Kevin Tighe. Tom Atkins, Bingo O'Malley and

William Kania were also cast. Lussier began shooting the film on May 11, 2008, along Route 28 in Armstrong County at places such as Sprankle's Market in Kittanning, the exterior of the Logansport Mine in Bethel and the Ford City police station. Kittanning served as the fictional town of Harmony. The production used locations such as Valliant's Diner in Ross Township and a house in Oakmont. The Tour-Ed Mine in Tarentum was one of the locations that attracted the filmmakers to come to Pittsburgh. The production crew spent thirteen days at the mine. It was the perfect location, being that it hadn't been used since the 1960s and remained open as a museum. Principal photography ended on July 19, 2008. *My Bloody Valentine 3D* was released on January 16, 2009.

Hollywood and Wine was written and directed by Matt Berman and Kevin P. Farley. They cast many alumni from *Saturday Night Live* such as Norm MacDonald, Chris Kattan, David Spade and Horatio Sanz. It was also written by Jennifer and John Farley. As for the leading roles, they cast Nicky Whelan, Jeremy London, Pamela Anderson and Vivica A. Fox. When Pittsburgh was chosen as a location, many local actors such as Tom Stoviak, Phil Nardozzi and William Kania were cast. The estimated $5 million production began shooting on June 2, 2008, at the local Smithfield Studios and lasted until July. They also used the Island Studios located in McKees Rocks.

Frank E. Johnson directed *Shannon's Rainbow*, which was written by Pittsburgh natives Larry Richert and John Mowod. Julianne Michelle, Eric Roberts, Louis Gossett Jr., Daryl Hannah, Michael Madsen and Steve Guttenberg were cast. This was Hannah's first time in Pittsburgh. It was a battle getting the production to Pittsburgh, and the Pennsylvania tax credit was the determining factor. With Pittsburgh's abundance of rural country and suitable locations, they had many options. They also shot at the Pittsburgh International Airport, the Meadows racetrack and the Ohio Valley Hospital in Kennedy Township, Pennsylvania. Tom Atkins was immediately back to work, demonstrating his versatility as an actor by working two completely opposite genres back to back. William Kania usually had uncredited roles but was given a credit this time. Principal photography for the estimated $8.5 million project began on June 23, 2008. The Ohio Valley Hospital was the first stop. Part of the hospital's parking lot housed some of the production's trailers. Principal photography wrapped on July 27, 2008.

The $2.2 million *On the Inside* began principal photography on July 21, 2008, lasting for about four weeks. It was written and directed by D.W. Brown and starred Nick Stahl and Olivia Wilde. The former Prospect Middle School on Mount Washington was used as the primary location and

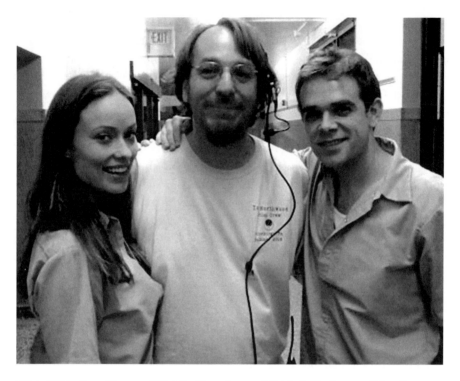

Olivia Wilde, Steve Parys and Nick Stahl on the set of *On the Inside*. *Courtesy of Steve Parys.*

was transformed into a hospital for the criminally insane. Pittsburgh casting included William Kania, and local crew members were hired.

At the 1996 Olympics in Atlanta, Georgia, Pittsburgh native Kurt Angle won a gold medal in heavyweight freestyle wrestling. He gained further popularity in professional wrestling organizations such as the WWE and TNA. He later made yet another leap as an actor. He starred in the Bruce Koehler film *End Game*, which also cast Pittsburgh performers such as Clayton Hill and Sharon Ceccatti. Jenna Morasca costarred with Angle in the crime drama. *End Game* began production on September 2, 2008, wrapping up in the middle of December that same year. The film had a lengthy shoot because many of the people involved had primary day jobs. Therefore, they shot when they could to work around schedules. Pittsburgh locations included the Lafayette Hotel in Sharpsburg and the home of Dave Czopek, a friend of Koehler. The filmmakers even took advantage of Pittsburgh's rivers. One of the final scenes shot took place at Cefalo's Restaurant and Lounge in Carnegie on December 11, 2008. *End Game* premiered on DVD a year later.

Carrie Fisher made her way to Pittsburgh for *Sorority Row*, the last major production of 2008. Directed by Stewart Hendler, the slasher film is a remake of the 1983 film *The House on Sorority Row*. Hendler cast Briana Evigan, Leah Pipes, Jamie Chung, Audrina Patridge, Julian Morris, Margo Harshman, Matt Lanter and Bruce Willis' daughter Rumer Willis. The filmmakers chose Pittsburgh because of the state's film tax credit and strong film crews. Principal photography for the estimated $12.5 million production began on October 6, 2008, and it shot at various locations. Many of the exterior scenes were shot during the month of October in order to take advantage of what warm weather was left. During the month of October, Nancy Mosser was looking for extras to play college students for a one-day night shoot on October 20. A block of about ten homes was used as sorority row in Homestead, Pennsylvania. On October 27, they shot the graduation scene at the Soldiers & Sailors Memorial Hall in Oakland, where nearly two hundred extras were used. *The Mercury Men* production also took place in 2008 for three weeks and was unlike any Pittsburgh production. The series premiered on the SyFy Channel website as webisodes. Christopher Preska, a Pittsburgh native who wrote and directed the series, cast local acting talent such as Mark Tierno to star.

The first production of 2009 was *New Terminal Hotel*, which primarily shot at the George Washington Hotel in Washington, Pennsylvania, from January to February. Months after principal photography, firefighters and police responded to a fire at the hotel and came across the gruesome set, thinking it was a real crime scene. The set had been left undisturbed in case the production needed to reshoot material. The CBS television pilot *Three Rivers* was shot next from March to April 2009. The Brownsville Tri-County Hospital was closed and served as the perfect location to shoot parts of the interior scenes. The David L. Lawrence Convention Center also contributed to certain interior shots. Several exterior shots were filmed around the city. Preliminary viewing of the pilot was less than favorable, and a new episode was filmed for the premiere. Despite the scrapped material, additional scenes were shot in Pittsburgh and were mainly exterior shots of the city. The October 4, 2009 premiere gave credit to two Pittsburgh food establishments, Primanti Bros. and Oram's Donuts in Beaver Falls. The show survived thirteen episodes before being cancelled.

Dr. Ravi Godse began working on his most ambitious film yet. "We were talking to Chevy Chase and Lisa Kudrow," said Dr. Godse, who cast actors such as Steve Guttenberg and Richard Kind. He also recruited Pittsburgh talent such as Franco Harris and Adrienne Wehr. Principal photography

took place in April 2009 and lasted a total of nine days. It was a memorable production for the director. "Franco Harris was great, very friendly. He came to my house," remembered Godse. "Steve [Guttenberg] is great. He's a very good guy. We became friends…Richard Kind is very serious. He's very funny on screen, but he's very committed to his work. He just wants to focus on the script. Because he is a SAG actor, I had to let him go at six [o'clock]. He said, 'No.'" Kind worked past time to help Dr. Godse finish the scenes. Throughout the production, the working title for the film was *If It Ain't Broke, Break It*. However, it was changed to *Help Me Help You*.

Attracted to the state's film tax incentives, the filmmakers of a mixed martial arts film called *Warrior* came to Pittsburgh. It was directed by Gavin O'Connor, who cast Tom Hardy, Jennifer Morrison and Nick Nolte. Pittsburgh acting talent included William Kania, Adrienne Wehr and Kurt Angle. The actors who participated in the fight scenes needed to undergo a rigorous workout regimen with stunt fight coordinator J.J. "Loco" Perry. This was Perry's first time in Pittsburgh, and he especially enjoyed dining at Eat N' Park, a local food chain. With an estimated budget of at least $20 million, principal photography began in late April 2009, lasting until the week of July 19, 2009. Colt's Gym was a set constructed in the Strip District. The set was so well done that locals thought it was real and inquired about using the facility. Mogul Mind Studios in Pittsburgh was utilized for additional shots, as well as the Twin Hi-Way Drive-In located in Robinson Township. The Meadows Racetrack and Casino was used for the casino scenes. One of the more notable locations was the Petersen Events Center, where about ten thousand extras were needed. This scene was shot on May 30, 2009, and the extras weren't paid. Money was donated to the Pittsburgh Police Fallen Heroes Fund for every person who came, and this was one of the largest casting calls the area ever had.

Another television pilot was made in 2009. FX came up with a new drama called *Justified*. Michael Dinner directed the pilot with Timothy Olyphant starring as U.S. Marshal Ravlan Givens. Pittsburgh was chosen as the primary location for the pilot, and they shot in late May with a wrap in early June for a total of a twelve-day shoot. "They called me up to work on *Justified*, but I had other commitments and only worked two weeks on the production. Because I quit CMU, I finally joined the union. I figured that was the only way I was going to get work," said Norman Beck. The Consol Energy Center was under construction at the time and was used as an under-construction federal building/courthouse. They also filmed at the David L. Lawrence Convention Center, with additional scenes shot in Kittanning

and Washington, Pennsylvania. The rest of the series was made elsewhere. *Justified* debuted on March 16, 2010, and was picked up for a second season.

Kurt Angle starred in yet another Pittsburgh production called *River of Darkness*, which began production and some principal photography around July 2009. This time, he was accompanied by many of his professional wrestling colleagues, such as Kevin Nash and Sid Eudy. It was written and directed by Bruce Koehler with an estimated budget of $3.2 million. Koehler cast locals such as Bingo O'Malley, Nick Tallo, Clayton Hill, Sharon Ceccatti, Bill Hinzman and William Kania. A bulk of the principal photography took place in September and October 2009 and was shot around certain people's schedules. The production primarily shot in the suburbs north of Pittsburgh and in southern Butler County. Student volunteers from Tom Savini's special effects makeup program were used. Not only did Koehler benefit from the free help, but the students also received the experience. *River of Darkness* was released on March 29, 2011, on DVD. Sadly, this was the last film for veteran Pittsburgh filmmaker Clayton Hill, as he passed away on July 26, 2009.

Preproduction for *Unstoppable* lasted for years. Robert Schwentke and Martin Campbell were set to direct at one point. Campbell signed on in June 2007, staying with the project until March 2009. Tony Scott was hired to direct and cast Denzel Washington, Chris Pine and Rosario Dawson. Fox Studios was looking to make the movie for $90 million, and Washington was an expensive $20 million purchase. The studio asked him to cut $4 million off his fee and Scott to cut $3 million. Scott remained on the project as Washington left in July 2009. He returned a few weeks later after the studio gave him an enticement package that included a revised script. The final budget ranged between $85 million and $100 million. Scott chose a variety of locations. The bulk of the shoot occurred in Pennsylvania, taking advantage of the state's film incentives. Scott also chose West Virginia, Ohio, New York and California. Scott chose to use Pittsburgh as his base of operations because it was centrally located for most of the production, staying at the Renaissance Hotel. Principal photography began on August 31, 2009, in Brewster, Ohio. For the next two months, Scott filmed in Ohio, New York, central Pennsylvania and West Virginia. The *Unstoppable* production finally headed to Pittsburgh, using the Mogul Mind Studios in the Strip District. "I had a good time working on it. I worked in two departments, and in a way I got to choose what I wanted to do. The two departments negotiated with each other for my time, and there's no better feeling than that," said Norman Beck. "It was one of the few times in my career where I felt loved. I worked over three months on that film in various capacities." They also shot

in Beaver County, Lawrenceville, Carnegie and PPG Place. The production also filmed for two days at the Monroeville Hooters. Pittsburgh casting included William Kania and Tom Stoviak.

Director Edward Zwick cast Jake Gyllenhaal and Anne Hathaway for *Love and Other Drugs* and, because of the film tax incentives and strong film crews, made his estimated $30 million production in Pittsburgh, doubling for Chicago. Several members of Pittsburgh's acting community such as Bingo O'Malley, Tony Amen and Phil Nardozzi were cast. Principal photography began on September 21, 2009, and lasted until the end of November. It was kept under great secrecy, as spectators didn't see much of anything and extras signed agreements not to talk about the film until it came out. Various locations such as the Omni William Penn Hotel, the Capital Grille, Jane Street in the South Side and the former Aliquippa Hospital were used. The hospital was one of the first locations used. The production crew built two towers to create the artificial rain for the scene. Four hundred extras were needed at Mellon Arena on October 13. The extras didn't get paid but did receive free meals. The production donated money to organizations such as the Pittsburgh Film Office, the Humane Society, Habitat for Humanity, Big Brother/Big Sister and the Greater Pittsburgh Arts Council for every extra who attended. Students in a Schenley High School film class were extras in a scene shot at a closed school in the Hill District. The shoot only took about an hour, with the first three hours of the experience in wardrobe. Zwick and Gyllenhaal then entertained their guests by talking to them about filmmaking and answering their questions. Next, the production set up shop at Ringgold High School on November 15 to film on the nearby Mon/Fayette Expressway until November 17. Ringgold School District superintendent Gary Hamilton was approached by location manager Shawn Boyachek about using the campus as a base of operations. The production made a donation to the district, and trailers were set up along the road to the campus, with production tents in the football field. The campus parking lot near the tennis courts was set aside for the actors. Other Pittsburgh locations included McCandless, Squirrel Hill, Fox Chapel, Sewickley and Brownsville. Gyllenhaal made his way around town and was seen at many local eateries. Some locals were nonchalant, while others couldn't help but pay notice to the actor.

Russell Crowe was also in town making *The Next Three Days*. He was accompanied by Elizabeth Banks and Olivia Wilde. Both actresses had recently been in Pittsburgh making other movies. Director Paul Haggis began principal photography on October 2, 2009, a week after *Love and Other Drugs* began shooting. The estimated $30 million picture was shot around

Pittsburgh. One of the first locations used was the Mon/Fayette Expressway between Brownsville and Uniontown. The near eight-mile roadway was shut down from 11:00 p.m. on October 4 until 11:00 p.m. on October 5 for a price of $25,000. The cost came with the services of the state police, local fire and medical services, turnpike maintenance and safety personnel. Later that week, Crowe made his way to the Allegheny County Jail, where filming began on October 8 and continued for the next day or two. It mainly occurred in the jail lobby and visiting area so the daily operations of the facility weren't disturbed. The county courthouse, a free location, was used on Election Day, when the facility was closed. The use of the facility for free attracted the filmmakers and is one of Pittsburgh's film incentives. Principal photography wrapped on December 14, 2009.

In November 2009, Steve Parys directed *The Chief*, starring Tom Atkins as Art "The Chief" Rooney Sr. It was shot on a stage at the Shady Side Academy. Next, Joseph Varhola wrote and directed *When the City Sleeps*, the first Pittsburgh production of 2010. He cast Bingo O'Malley, Rik Billock and Joe Shelby, among other locals. Principal photography took place in February 2010, during one of the worst snowstorms in Pittsburgh history. This was the only production that winter. It was released on May 7, 2010, on DVD.

The estimated $7 million *Riddle* was written and directed by John O. Hartman and Nicholas Mross. They cast Elizabeth Harnois and Val Kilmer. Local casting included Adrienne Wehr, Bingo O'Malley, Tommy Lafitte,

The Chief set photo. *Courtesy of Steve Parys.*

Constructed set for *Riddle. Courtesy of Steve Parys.*

Tony Amen, William Kania and Phil Nardozzi. Principal photography took place in April and May 2010. The majority of the shoot occurred in Brownsville, Pennsylvania, with additional scenes being filmed in other local areas. It was a rigorous schedule for the production, as it operated from 8:00 a.m. to 10:00 p.m. Residents were excited about the shoot. One positive impression the Brownsville community made was when the production needed to use a downtown parking lot and locals moved their cars in minutes. The Brownsville Public Library was a stand-in for the film's police station and featured a temporary police symbol in the window. Twenty thousand books were temporarily relocated, but the library didn't mind. The production also used Fiddles Restaurant on Bridge Street. *Riddle* wrapped in May 2010.

Director D.J. Caruso came to Pittsburgh. The Michael Bay production *I Am Number Four* starred Alex Pettyfer, Teresa Palmer and Timothy Olyphant. Sharlto Copley was originally cast, but he had contractual obligations to *The A-Team*. Because of the film tax incentives and positive experience with *She's Out of My League*, they chose Pittsburgh as its primary location. "It

was fabulous! I had a great time. We were blowing things up, making walls explode," said Norman Beck. The estimated $60 million production began filming on May 17, 2010. Vandergrift was a stand-in for Paradise, Ohio. Vandergrift's original look appealed to the filmmakers. The production bought local food, rented over one hundred hotel rooms for weeks at a time and rented cars. Much of the money spent benefited local businesses in Vandergrift. Some of the first scenes shot were on Grant Avenue. Equipment trailers stretched down Columbia Avenue, with local security watching over the equipment. Many of the shops along Grant Avenue got fictitious makeovers. The filmmakers also chose the Franklin Regional High School, doubling as Paradise Regional Senior High School. It didn't interfere with classes because the school was closed for the summer. Filming began on June 14 under an agreement that the school receive $50,000 for the use of the facilities. The school was also reimbursed for any additional maintenance and staffing required. The filming took place for several weeks, and the extras used the school's auxiliary gym as a break room. All the school scenes weren't shot at Franklin Regional; a studio in Monroeville was used to supplement certain scenes. The former Conley Inn in Homewood, Buttermilk Falls and a boat launch in Monaca were also used. The production also took advantage of local parks, using Deer Lakes Park, North Park and Hyde Park. It was reported that the production paid Allegheny County $10,000 to use the parks for a week. The money was used to restore the decorative tile on the North Park water tower. DreamWorks agreed to post a $50,000 bond covering any repair or restoration costs. Further locations included Port Vue and New Kensington. The shoot wrapped on August 17, 2010.

Katherine Heigl starred in the $40 million production called *One for the Money*, a film directed by Julie Anne Robinson. Debbie Reynolds and John Leguizamo were also cast. Pittsburgh was chosen as a stand-in for Trenton, New Jersey. The film company's positive experience with *The Mothman Prophecies* and the tax incentives were the major reasons to film in Pittsburgh. Principal photography began the week of July 12, 2010, and lasted until early September. One of the first locations used for the shoot was in Ambridge, a borough in Beaver County. The UPMC building in Braddock and Pittsburgh's Central Northside neighborhood were also used, specifically the Garden Theater area. Miscellaneous other locations included Wilkinsburg and Shadyside.

One of the more exciting productions to come to the region was the $40 million *Abduction*, a film directed by John Singleton. Riding off the success from the *Twilight* series was Taylor Lautner, the star. Young girls jumped at the

chance to see the *Twilight* heartthrob in person. The Pittsburgh Film Office received calls from many mothers who were calling for their daughters. The office claimed that it received more calls about Taylor Lautner than any other Hollywood star who came to town. Alfred Molina, Maria Bello and Sigourney Weaver were also cast. Again, Pittsburgh was chosen for the tax incentives. Mount Lebanon's Virginia Manor was a neighborhood the filmmakers chose as a location. Some residents denied permission for their homes to be used, while others welcomed the opportunity. Many young girls populated the neighborhood days before the shoot in the hopes of catching an early glimpse of Lautner. "They couldn't get enough carpenters. I worked on that movie for a couple of weeks and had a terrible time. It was a very unhappy production, very unhappy crew because they didn't have as much money as they would've liked to have had," said Norman Beck. "I started working on *I Am Number Four*, and I got a call from the construction coordinator on *Abduction*. I don't know if he didn't remember who I was because he was so drained, but he talked as if we never met each other. It was a very surreal experience because he didn't remember the ugliness of our relationship." Beck acknowledged that things changed and said, "I don't think it was an unhappy production from that point on. My wife actually worked on costumes in Sigourney Weaver's trailer. Sigourney Weaver seemed like she was delighted to be here. She was a very level-headed, personable and honest woman. They were like buddies for a couple of days." CMU held auditions on June 30 in the Rangos Ballroom for interested extras and performers.

Principal photography began on July 12, 2010, and lasted until September 22, 2010. Throughout the shoot, Lautner pleased Pittsburgh fans by doing a few appearances and greeting spectators. One of the first locations was at Hampton High School. Joe Bursick, the wrestling coach for Hampton, worked with Lautner and taught him wrestling moves. High school wrestlers from Fox Chapel and Hampton were used for the shoot. PNC Park was also featured, as film crews were stationed outside the stadium on August 26. Many pedestrians walking by the stadium were directed away from the shoot as they unknowingly stumbled on the set. The production needed one thousand extras for the two-day shoot at PNC Park. The baseball game was a matchup between the Pittsburgh Pirates and New York Mets. Extras were encouraged to wear Pirates gear or Mets gear in support of their favorite team. The production also built wooden steps up a steep hill next to Old National Pike road in West Brownsville. A few security guards remained alongside the road as filming took place. Several other Pittsburgh communities, such as Greensburg, also saw some action.

A New York Heartbeat was directed and written by Tjardus Greidanus, who cast Escher Holloway, Rachel Brosnahan, Jack Donner and Eric Roberts to star. Laura Davis, a native of the Pittsburgh area and the film's producer, is also Greidanus' wife. *A New York Heartbeat* was filmed between October 4 and October 29, 2010. The Strip District was one of the locations, as well as Squirrel Hill. The cast and crew had nothing but nice things to say about the production and the city, including Eric Roberts, who loved Pittsburgh.

Mafia was written and directed by Ryan Combs. He cast Ving Rhames, Robert Patrick and Pam Grier to star with Pittsburgh actors such as Tom Stoviak, Tony Amen, William Kania and Phil Nardozzi. Principal photography began on November 8, 2010. *The Sibling* immediately followed, directed and written by Matt Orlando. He cast Michael Clarke Duncan to star. Principal photography took place in December 2010 for a twenty-day shoot. Both films were in postproduction until 2012, awaiting release.

Locke and Key was for the Fox network. The pilot was directed by Mark Romanek, who cast Jesse McCartney, Nick Stahl, Mark Pelligrino and Sarah Bolger. According to Michael Thorn, the senior vice-president of creative affairs, the mansion at Hartwood Acres was the only place they found suitable. The state's film tax incentives also played an important role in the decision to shoot in Pittsburgh. They also used 31st Street Studios (formerly Mogul Mind Studios) in the Strip District. Filming began the week of February 7, 2011, and lasted until the end of the month with an estimated budget of $7.5 million.

Emma Watson began principal photography in Pittsburgh on *The Perks of Being a Wallflower*, a film directed by Stephen Chbosky. She ended up staying at the Crowne Plaza Hotel in Bethel Park for the duration of the shoot. Principal photography began on May 9, 2011, in Chbosky's hometown of Upper St. Clair. They were at a home along Mill Grove Road until May 13. The production headed over to the Peters Township High School, where they filmed for several days. The Kings Resturant on McMurray Road was used next from May 19 to May 21. It was closed from 2:00 p.m. Thursday to 5:00 p.m. Saturday. For the next few weeks, they were at the Hollywood Theater in Dormont. Other locations in the Pittsburgh area included the Fort Pitt Tunnel, the Bethel Presbyterian Church and the West End Overlook. Upon the production's return to Peters Township in late June, Watson found time to talk about her project. Besides listening to music and hanging out, she really enjoyed Pittsburgh local restaurant Eat N' Park. They wrapped on June 29, 2011.

Director Daniel Barnz cast Maggie Gyllenhaal, Viola Davis, Ving Rhames, Holly Hunter and Rosie Perez for the production that had several

Screenshot of Jeff Monahan in *Corpsing*. *Courtesy of Jeff Monahan.*

working titles such as *Still I Rise, Steel Town, Learning to Fly* and finally *Won't Back Down*. Principal photography ran from May 23 to the end of July 2011 for a forty-six-day shoot, and the set was off-limits. The lower Hill District and several downtown locations such as the Union Trust Building were used. On the weekend of July 9, an open casting call was held at the Radisson Hotel in Green Tree, where some eight hundred extras were needed for a big scene on July 18. Extras were directed to park in the Strip District by 6:00 a.m. as buses took the extras to the set, located near the Allegheny Commons Park. Late-day rain showers put principal photography on hold. Hoping for a break in the weather, the hundreds of extras were held for a few hours. Given the congestion in the building, tempers rose among many extras and production assistants. Extras were asked to return the next day, and many couldn't. At the same time, Jeff Monahan directed, wrote and starred in a small film called *Corpsing*. Local film crew members such as Steve Parys worked on the production. Principal photography began on July 6 and wrapped on July 29, 2011.

CHAPTER 18
PITTSBURGH RISES

C hristopher Nolan added Pittsburgh as one of the locations for his $250 million *The Dark Knight Rises*. He was scouting Pittsburgh as early as February 2011. He chose Pittsburgh for its visuals and received no tax incentives from the state. "Pittsburgh is a beautiful city. We have been able to find everything we were looking for here, and I am excited to spend the summer in Pittsburgh with our final installment of Batman," said Nolan. Christian Bale, Michael Caine, Gary Oldman, Morgan Freeman, Joseph Gordon-Levitt, Marion Cotillard, Anne Hathaway and Tom Hardy were all cast.

Principal photography began on May 6, 2011. Many locations outside the United States were used for the first few months of the shoot. Pittsburgh preparations lasted for months. One such preparation was extras casting. Nancy Mosser cast the extras and began publicizing in early June 2011. Thousands showed up at the Omni William Penn Hotel for the possibility to be in the next Batman movie. Because of the expected turnout, Mosser held extras casting the weekend of June 11 and June 18 at designated times. As hundreds of these hopeful extras lined up outside the hotel on June 18, they got a surprise. Maggie Gyllenhaal, who had appeared in the previous Batman movie, was filming *Won't Back Down* across the street. BeInAMovie. com worked in conjunction with the production, holding an online casting call for the Heinz Field shoot on August 6. The website was also responsible for finding several production assistants for that day.

On July 27, the city had its own makeshift Bat signal illuminated on the side of the Highmark Building. The next day, a press conference was held at Pittsburgh Renaissance Hotel with film office director Dawn Keezer, Russ

Streiner, Christopher Nolan, Christian Bale and Governor Tom Corbett. "I've never been to Pittsburgh before. I'm looking forward to filming in your city. There will be fighting on the streets a great deal. Thank you so much for your generosity of spirit and hospitality ahead of time, and we'll try and stay out of your hair as much as possible and hopefully leave with good memories for everybody," said Bale. Nolan concluded, "I just wanted…to thank, really, everybody in the city of Pittsburgh for the welcome we've been shown." He also discussed the beautiful architecture and how it played into his vision.

Principal photography in Pittsburgh lasted from July 29 to August 21, filming Wednesdays to Sundays in the hopes of avoiding disruptions. Thousands of pictures were taken on cellphones and cameras. Most were found on the Internet as daily updates were being reported on fan pages and social media. The eyes of the world were on Pittsburgh. Lawrenceville was the first location used. The production utilized a parking lot on Forty-first Street in Lawrenceville for trailers and equipment. Residents were asked to remove flowers and plants because the film is set in the winter. Oldman, Levitt and Cotillard all appeared on this set. Residents reported seeing Batmobiles around town, and Hathaway was spotted in Squirrel Hill.

The production shot in Oakland from July 30 to August 5. Most of the action took place in front of the Mellon Institute along Fifth Avenue, substituting as Gotham City Hall. Here, hundreds of fans got their first glimpse of Tom Hardy as Bane, Christian Bale as Batman and a stuntwoman as Catwoman on a Batpod motorcycle. Although fans didn't see Hathaway as Catwoman, they were finally able to see the suit. The production's first accident occurred in Oakland when the Catwoman stunt double accidentally wrecked her motorcycle into the expensive IMAX camera and destroyed it. No one was injured.

On a dreary Saturday morning, crews were prepping to shoot at Heinz Field while extras parked at Mellon Arena. Buses took the extras to Heinz Field, and crew members checked in extras at the gate. Thousands poured into the stadium wearing black and gold, the colors of the Gotham Rogues. They dressed in winter clothing, adhering to what was asked of them by the production. The August 6 shoot was officially underway with the singing of the National Anthem. Throughout the early morning, rain postponed filming a few times, but it didn't last long. The sun came out, as well as the summer heat. Extras shifted around the stadium a few times to give the illusion of a packed stadium. The day was accompanied by the Pittsburgh Steelers, explosions, Batmobiles and raffles. Fans got to witness Hines Ward riding on top of a Batmobile, as well as the villainous Bane making a

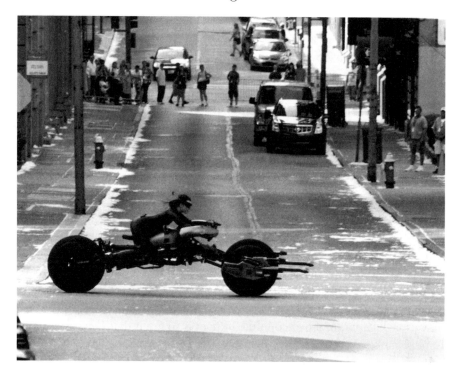

The Catwoman stunt double in downtown Pittsburgh for *The Dark Knight Rises*. *Courtesy of Julio Kuok.*

speech. Hardy and Nolan both thanked everyone at the end of the day for bearing the heat and being professional. *The Avengers* production was also in Pittsburgh that weekend for a total of five shooting days. Pittsburghers such as Jarrett Buba and William Kania worked on *The Avengers* production. Meanwhile, the Batman production spent the rest of its time downtown, closing streets and making the city into a war zone. Batman's new aerial vehicle was also spotted and was the victim of a second accident as it crashed into a lighting array. No injuries were reported, but the production was put on hold to repair the damage. Local businesses benefited from the production. S.W. Randall Toyes & Giftes owner Jack Cohen established his business on Smithfield Street and benefited from the production as people came in to buy Batman merchandise. Nolan and his family were some of those people. As they departed to continue their production in Los Angeles, the filmmakers took out a one-page ad in the *Pittsburgh Post-Gazette*. It was the film's poster that read, "Thank You, Pittsburgh."

Auditions were held for male and female dancers in their twenties at the Benedum Center for an ABC Family movie called *Elixir*. Jane Seymour,

Chelsea Kane and Sara Paxton were all cast. Pittsburgh locations included a house in O'Hara Township, with the nearby Meadow Park serving as a base of operations for the production. Principal photography took place in October 2011 and lasted the entire month for a twenty-three-day shoot. The David L. Lawrence Convention Center, the Consol Energy Center, Schenley Park, Frick Park, Hartwood Acres and a local mansion were all used. The Benedum Center was used again for a large dance number. Chelsea Kane and a few members of the cast appeared at Heinz Field on October 9. Kane was reunited with fellow *Dancing With the Stars* contestant Hines Ward. Producer Gaylyn Fraiche loved filming in Pittsburgh, and ABC Family president Michael Riley expressed interest to return.

Pittsburgh's story has no epilogue in sight. The history of Pittsburgh cinema continued with Tom Cruise's *One Shot*, Christian Bale's *Out of the Furnace* and Matt Damon's *Promised Land*. When the stunning and broad visuals are accompanied by an efficient and talented film community, moviemakers obviously decide to take advantage of the many incentives and make their movies in Pittsburgh. The economic impact is so great that Democrats and Republicans alike have agreed to keep the Pennsylvania Film Tax Credit in place, sustaining a successful industry in Pittsburgh. Many residents know very little about their own cinematic history, and this can be said of many cities all across America. Unknowingly, many Americans can venture through their neighborhoods and discover a little piece of Hollywood.

BIBLIOGRAPHY

Aber, Chuck. Interview by the author, 2003.

Ackerman, Jan. "Courthouse Star Struck for TV Movie." *Pittsburgh Post-Gazette*, May 27, 1985.

Adams, Bud. Interview by the author, 2004.

Allas, Peter. Interview by the author, 2003.

Allegheny Times. "Movie Examines Homelessness." May 22, 1989.

Anderson, George. "DeVito Hoping 'Hoffa' Is a Hit." *Pittsburgh Post-Gazette*, March 10, 1992.

———. "Romero Starts Shooting His Biggest-Budget Film." *Pittsburgh Post-Gazette*, October 22, 1990.

———. "The Tattler: Cameras to Roll Here Again." *Pittsburgh Post-Gazette*, October 15, 1987.

Associated Press. "Bodies in Van Only Dummies." *Beaver County Times*, October 2, 1991.

———. "City to Be 'Hollywood on the Mon?'" *Pittsburgh Post-Gazette*, October 7, 1969.

———. "Jackson Family to Be Focus of Miniseries Planned for ABC." *Williamson Daily News*, April 16, 1992.

———. "Pennsylvania Scenes to Be Used in Show." *Reading Eagle*, December 21, 1985.

———. "'Silent Witness' Being Filmed in Pittsburgh." *Gettysburg Times*, June 14, 1985.

Bagsarian, Tom. "Almost Heaven, Our Mill Creek." *The Vindicator*, July 19, 1994.

Bailey, Laurie. "An Alien Ticket to Paradise: Movie Crew Invades Franklin Regional." *Pittsburgh Post-Gazette*, June 24, 2010.

Balogh, Todd. Interview by the author, 2003.

Barcousky, Len. "Allegheny County OKs Movie Filming in Two Parks." *Pittsburgh Post-Gazette,* June 2, 2010.

Bauknecht, Sara. "Jail Plays a Role in Russell Crowe Movie." *Pittsburgh Post-Gazette*, October 9, 2009.

Beaver County Times. "Movie in City." February 21, 1989.

———. "Sewickley Girl Glides into Film Role as Skater." November 13, 1994.

Beck, Norman. Interview by the author, February 2011.

Bell, Patty. Interview by the author, 2011.

Bennett, Samantha. "Killing Time as an Extra at 'Kill Point.'" *Pittsburgh Post-Gazette*, May 23, 2007.

Bianco, Robert. "Criminal Starts." *Pittsburgh Press*, March 9, 1990.

———. "Pittsburgh 'Stuck' in N.Y. Shadow, but It's No. 1 in Director's Heart." *Pittsburgh Press*, February 21, 1989.

Billock, Rik. Interview by the author, 2011.

Bishop, Pete. "Polish-Born Director to Begin Filming 'Spruce Goose' Here in March." *Pittsburgh Press*, February 5, 1985.

———. "Some City Officials Uneasy as State Film Bureau Is Swallowed Up." *Pittsburgh Press*, September 18, 1987.

Blank, Ed. "Another Movie, 'Street Law,' to Film Here." *Pittsburgh Press,* July 2, 1988.

———. "Brownsville Turns Out for 'Maria's Lovers.'" *Pittsburgh Press*, January 12, 1985.

———. "DeVito Shooting 'Hoffa' Film Epic in Pittsburgh." *Reading Eagle*, March 27, 1992.

———. "Film Crew for 'Rappin' Hops Around City." *Pittsburgh Press*, February 21, 1985.

———. "Movie Brings 2 Oscar Winners to Mercer." *Pittsburgh Press*, November 19, 1988.

———. "Movie with Lancaster to Film in Brownsville." *Pittsburgh Press,* July 13, 1983.

———. "New Movie Begins Filming Here July 18." *Pittsburgh Press,* June 24, 1988.

———. "Oliver Stone–Produced 'Iron Maze' to Film Here." *Pittsburgh Press*, March 23, 1990.

———. "They Savor Pittsburgh Sites for New Film." *Pittsburgh Press,* July 1, 1988.

———. "Veteran Producer Begins Shooting 'Lady Beware' Tomorrow." *Pittsburgh Press,* July 20, 1986.

Braknis, Greg. "New Union Not Expected to Chase Away Movies." *Pittsburgh Press*, December 8, 1991.

Brindle, Becky. "Kings Restaurant Closing for 'Perks' Movie Shoot." *Peters Patch*, May 19, 2011.

———. "Movie Begins Filming in Upper St. Clair." *Upper St. Clair Patch*, May 9, 2011.

Brown, Carole Gilbert. "Walkers Mill Neighborhood Featured in TV movie." *Pittsburgh Post-Gazette*, June 17, 1993.

Buba, Pat. Interview by the author, November 4, 2010.

Butler, William. Interview by the author, 2004.

Cameron, William. Interview by the author, 2004.

Cardille, Bill. Interview by the author, 2003.

Cattaneo, Jennifer. Interview by the author, 2003.

Chopin, John. Interview by the author, 2004.

Coleman, Alex. Interview by the author, 2003.

Conte, Judith. Interview by the author, 2003.

Crawford, David. Interview by the author, 2003.

Dawn of the Dead: Divimax Edition. Directed by George A. Romero. Troy, MI: Anchor Bay Entertainment, 2004. DVD.

Day of the Dead: Divimax Special Edition. Directed by George A. Romero. Troy, MI: Anchor Bay Entertainment, 2003. DVD.

Deggans, Eric. "Harmony to Be Backdrop for Filming of Mill-Town." *Pittsburgh Press*, July 3, 1990.

Dormont-Brookline Patch. "USC Native to Film Scenes for Movie at Dormont's Hollywood Theater." April 25, 2011. Web.

Dugan, Joe. Interview by the author, 2004.

Dvorchak, Robert. "Hollywood Breaks Out at a Hockey Game." *Pittsburgh Post-Gazette*, March 26, 2008.

Dym, Victoria. Interview by the author, 2011.

Early, David. Interview by the author, 2003.

Effects. Directed by Dusty Nelson. Romulus, MI: Synapse Films, 2005. DVD.

Falcione, Orlando. Interview by the author, 2011.

Ferrante, Tim. Interview by the author, 2010.

Fred Rogers—America's Favorite Neighbor. Hosted by Michael Keaton. Pittsburgh, PA: Family Communications Inc. & WQED Multimedia, 2003. DVD.

Gagne, Paul R. *The Zombies That Ate Pittsburgh: The Films of George A. Romero*. New York: Dodd, Mead & Company, 1987.

Godse, Ravi. Interview by the author, March 2011.

Gordon, Debra. Interview by the author, November 2010.

Gracia, Bob. Interview by the author, 2004.

Green, Matt. Interview by the author, 2005.

Gwin, Harold. "Film May Have Its Premiere in Sharon." *The Vindicator*, April 7, 1987.

Gyllenhaal, Stephen. Interview by the author, February 2011.

Hamilton, Elizabeth. Interview by the author, 2001.

Harrison, John. Interview by the author, November 2010.

Hentges, Rochelle. "TV Series 'Kill Point' Films in Downtown." *Pittsburgh Tribune-Review*, May 15, 2007.

Herd, Richard. Interview by the author, January 2011.

Hotchner, A.E. *Paul and Me: Fifty-three Years of Adventures and Misadventures with My Pal Paul Newman*. New York: Knopf Doubleday Publishing Group, 2011.

Hyland, Jane. Interview by the author, 2003.

Internet Movie Database. www.imdb.com.

Johns, Brenda. Interview by the author, 2003.

Jones, R. LaMont, Jr. "Role in 'Lorenzo's Oil' Is Latest in Peters Teen's Rise as Actor." *Pittsburgh Press*, November 24, 1991.

Kane, Joe. *Night of the Living Dead: Behind the Scenes of the Most Terrifying Movie Ever*. New York: Citadel Press, 2010.

Kania, William. Interview by the author, 2004.

Karas-Borys, Sandy. "Movie Being Filmed in New Sewickley." *Beaver County Times*, November 11, 1987.

Keezer, Dawn. Interview by the author, 2004.

Kerlin, Janet. "Movie Crew to Squeeze Filming in Between Flights." *Pittsburgh Press*, June 13, 1990.

Kozak, Karl. Interview by the author, 2003.

Krut, Jim. Interview by the author, 2004.

LaRussa, Tony. "'Love and Other Drugs' to Start Shooting Sept. 21 in Pittsburgh Region." *Pittsburgh Tribune-Review*, September 4, 2009.

Levy, Shawn. *Paul Newman: A Life*. New York: Three Rivers Press, 2009.

Lewiston Morning Tribune. "DeVito Visits Prison for 'Hoffa' Film." December 22, 1991.

Lloyd, Harold. Interview by the author, 2003.

Loeffler, William. "Just No Zombies." *Pittsburgh Tribune-Review*, October 27, 2007.

Lowry, Patricia. "Wrecking Ball: Neighbors Battling to Preserve Edgeworth Estate." *Pittsburgh Press*, November 27, 1991.

Machosky, Michael. "Pittsburgh Film Production Boom Continues." *Pittsburgh Tribune-Review*, June 24, 2008.

Margolis, Lynne. "Jackson Miniseries Might Tap 2 Young Locals." *Observer-Reporter*, April 13, 1992.

Martin. Directed by George A. Romero. Santa Monica, CA: Lionsgate Home Entertainment, 2004. DVD.

McCoy, Adrian. "'End Game' Wraps Filming Here." *Pittsburgh Post-Gazette*, December 12, 2008.

―――. "'Mercury Men' Web Series Gets a Shot on SyFy Site." *Pittsburgh Post-Gazette*, July 22, 2011.

Moseley, Bill. Interview by the author, September 10, 2004.

Mosser, Nancy. Interview by the author, March 2011.

The Mothman Prophecies: Special Edition. Directed by Mark Pellington. Culver City, CA: Sony Pictures Entertainment, 2002. DVD.

Mundell, Jerry. Interview by the author, 2004.

Nelson, Dusty. Interview by the author, December 2010.

Newell, David. Interview by the author, 2003.

Newman, Chris. Interview by the author, January 2011.

Nickel, John-Paul. Interview by the author, March 2011.

Night of the Living Dead. Directed by Tom Savini. Culver City, CA: Sony Pictures Home Entertainment, 1999. DVD.

Night of the Living Dead: Millennium Edition. Directed by George A. Romero. Scarborough, ME: Elite Entertainment, 2002. DVD.

Nolfi, Joey, and Dan Majors. "Pittsburgh Businesses Get Major Boost from Batman Film." *Pittsburgh Post-Gazette*, August 20, 2011.

Novak, Nardi. Interview by the author, 2004.

Nunnally, Scott. Interview by the author, 2003.

Observer-Reporter. "Star Gazing." March 13, 1999.

―――. "Wanted: A Few Good Men." November 15, 1990.

O'Dea, Judith. Interview by the author, November 22, 2003.

O'Donnell, Cathey. "Horror Movie Creep Onto Farm." *Beaver County Times*, November 19, 1987.

Oliver, Jeff. "Movie Crew Hanging Out at Ringgold High." *Valley Independent*, November 17, 2009.

O'Malley, Bingo. Interview by the author, 2003.

Owen, Rob. "Broadcast Pioneer Josie Carey Was There from the Start." *Pittsburgh Post-Gazette*, March 28, 2004.

―――. "City Sets the Scene for Sorority Thriller." *Pittsburgh Post-Gazette*, October 28, 2008.

―――. "Evil Lurks in Collier." *Pittsburgh Post-Gazette*, November 21, 2006.

————. "Film Production Mines Tour-Ed's Realistic Setting." *Pittsburgh Post-Gazette*, June 17, 2008.

————. "Horror Movie to Be Shot Here in Fall." *Pittsburgh Post-Gazette*, September 10, 2008.

————. "'Justified' Another Worthy FX Offering." *Pittsburgh Post-Gazette*, May 15, 2010.

————. "'Three Rivers' Hospital Set a Complex Operation." *Pittsburgh Post-Gazette*, August 5, 2009.

————. "Tuned In: Fox Pilot 'Locke & Key' Filming in Pittsburgh." *Pittsburgh Post-Gazette*, February 11, 2011.

Panizzi, Tawnya. "ABC Movie 'Elixir' Shoot Coming Soon to O'Hara Township." *Valley News Dispatch*, September 26, 2011.

Parys, Steve. Interview by the author, 2003.

Paterra, Paul. "Mon-Fayette Expressway Closed for Taping of Russell Crowe Movie." *Tribune-Review*, October 6, 2009.

Paulson, Al. Interview by the author, 2004.

Perlmutter, Ellen M. "Family Turns Home into Set for Anti-Drug Movie." *Pittsburgh Press*, November 17, 1986.

Peters, Andrew, and Laura Thorén. "'Smart People' on Campus." *The Tartan*, November 13, 2006.

Pikulsky, Jeff. "'Dice' Nice for Aspiring Actor." *Valley Independent*, September 23, 2004.

Pittsburgh Post-Gazette. "Joanne Woodward Due Here." April 17, 1993.

————. "On Time and Happy." March 9, 1989.

————. "Still More Movies." June 8, 1993.

Pittsburgh Press. "Take One." March 2, 1989.

Pitz, Marylynne. "'Dark Knight Rises' Filming Continues in Oakland." *Pittsburgh Post-Gazette*, July 31, 2011.

Puko, Tim. "Actor Crowe to Be in Allegheny Lockup for Filming." *Pittsburgh Tribune-Review*, October 6, 2009.

Puskar, David. Interview by the author, 2003.

Ramirez, Chris. "Big Movies Are Shooting in Pittsburgh, but Key Tax Credit Might Be Lost." *Pittsburgh Tribune-Review*, October 5, 2009.

Rapp, Mark. Interview by the author, 2011.

Rawlins, John. Interview by the author, 2003.

Record-Journal. "Bertinelli Prefers Privacy Off the Set." October 20, 1991.

Reiniger, Scott. Interview by the author, 2004.

Rice, John. Interview by the author, 2011.

Riely, Kaitlynn. "City Students Treasure Session with Director and Star of 'Love & Other Drugs.'" *Pittsburgh Post-Gazette*, November 26, 2010.

———. "Taylor Lautner Filming in Mt. Lebanon." *Pittsburgh Post-Gazette*, July 10, 2010.

Rittmeyer, Brian C. "'I Am Number Four' Offers Many Western Pennsylvania Locations." *Valley News Dispatch*, February 6, 2011.

Roberts, Hunter F. Interview by the author, April 2011.

Roche, Kevin. Interview by the author, 2003.

Rosenthal, Lauren. "Snowy Gotham City Sets Up Camp on Lawrenceville Street." *Pittsburgh Post-Gazette*, July 30, 2011.

Russo, John. *The Complete Night of the Living Dead Filmbook*. Pittsburgh, PA: Imagine, 1985.

Savini, Tom. Interview by the author, 2001.

Schiff, Marty. Interview by the author, January 2011.

Schon, Kyra. Interview by the author, 2004.

Schooley, Tim. "Fox's Locke & Key May Be Filmed at Strip District Studio." *Pittsburgh Business Times*, December 22, 1010.

Sciullo, Maria. "ABC Family Films TV Musical 'Elixir' in Pittsburgh." *Pittsburgh Post-Gazette*, October 21, 2011.

———. "Jake Gyllenhaal Winning Over the 'Burgh." *Pittsburgh Post-Gazette*, September 28, 2009.

Season of the Witch/There's Always Vanilla. Directed by George A. Romero. Troy, MI: Anchor Bay Entertainment, 2005. DVD.

Serrao, Frank. Interview by the author, 2010.

The Silence of the Lambs: Special Edition. Directed by Jonathan Demme. Beverly Hills, CA: MGM Home Entertainment, 2001. DVD.

Skena, Rossilynne. "Vandergrift Locations Part of Week's 'Number Four' Film Shoot." *Tribune-Review*, June 3, 2010.

Smith, Stephanie. Interview by the author, 2003.

Sostek, Anya. "Movie Stars on Location Might Be Living in Your Home." *Pittsburgh Post-Gazette*, July 18, 2010.

Spokesman-Review. "Guess No One Thought of Using Those Bubblegum Cigarettes." March 4, 1992.

Steigerwald, Bill. "Pines Plaza Lanes Goes Hollywood." *Pittsburgh Post-Gazette*, September 27, 1990.

———. "Prices, Place Lure Movie Firms." *Pittsburgh Post-Gazette*, September 27, 1990.

Sterling, Joe. "Movie SWAT Team to Descend on Shaler Street." *Pittsburgh Press*, November 29, 1989.

Stevens, Jon. "Assistants Hold Key Grip on Movie Set." *Observer-Reporter*, September 10, 1993.

Stoviak, Tom. Interview by the author, 2011.

Streiner, Russ. Interview by the author, 2004.

Swauger, R. William. "'Gung Ho.'" *Beaver County Times*, August 28, 1985.

Swayze, Patrick, and Lisa Niemi. *The Time of My Life*. New York: Atria Paperback, 2009.

Tallman, Patricia. Interview by the author, 2004.

Tallo, Nick. Interview by the author, February 2011.

The Tartan. "'Smart People' to Film This Week." November 6, 2006.

Tatar, Ben. Interview by the author, 2004.

Templeton, David. "Remake of Zombie Classic to Help Church Raise Funds." *Pittsburgh Press*, April 1, 1990.

Times Daily. "Minneapolis Lacks Sleaze." September 17, 1987.

Todd, Tony. Interview by the author, 2004.

Tri-City Herald. "Mom Fixes Up Punk Extra." August 31, 1987.

Twedt, Steve. "Pittsburgh Punks It Up to Answer TV's Call." *Pittsburgh Press*, August 29, 1987.

Uricchio, Marylynn. "Bright Lights in This City." *Pittsburgh Post-Gazette*, March 14, 1991.

———. "Movie Makers Find City Right for New Thriller." *Pittsburgh Post-Gazette*, August 4, 1988.

———. "'Spruce Goose' Lifts Off." *Pittsburgh Post-Gazette*, March 25, 1985.

Utterback, Debra. "Forget the Rumors! Local Movie Industry's Alive and Well." *Beaver County Times*, May 14, 1993.

———. "Pittsburgh Is Dead Right for 'Dead Wrong.'" *Beaver County Times*, May 2, 1993.

Vancheri, Barbara. "Another Romero Scares Up a Movie." *Pittsburgh Post-Gazette*, October 26, 2009.

———. "British Actress Enjoyed Time with Good Ol' Boys." *Pittsburgh Post-Gazette*, August 8, 2008.

———. "CMU Grad Tweaks Amusement Park as Setting for Nostalgic 'Adventureland.'" *Pittsburgh Post-Gazette*, April 2, 2009.

———. "Dreamworks Film, 'I Am Number Four,' Begins Shooting Here Next Month." *Pittsburgh Post-Gazette*, April 23, 2010.

———. "Filming Starts Today for Finale in Batman Trilogy." *Pittsburgh Post-Gazette*, July 29, 2011.

———. "Filming Wraps Up on Post-Apocalyptic 'The Road.'" *Pittsburgh Post-Gazette*, April 24, 2008.

———. "Film Note: Walkers Surprised by 'Abduction.'" *Pittsburgh Post-Gazette*, August 27, 2010.

———. "Film Notes: Movie Needs 400 Extras for Scene at Arena." *Pittsburgh Post-Gazette*, October 6, 2009.

———. "Focus on Justice." *Pittsburgh Post-Gazette*, March 23, 1989.

———. "Hospital, Racetrack Double as Movie Set." *Pittsburgh Post-Gazette*, June 24, 2008.

———. "Katherine Heigl to Star in Movie Starting Here in July." *Pittsburgh Post-Gazette*, May 28, 2010.

———. "'Love' Under Way as Film Crews Roll into Pittsburgh." *Pittsburgh Post-Gazette*, September 25, 2009.

———. "Making Room for 'Roommates.'" *Pittsburgh Post-Gazette*, July 19, 1993.

———. "'The Next Three Days' Production Days in Pittsburgh Come to an End." *Pittsburgh Post-Gazette*, December 14, 2009.

———. "One-Two Punch: 'Warrior' Filmmakers Drawn by City's Look, State's Incentives." *Pittsburgh Post-Gazette*, May 8, 2009.

———. "The Perks of a Pittsburgher: Back Home, Stephen Chbosky Directs a Film Version of His Novel." *Pittsburgh Post-Gazette*, June 1, 2011.

———. "'Perks of Being a Wallflower' Stars Just Enjoyed 'Hanging Out.'" *Pittsburgh Post-Gazette*, October 10, 2011.

———. "'Twilight' Star Lautner Will Come to Pittsburgh for 'Abduction.'" *Pittsburgh Post-Gazette*, March 31, 2010.

———. "Underwood to Direct Film Here." *Pittsburgh Post-Gazette*, March 6, 2007.

———. "'Unstoppable' Director Tony Scott Loved Filming in Pennsylvania." *Pittsburgh Post-Gazette*, November 12, 2010.

Vancheri, Barbara, and Jim McKay. "Dispute Over Films Is a Big Production." *Pittsburgh Post-Gazette*, January 23, 1993.

Vancheri, Barbara, Maria Sciullo and Rob Owen. "Pittsburgh Is a Movie Star." *Pittsburgh Post-Gazette*, January 1, 2012.

The Vindicator. "Chaudhri Will Complete 'Life' by Filming Greek Historic Spots." December 10, 1988.

Voas, Sharon. "Sheen, Caravan to Protest Incinerator." *Pittsburgh Post-Gazette*, June 1, 1991.

Wallace, Dee. Interview by the author, 2003.

Wehr, Adrienne. Interview by the author, 2004.

Weiskind, Ron. "'Boss' Star Changes Pace." *Pittsburgh Post-Gazette*, November 22, 1991.

———. "'Bump' Stars Go Against Type." *Pittsburgh Post-Gazette*, January 4, 1991.

———. "'Joey Coyle' Calling It a Wrap Here." *Pittsburgh Post-Gazette*, March 27, 1993.

———. "Woods, Wisdom on 'Citizen Cohn.'" *Pittsburgh Post-Gazette*, March 16, 1992.

Weiskind, Ron, and Barbara Vancheri. "'Mothman Prophecies' Transforms Post-Gazette into a Movie Set." *Pittsburgh Post-Gazette*, February 20, 2001.

Williams, Tom. "Sellout Crowd Sees Movie Filmed in Hermitage Area." *The Vindicator*, June 17, 1989.

Winks, Michael. "Romero Kicks Off Star-Studded 'Dark Half' Here." *Pittsburgh Press*, October 22, 1990.

Wolford, Stacy. Interview by the author, 2003.

———. "Lights, Camera, Action: Fallowfield Township Farm to Serve as Film Site for Gere Movie." *Valley Independent*, January 30, 2001.

Wunderley, Ken. "PG North: Hampton's Hart Has Star Potential." *Pittsburgh Post-Gazette*, July 15, 2010.

Yost, John. Interview by the author, 2004.

Youtube. "'The Dark Knight Rises' Pittsburgh Press Conference." Uploaded July 28, 2011.

Zea, Kristi. Interview by the author, March 2011.

INDEX

U

V

W

Z

ABOUT THE AUTHOR

John Tiech is a lifelong resident of the Pittsburgh area and an English college instructor. At a very young age, he had a passion for film and television. After a decade of research, he is one of very few individuals with the extensive and accurate knowledge about the history of Pittsburgh cinema. He is friends with many members of the Pittsburgh film community and has even been part of local movie productions such as *The Dark Knight Rises* and *Won't Back Down*.

Visit us at
www.historypress.net